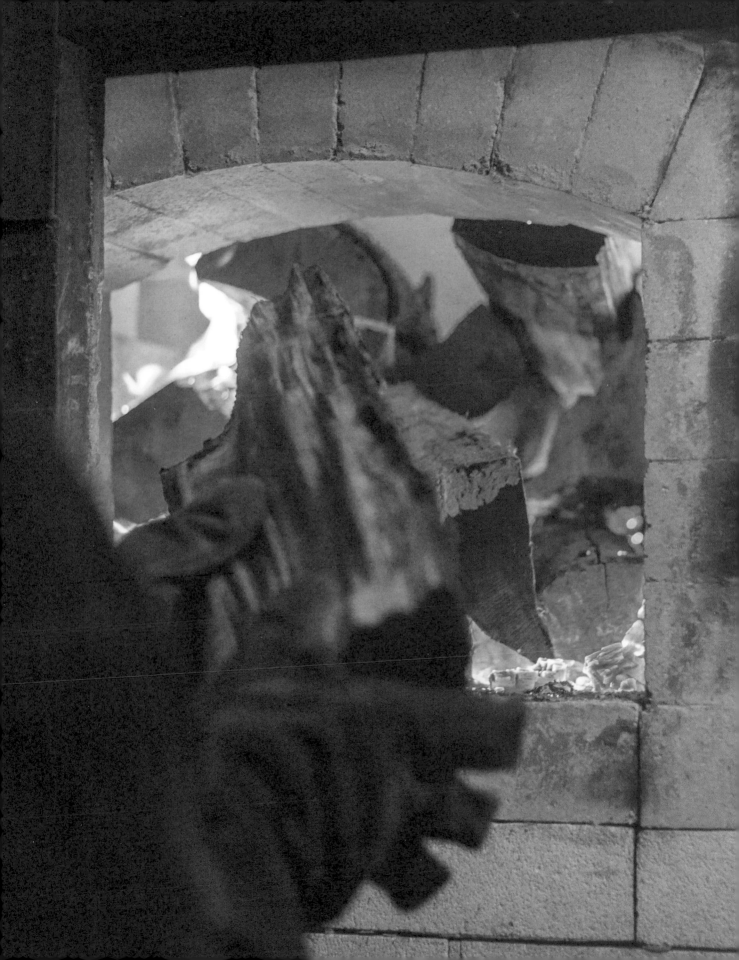

Brimming with creative inspiration, how-to projects, and useful information to enrich your everyday life, Quarto Knows is a favorite destination for those pursuing their interests and passions. Visit our site and dig deeper with our books into your area of interest: Quarto Creates, Quarto Cooks, Quarto Homes, Quarto Lives, Quarto Drives, Quarto Explores, Quarto Gifts, or Quarto Kids.

First Published in 2020 by Quarry Books, an imprint of The Quarto Group,
100 Cummings Center, Suite 265-D, Beverly, MA 01915, USA.
T (978) 282-9590 F (978) 283-2742 QuartoKnows.com

Quarry Books titles are also available at discount for retail, wholesale, promotional, and bulk purchase. For details, contact the Special Sales Manager by email at specialsales@quarto.com or by mail at The Quarto Group, Attn: Special Sales Manager, 100 Cummings Center, Suite 265-D, Beverly, MA 01915, USA.

10 9 8 7 6 5 4 3 2 1

ISBN: 978-0-7603-6488-8

Digital edition published in 2020
eISBN: 978-0-7603-6489-5

Library of Congress Cataloging-in-Publication Data is available

Cover and Page Design: Laura Shaw Design
Cover Images: Tim Robison Creative
Photography: Tim Robison Creative and Abram Eric Landes; gallery art courtesy of the artists

Printed in China

The high temperatures and bright flames involved with firing a kiln can be extremely dangerous. Proper safety attire should be worn at all times when interacting with the kiln, including clothing made from natural fibers such as cotton, heavy leather or welding gloves, welding glasses or mask, and closed-toe shoes. Check with your local fire department before building a kiln to ensure you follow local safety regulations. Use caution, care, and good judgment when following the procedures described in this book. The publisher cannot assume responsibility for any damage to property or injury to persons as a result of misuse of the information provided.

MIX
Paper from
responsible sources
FSC® C016973

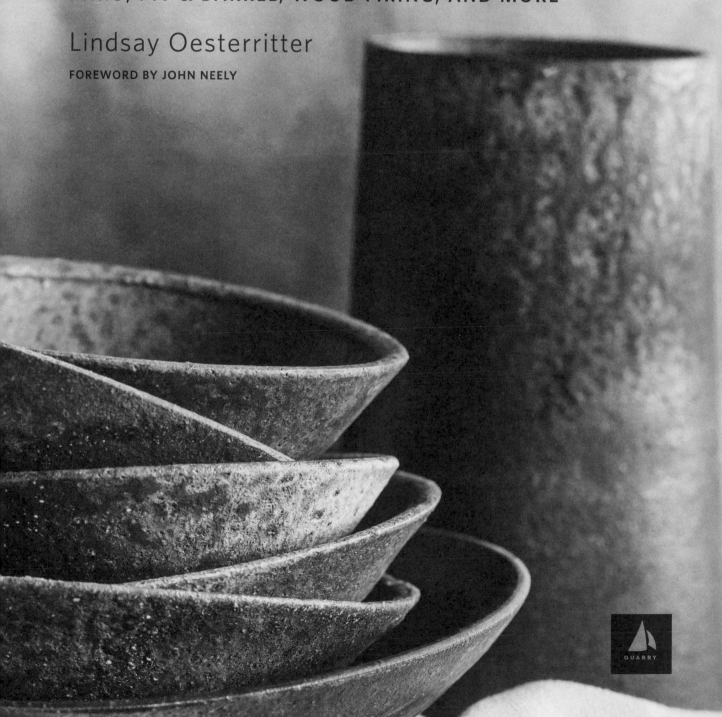

MASTERING
KILNS & FIRING

RAKU, PIT & BARREL, WOOD FIRING, AND MORE

Lindsay Oesterritter

FOREWORD BY JOHN NEELY

QUARRY

CONTENTS

ARTIST'S FEATURES

FOREWORD

When beginners take up ceramics, they are seldom aware of all that the subject entails. The struggle to impose form on a formless lump of clay is trouble enough. How to finish a hard-won form is too often an afterthought. And yet, it is not until that clay has been fired that it gains utility or permanence. In shorthand, one can simply say that *clay + fire = ceramic*. It is the second element in this equation, fire, that is the subject of this book.

In our push button contemporary world, it is possible to buy equipment that brings electric stove convenience to the heat treatment of clay. The fact that in English we call this heat treatment *firing*, though, is deeply significant. Electric kilns, for all of their convenience, come with many limitations. There are many ceramic processes that require the action of a live flame. Lindsay Oesterritter came to this realization early in her ceramic career, building kilns and firing with wood almost immediately. The research and experimentation she has engaged in over the years have had a profound influence on her studio work, and, in great measure, shaped this book.

My own involvement in ceramics began in high school, and I, too, soon found myself using wood as a fuel. This was spurred in equal parts by a fascination with the history of the medium and a fascination with fire and flames, the same urge that leads us to peer into campfires, stir the coals, and tell stories. Of course, for most of the history of ceramics, wood and other plant materials were the only fuels available. Some relatively treeless places like northern China adopted coal as a fuel, but coal, too, is ultimately of plant origins. It was

coal that fueled the industrial revolution, and coal was added to the western potter's arsenal at about the same time. Petroleum technology came along by the end of the nineteenth century; electricity came into wide use only in the twentieth century.

When I took up a teaching post at Utah State University some thirty-five years ago, acquiring kilns was the first order of business. That I had no budget was also a factor, but as I tried to construct a curriculum, it seemed to me that wood firing had the potential to play an important role. It was clear to me that students who use the same means of production as their historical antecedents would have a different understanding of both history and technology. Wood firing connotes rather more than the heat treatment of ceramic objects. There exists around wood firing a complex of concerns only peripherally related to the objects fired. I find the wood kiln useful as a teaching tool just *because* it stimulates discussion and understanding of these concerns.

Wood firing students have a greater understanding of the value of the work they do—certainly they gain a direct understanding of the amount of biomass that must be sacrificed to make their pots permanent. They learn with their bodies the kilocalories or BTU's and work hours that it takes to make a coffee cup hold coffee. This particular issue will only grow in significance in the future. As we deplete our stocks of fossil fuels, renewable resources will be our only alternative. Wood, as a method of harvesting solar energy, seems likely to stay in the mix of viable options for the foreseeable future.

The best reason for the use of wood firing and the related processes of raku and pit and barrel firing, however, is aesthetic. Michael Cardew, writing in *Pioneer Pottery* observed that "There are certain subtleties and qualities of color, texture, and depth which wood firing, properly managed, will give you as a free gift. I do not doubt that this glow of life in pots and glazes can also be obtained using other fuels, but I am sure that it is much easier to achieve it with wood." There are surfaces, textures, and colors that are possible with no other methods of firing. This book provides the reader with a solid introduction to the use of live flame and allows us to amend the ceramic equation to read *clay + fire + know-how = beautiful ceramics*. To truly master kilns and firing is a lifelong endeavor, but with Lindsay illuminating the path, aspiring potters will soon be on the way.

—JOHN NEELY, potter and professor, Utah State University

INTRODUCTION

I built a kiln in my backyard because I needed a kiln to make a living. My style of firing is specialized enough that sharing a kiln with another potter is difficult. However, from the start, building that kiln has been rewarding in ways I never imagined. Beyond the obvious satisfaction of a successful firing, I was pleasantly surprised at how it helped strengthen my own community.

The build started with the timber frame kiln shed. My husband's father and stepmom came out for several weeks to help chisel the joinery, so even this part of the build brought in family and friends. Since our family was new to the neighborhood, we decided to turn our shed raising into a party—a nice way to get to know our neighbors and get help with the heavy lifting. When it came time to build the kiln, I worked with my good friend and kiln builder Ted Neal and a few local volunteers. After the first firing, I gifted all the neighbors that helped with the build a mug as a thank-you present. The communal nature of firings has continued to this day. With each firing, we invite friends and neighbors over to hang out by the kiln. I have also found new wood sources in neighbors knocking at my door after cutting down oak trees or because they know someone who is looking to get rid of rounds.

No matter the kiln you are thinking about building or the firing process you are thinking about exploring, it is sure to foster a community of makers (and friends of makers). Alternative firing requires a little more attention by the kiln, a little more patience by the fire, and a genuine love of the process. My goal in writing this book is to make alternative firing techniques and ideas approachable for everyone, including beginners and enthusiasts. Along with tips from my own studio and firing experience, throughout this book there are artist features from talented makers highlighting additional processes and materials, and gallery artists that showcase the limitless potential and possibilities within alternative firing.

I will introduce a variety of firing techniques, including raku, pit and barrel, and wood firing. These chapters are process-based, focused on helping eliminate some of the mistakes many of us made as beginners. The goal is to give you a framework from which to start your own fire! I will also cover kiln design basics, to help you better approach and assess kilns you might come across in community studios, workshops, and classes. If you are thinking about building your own kiln, along with considerations for design, I'll cover some of the personal and practical matters of designing and building that kiln. In the final chapter, I'll introduce a few ways to experiment with kilns and firings to add to your studio practice.

I hope that after reading this book, the idea of experimenting and learning from the firing process is more approachable, achievable, and exciting. Whether in your own kiln or the kiln of a local studio, I encourage you to get your foot in the kiln. Mastering alternative kilns is something you will do through your own trial and error, gaining experience through multiple firings to master your own set of variables. The good news is that this journey is an enjoyable one, and you are sure to receive plenty of help from your community.

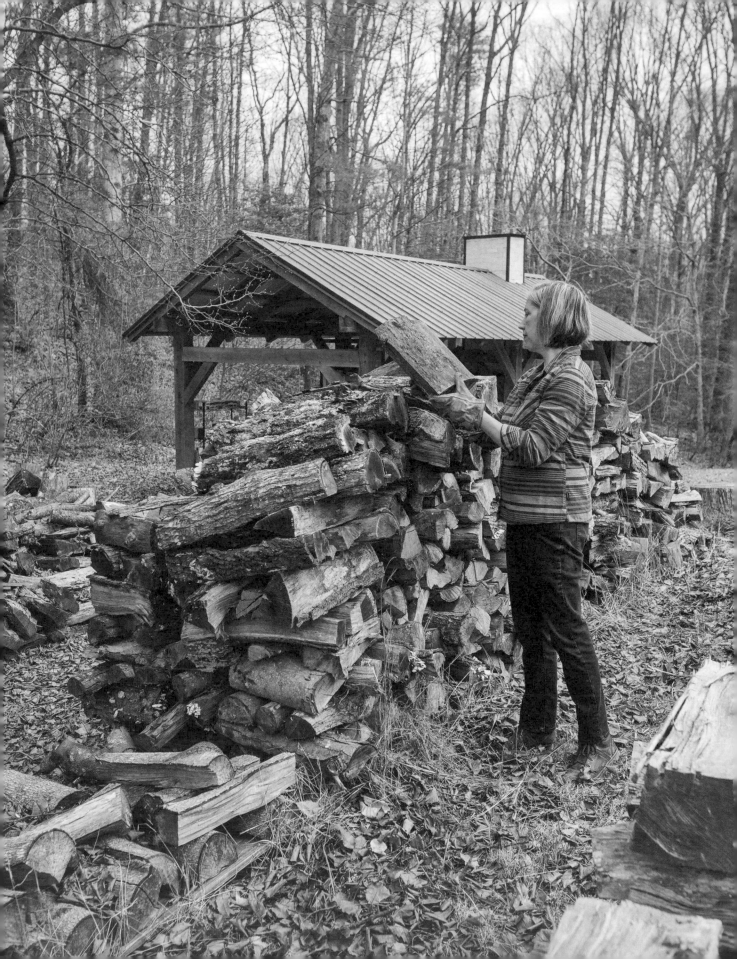

1

GETTING STARTED

BEFORE WE EXPLORE KILNS AND FIRINGS, THERE are a few important basics to cover. After all, when you're starting out even the terminology can be confusing! Raku, pit, and barrel are all firing types. While wood firing is a firing type, it also references the fuel source. If a raku, pit, or barrel firing is fueled with wood, it can also be considered wood firing. Why does this matter? I wanted to mention this up front because in this chapter I'll cover wood sourcing and storage. This information is useful for those considering any alternative methods in this book, not only for those looking to explore wood firing (as in chapter 5). Wood is a fuel source you can easily experiment with for other firing types as well.

No matter which firing you're most interested in, safety always comes first when working with fire. This chapter covers basic safety, as well as a few safety tips to consider while you fire your kiln. I'll cover ways to individualize your clay for your specific needs, including a feature of Michael Hunt and Naomi Dalglish's clay sourcing and processing techniques. This chapter also includes information on making a cone pack, how to clean your work, and shelves and tools that I recommend, as well as tips about sourcing and storing wood.

BASIC SAFETY

No matter which type of firing you pursue, you must put safety first. This starts with proper attire for everyone attending the firing. For the classes and workshops I teach, I always include a list of the type of clothing to wear to the firing: natural fiber (wool, hemp, bamboo, and cotton), long sleeve if possible, leather and welding gloves, a bandana, and no open-toed shoes. However, it never fails that someone shows up in a polyester fleece, synthetic pants, or open-toed shoes. I send them home to change.

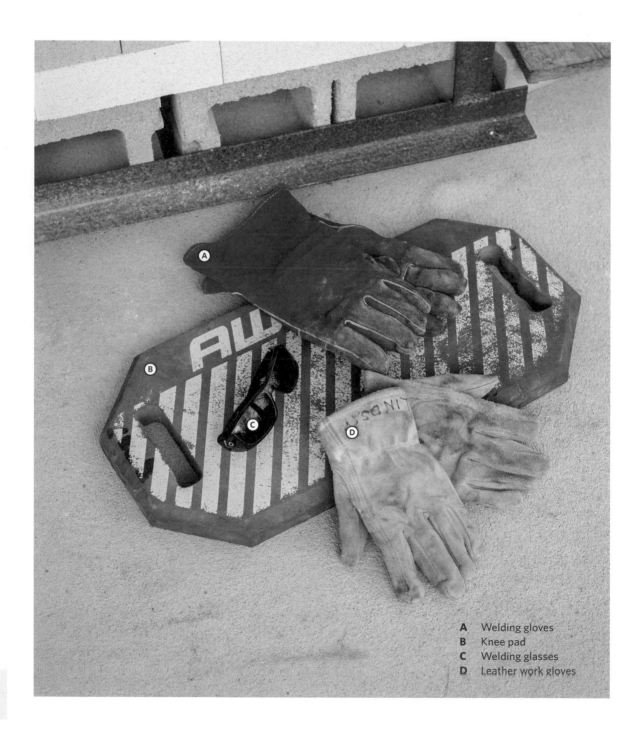

A Welding gloves
B Knee pad
C Welding glasses
D Leather work gloves

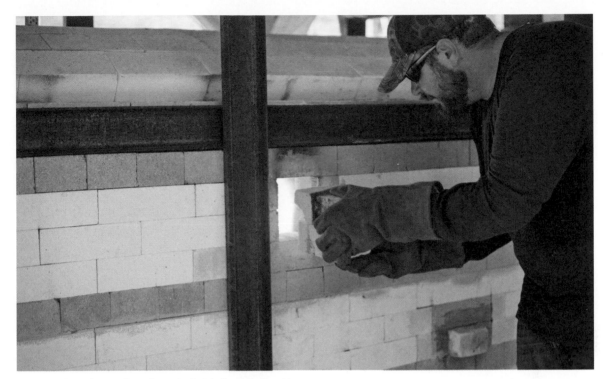

Chris Landers placing the side-stoke bricks back in the side port.

Clothing made from manufactured materials such as polyester, nylon, and fleece can melt, stick to skin, and cause severe burns. Wearing clothing made from natural fibers such as cotton is a simple but important safety choice and should not be disregarded. I am confident that if you pursue alternative firing, there will come a time when you will be thankful you wore the right clothes. I am also confident you will be in a firing where someone will have ignored the clothing standards and be wearing polyester. I urge you to make sure they change.

Here are some additional safety tips for around the kiln when the fire is burning:

- Keep long hair pulled back and scarves tucked in.

- Always have a bottle of drinking water nearby.

- Wear leather gloves and or welding gloves when stoking the fire.

- If there is an axe or splitting axe on site, make sure it is sheathed and/or stored out of the way when not in use.

- Do not leave the hand torch (and/or other fire starters) by the kiln during the firing.

- Do not look at a red hot kiln without welding glasses.

- Particulate masks that help with smoke inhalation are P100 and N95.

- Live embers should only be stored in galvanized metal; never vacuum them. It is best to quench them with water after the firing is unloaded, if they are in an open pit.

- Have adequate light for nighttime firing.

- Have a first aid kit on hand.

- Have a fire extinguisher and a water hose (when possible) on hand.

- Communicate with anyone that is firing with you when you are lifting a lid or adding to the fire.

Depending on the materials and equipment you use, make sure you know how to safely handle them and take precautions to protect your eyes, ears, lungs, and hands. Avoid consuming any alcohol during a firing that you are actively involved in (meaning in charge of or taking a shift in). You are already playing with fire; don't make it any more dangerous than it already is.

SAFETY AROUND THE STUDIO

Make sure your studio and kiln are safe. You should know the location of (and how to use) the nearest fire extinguisher, have a comprehensive first aid kit, and have a working water hose. Call the fire department if they want to be advised when you are firing and let your neighbors know, so *they* don't call the fire department.

Depending on where you live, weather conditions may or may not determine when you can fire your kiln. In the summer, this can be because everything is too dry and at a high fire risk, whereas in the winter, it can be because of poor air quality due to temperature inversion. Make sure you check any weather advisory before lighting the fire. Your county may also have seasonal fire restrictions and regulations you need to be aware of and follow. These restrictions can be different depending on if your fire is an open fire (pit) versus a contained fire (in a brick kiln).

ADDITIONAL RECOMMENDED SAFETY EQUIPMENT

Safety Glasses These are great for any situation where debris could find its way into your eyes—specifically when you're cleaning pots, cleaning shelves, splitting wood, or loading sawdust.

Welding Glasses These are great for looking into the kiln, when the bright light could damage your eyes. Standard sunglasses are not a good alternative because they do not fully protect your eyes from the infrared and ultraviolet light the kiln produces. You should use welding glasses, goggles, or a full welding mask. Depending on the kiln, some people prefer using a mask because it also protects your face from the heat.

Earplugs If you are using a wood splitter or angle grinder, these are loud tools and you should protect yourself from hearing loss. On occasion, you might want to use earplugs while using a dremel tool on your pots as well.

Kneepads and Back Brace For larger kilns or pit kilns, kneepads or a pad to kneel on are great for easing the stress on loading day. Depending on your physical needs, a back brace could serve you well. A lot of kiln loading involves bending down, bending over, or holding heavy shelves and working at a cantilever. All of these actions put stress on your back.

Particulate Mask If you are around a lot of smoke from a raku kiln or are creating a lot of dust cleaning pots, shelves, or the kiln itself, a particulate mask is a must. The non-disposable masks come in different sizes; make sure your mask fits your face snugly. It should be noted that they do not work as well if you have a beard.

Chainsaw Chaps Chainsaw chaps are the very least you should be wearing, and it is far better to be too safe when it comes to using this tool than not safe enough. If you saw your own firewood, make sure you keep your equipment in good condition and know the proper way to cut through the wood. If the saw is communally shared, check the chain and the oil and clean it before every use. If it's solely your saw, keep it well maintained.

CLAY

For many alternative firing processes, little to no glaze is used and the clay is integral to the surface of the finished piece. At the same time, most clay manufacturers don't test their clays for atmospheric firings or have a very limited range of clays listed as raku or wood clay bodies. While this is a pain when you are starting out, it does foster a lot of enthusiasts finding ways to create a clay that works well for them and is aesthetically interesting for their firing process. This includes mixing several different premade clays together, wedging in coarse materials, making clays from purchased dry materials, or finding a source for local clay to dig and process. The local clay can be used in conjunction with bought clay, as a slip, or as an aggregate that gets wedged in. If you are lucky, it can also be used all on its own. In terms of premade clay, I encourage you to test a bunch of clays from different manufacturers; there might be one that already perfectly suits your needs. However, if there is not, figure out a way to make a blend that works for you.

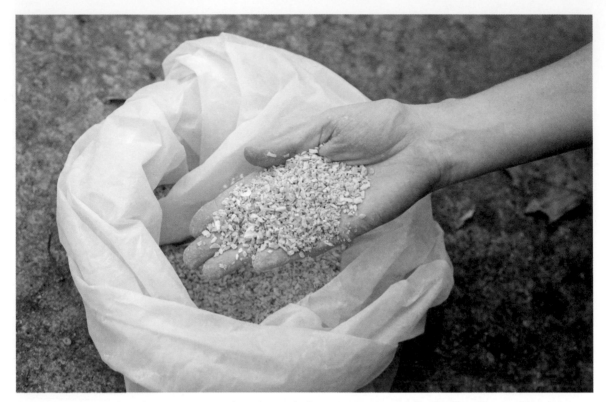

Quartz aggregate such as this—sometimes referred to as chicken grit—is commonly wedged into clay to add variation, texture, and tooth.

Early on in my ceramics studies, I paid for school through work-study, also known as the tech for the ceramics department. Among other things, I made tons and tons of clay for all the beginning and intermediate classes. Until recently, I have always had the equipment to easily make my own clay and have developed and redeveloped my recipe with every move that I made for residencies and jobs. One of the most commonly asked questions I get about my clay body is if it is a locally dug clay. I have used local materials depending on where I lived at any given time, to varying degrees. However, I have never solely used local materials. I appreciate how varied their surfaces can be because of minimal processing, and I often have a few buckets of local clay waiting for me to find the time to process and test.

At the time of this writing, my main clay body is being made by a company. My studio is too small to house a clay-making area that does not get in the way of my making space. It has been interesting working with a supplier and there have been a few hurdles—one being the fact that I had been making my own clay for long enough that many of the ingredient amounts were not measured and instead determined by color or texture while mixing. Since I did not have the ingredient percentages worked out, I am slowly making adjustments to the recipe to get it just right.

If you want to explore customizing your own clay from either premade bodies or dry materials, wire wedging and blundging are two relatively simple and common techniques. An example of mixing clay by wire wedging is to take two separate blocks of clay—clay A and clay B—and cut them into slices like a loaf of bread. Take a slice of clay from clay A, top that with clay B, then clay A, then clay B, and repeat until the two stacks of clay are one block. Ⓐ Pick up this block and gently drop it a few times on your table, flipping it on all sides

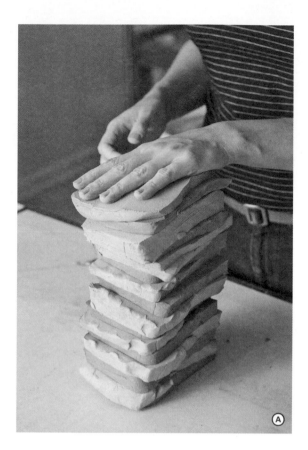

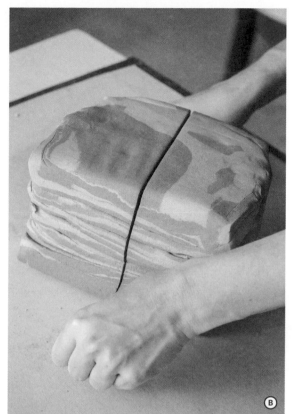

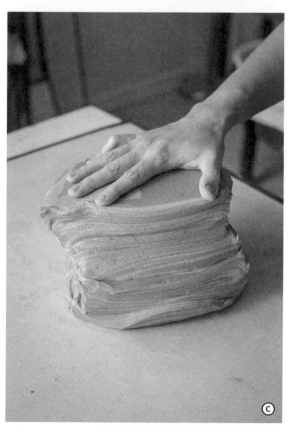

to get it back to a block shape. Then, separate it back into two blocks of clay. Make sure you slice it in half perpendicular to the layers of clay you have just wedged together. ⓑ Now, stack one half on top of the other and gently drop it a few times on your table to get it back to a block shape. Repeat the process until you are satisfied with how well it is mixed. The more times you repeat, the more layers you create and the more mixed it becomes. ⓒ In the end, finish by wedging it traditionally, with the conical or ram's head method. This method works best with small batches of clay. Potters I know who successfully work two (or more) clays together in larger amounts usually have a pug mill.

The other simple way of mixing clay bodies together is to slake them down and blunge them into a slurry. (This is also a great way to reclaim your clay.) First, with your clay in buckets, cover the clay bodies you want to mix with water. No clay should be visible

above the water line. Soak your clay until it is super soft; plan on this taking at least one day. Then, siphon the excess water from the top. With a paddle attachment on a drill, mix the clay until it is well-mixed and creamy. The next step is drying it out. It's important that you have a lot of surface area to help the clay dry faster and more evenly. Two common ways of drying your clay slurry are on a wide plaster slab that has a shallow reservoir or in a raised fabric and mesh box (like featured artist Michael Hunt and Naomi Dalglish). With the plaster slab, the plaster sucks the moisture from below while the air dries the top. If you use both light and dark clays in your studio, I recommend having a plaster slab for each. Otherwise your light clays will get contaminated with the darker clays when you reclaim this way. You can also make mesh boxes from window screens framed with wood, so they are raised off the ground, and lined with fabric. In this case, water drips out the bottom and air is able to circulate around all of it. In both of these setups, plaster and window screens, it's a good idea to keep a piece of fabric on top of the clay to keep out debris and help ensure even drying. Depending on how thick your clay slurry is and the climate where you are drying, you may need to rotate or move the clay around some as it dries. This will ensure that you don't have a middle section that is soppy wet while the top and bottom get too dry. You may find you like reclaiming your clay by slaking it down because of how much a well-hydrated clay can aid in clay plasticity.

Michael Hunt & Naomi Dalglish | Wild Clay

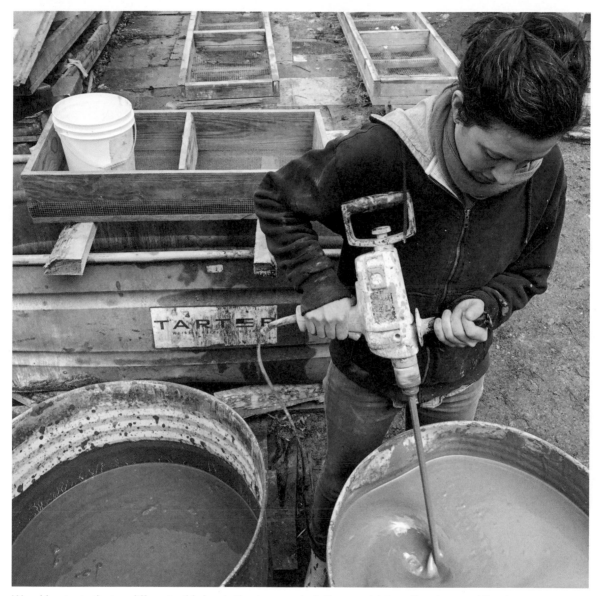

We add water to the two different wild clays in the drums and mix them each into a slip using a paddle mixer on a heavy-duty drill. *Photo courtesy of the artist.*

Within every step of making a pot is an opportunity for aesthetic exploration and expression. At the end of the process, you have decisions about how to fire. In the middle, you have decisions about forming the pieces. And going all the way back to the beginning, you have clay.

Clay is the material with which we most intimately acquaint ourselves, and it deserves deep consideration. We were first drawn to experimenting with local, wild clays because of our love of the coarse beauty of historical folk pots. We were aware that these pots were created in an

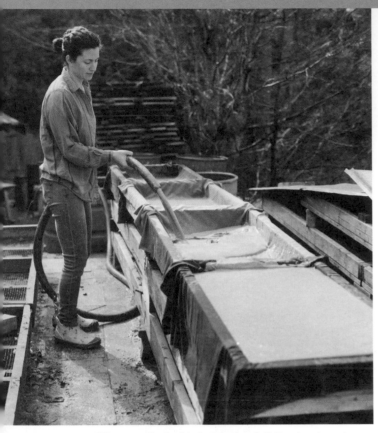

We pump the liquid slip into the cloth lined racks, using spacers to stack more racks on top of the first layer as they are filled. *Photo credit: D. O'Connor.*

Michael Hunt and Naomi Dalglish, *Bowl*, wood fired.
Photo courtesy of the artist.

environment in which technique, forms, and firing all developed in accordance to the character of the clay available to those potters. Each clay has its own properties, which offer limitations and invitations for exploration. A coarse and short clay may not be very good for throwing the demanding form of a pitcher, but it may reveal the most beautiful texture when you carve the foot. Another clay may be so fine that it records our fingerprint or absorbs wood ash from the kiln in a particularly beautiful way. We love that wild clays are like dance partners with an attitude: We are in the constant process of finding out what we can do together.

There are a variety of ways to incorporate wild materials into clay, from simply wedging an interesting sand into an existing clay body, to finding a clay suitable to use straight from the ground, to digging and processing clays to make your own clay body. All materials have different melting points, shrinkage rates, and porosity, so it is, of course, important to test these qualities before making a significant quantity of clay or pots from that material. Our main clay body is mostly comprised of a mixture of two clays from our area: a coarse, red clay that is near our home in the higher mountains (50%) and a more plastic grey clay that settled near a creek bed further down the mountain (25%). While dark, both these clays are so refractory in their pure state that we still need to add feldspar to the body to make it vitrify and hold water at stoneware temperatures. We also found that we need to add small amounts of ball clay, sand, and silica to our clay body to be durable and make the glazes fit. This brings up an important and interesting question: how much should we tame a clay to meet our functional expectations, and how much should we adapt and learn from the beautiful (and limiting) qualities that drew us to the wild clay in the first place?

CONE PACKS

Cone packs are used to help read the temperature in a specific area of the kiln. They are great because they are made of clay and are able tell you how the clay is reacting to the combination of time and temperature. For example, if I am stalling a kiln at cone 7 for a longer amount of time, let's say 5 to 8 hours, it is likely that during those eight hours, without increasing the temperature beyond cone 7, cones 8 and even 9 could begin to get soft. If you are firing for a longer amount of time but at a lower temperature, the clay can still react like you reached that higher temperature.

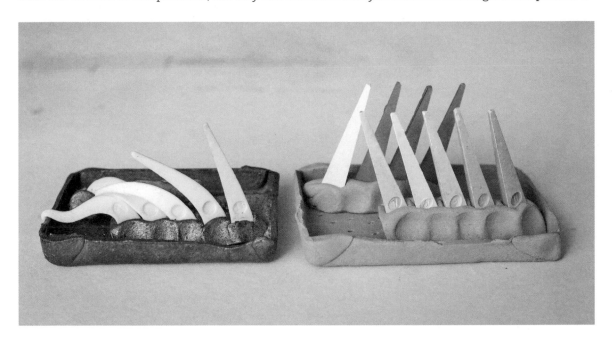

Cones also help with knowing if you are reaching a similar temperature throughout the kiln. You can place a single target-temperature cone in several different spots throughout the kiln. Some cones can be seen during the firing, while others you look at during unloading. By looking at the target-temperature cones you placed throughout the kiln, you can see how the temperature stays the same or varies throughout the kiln. This can be especially helpful with smaller electric and gas kilns where you are troubleshooting glaze problems, or raku kilns when you want to pull a piece at a very specific temperature.

Cones are made by Orton Cones and range from 022 to 14: 022 being the coolest or lowest temperature and 14 being the hottest or highest temperature. Each cone is designed to melt at a specific temperature. Depending on the type of firing you are doing and the temperature you are planning, the cones you use in your cone pack will vary. Cone packs can be anything from a single cone to as many as you see fit to use for your firing information. The cones you use will likely change in the beginning and then become rather standardized as you progress in your firing comfort. The important thing is that you place them in the kiln where you can easily see them and that you put them in a clay-made carrier (also called a boat), so they don't melt all over the shelf.

Note: When you buy cones, they come in sets of two. To use the cones, the first thing you need to do is snap the two cones free from one another. It is not a difficult task, but does take a little practice in the beginning. To snap the cones in half, align your left thumb on top

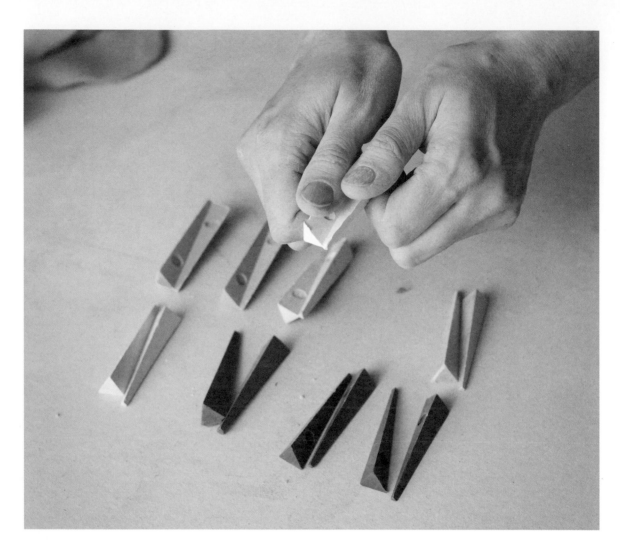

of the left cone and your right thumb on top of the right cone. Gently but firmly pull the two cones down and away, as shown above. (Don't worry, we have all broken our share of cones.) I do not advise using a broken cone in the kiln. Just try again! I am sure you will get the hang of it.

HOW I MAKE A CONE PACK

First, start by making the boats. Roll out a thin slab of clay. I like to make slabs as thin as I can while still being able to handle them without worry of breakage. After the slab is rolled out, cut a piece off that is a few inches (8 to 10 cm) bigger than a half brick. Take that piece of slab and wrap and fold it around the brick, using the half brick like a hump mold. Ⓐ Then, cut the side wall of the boat about ½ to ¼ inch (1.3 to 0.6 mm) tall while it is still being supported on the hard brick. Ⓑ

After you make this cut on all four sides, gently remove the boat, setting it on the table to poke it with holes with a fettling knife or needle tool. Ⓒ Ⓓ Once the holes are poked, set it aside. I cut the walls at this height because it is low enough to still easily see the cones, but high enough to catch any of the melting cones. Poking small pointer-tool holes in it helps it dry fully and it is less likely to explode in the kiln. This is important because even if you generally bisque fire your work for the kiln, cone packs are green fired. Having a cone pack explode in the kiln is the worst. It can literally

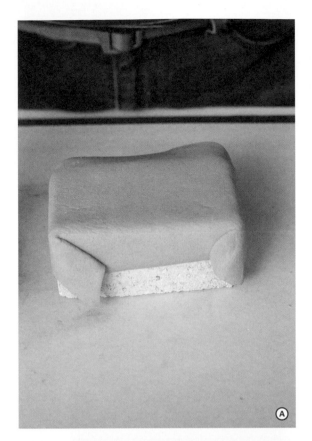

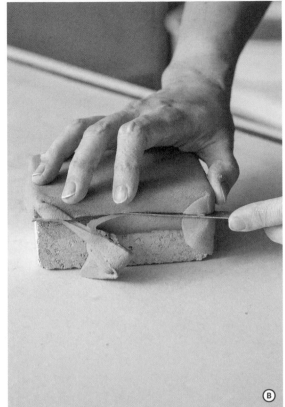

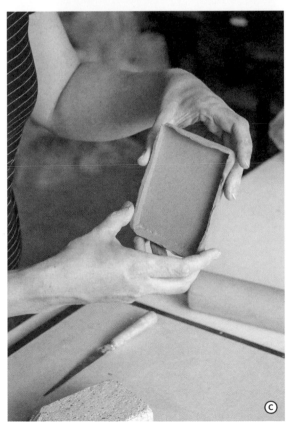

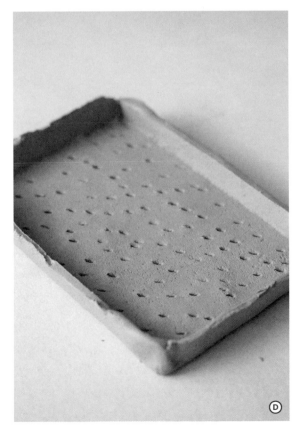

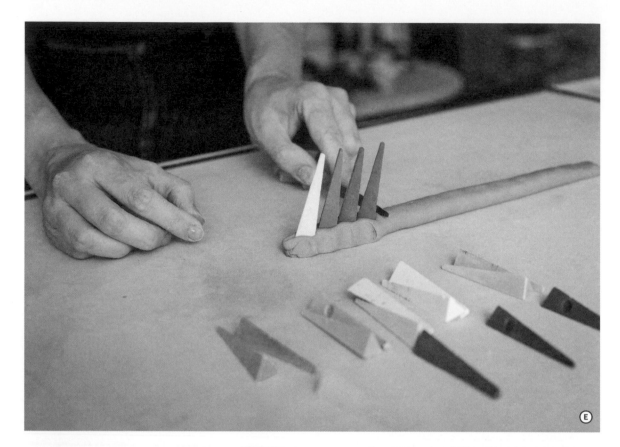

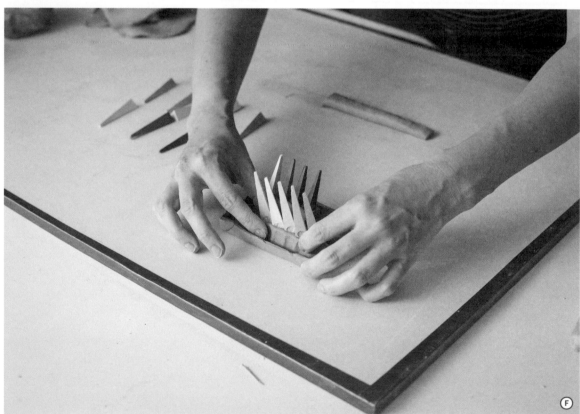

ruin any work near it. Along with poking holes in the boat, I also highly recommend making cone packs several days ahead, to ensure they are dry.

Now you are ready to set the cones you are using in a thin coil. First, organize the cones in order of coolest to hottest in one or two rows that are close to equal in number. For example, the cone packs I use in the wood kiln make two rows. The first row is 08, 1, 3, 5; the second row is 7, 8, 9, 10, 11. (I don't recommend making a row longer than five cones.)

Then, set the cones you are using in a thin coil. The coil should be big enough so that the cones' bases are just smaller than the coil. A good way to check that you are setting the cone correctly in the coil is to first hold the cone on the table, with the bottom of the cone flush with the table. You will notice a slight slant in the cone; make sure you organize the cones so they are all slanting in the same direction and that the lowest number cone is last in the row. When you place the cone in the coil, gently pinch the coil around the base of the cone to secure it in the coil and then move on to the next cone. After you place your last cone for that row, use your fettling knife to cut the coil just behind the cone. Ⓔ After you have finished your one or two rows, place them in the cone boat and let it dry together. Make sure there is enough room behind the rows in the boat for the cones to melt and that the two rows go in opposite directions. Ⓕ This makes it easier to differentiate the cone rows in the kiln, where visibility can be low. If you are using one row of cones, I recommend making the cone boat narrower than the half brick.

OTHER CONE PACKS

There are other ways to make a cone pack as well. The thing to remember is that you want to be able to clearly see the cones and not have them melt on one another or the shelf. Other materials I have used, or seen used, as cone boats include fiber board and 1-inch (2.5 cm) ceramic fiber insulation leftover from a kiln build. In both cases, you can press the cones in the insulation or carve out a divot for the cones to use these materials as a boat. Then, cut it in a shape that leaves an appropriate amount to catch the melting cone. If you don't have too much cone melt, you can reuse this boat several times. If you are making a cone pack for the raku kiln, this is what I would advise doing because it is much easier than making a boat in clay and bisquing it. (A greenware cone boat is too dangerous to use in a raku kiln.)

Note *There are self-supporting cones. If you just need one as a sight cone, you could use the self-supporting kind . . . but I always advise using a boat because it could fall over. You just never know!*

CLEANING

This is the final step toward getting your wares user friendly and table ready. You'll get to handle each piece individually as you decide how to best clean it and get it ready for showcasing; this one-on-one time allows you to discover each piece's subtleness and beauty. Depending on the type of kiln and firing process you use, this process can take hours or days. Regardless of the time, these finishing touches are important. Through cleaning a kiln load, you will more fully see each pot and better understand the overall results from the firing.

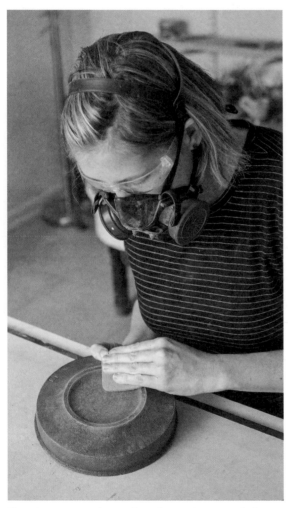

Here, I am using a diamond sanding pad to smooth the bottom of a basin.

CLEANING WORK

It is always a great feeling to have a fresh kiln load of work that needs to be cleaned and an even better feeling when the cleaning is done. This is when you really get to know the pots individually and are able to see their beauty and flaws up close. Following are a few ways that I have cleaned my wares over the years, loosely listed from roughest (or strongest removal) to finishing with mild soapy water. There is no need to do all these techniques at once, or ever, for that matter. I am always learning about new cleaning devices from other crafts and have no doubt that there are stellar cleaning strategies and tools that are not mentioned here. These methods showcase a variety of tools and approaches as a starting point. (And again, always wear a respirator and safety glasses when you are grinding, chiseling, sanding, or creating dust!)

Chuck It Don't clean something that you don't think is worth the time. Too harsh? Maybe. But as the saying goes: your favorite pot going in is not always your favorite pot coming out of the firing. Sometimes, the best decision is to let a pot go.

Bench Grinder These work great for grinding off large wads that are fused onto the pot. Green stone and flap wheel sanding are a great combination. Grinding produces a lot of dust, so I recommend trying to grind outdoors to mitigate dust in the studio. This is a fast process, so make sure you have good lighting

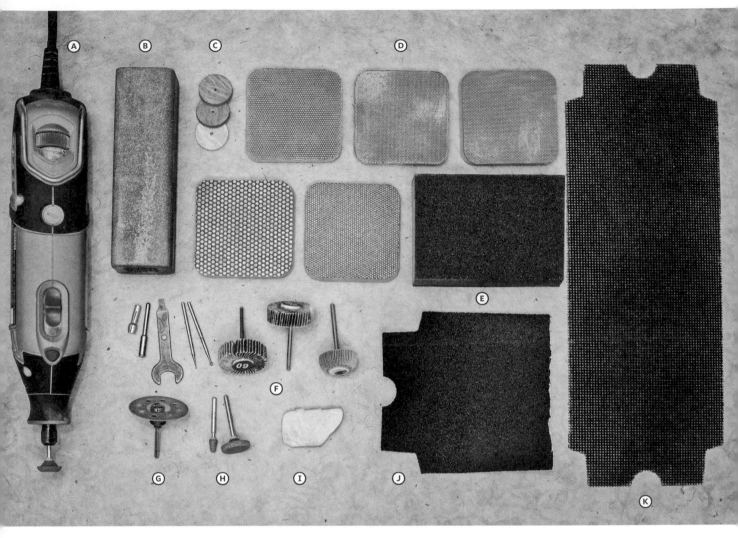

TOOLS THAT I USE WHEN CLEANING POTS

A Dremel tool
B Silicon carbide brick
C Burnishing pads (Dremel)
D Diamond sanding pads 80–800 mesh
E Sanding sponge
F Sanding wheel (Dremel)
G Diamond wheel (Dremel)
H Green grinding stones (Dremel)
I Sharpening stone
J Wet/dry sandpaper
K Drywall sanding screen

or you will quickly discover (but not quick enough) that you have ground into your piece.

Masonry Chisel If you are looking at a fused wad and can see that there is a good buildup of fluxed ash at the base of the wad, a mallet (or hammer) and small masonry chisel works great. Always angle the chisel just above the pot and chisel toward the center point of the pot. While this method is quick when it works well, the risk is that a piece of the ware pops off with the wad.

Dremel Tool This is by far the most frequent way I remove wadding and other crusty bits from the firing that are too big to be removed by sanding alone. There are many types of bits available (and I have a large bowl full of them in my studio), but the two I use most often are the half-inch (1.3 cm) green grinding stone and diamond-cutting wheel. The diamond-cutting wheel is good for cutting around the base of a wad and knocking it off, while the green stone grinds everything else. I should also mention that the diamond-cutting wheel lasts longer if it does not get red-hot. When I use mine, I spray water as I grind, which also keeps the dust down.

When you use your Dremel tool, make sure to take breaks. Depending on your tool or if you are using a flexible shaft, you will experience varying degrees of vibration. Putting your hand through extended periods of prolonged vibration can result in nerve damage. If you finish using your Dremel tool and notice that your fingers are tingly, you have used it for too long. Except for special circumstances, it is as easy as taking regular breaks to eliminate this issue.

Silicon Carbide You can purchase a grinding disk for your wheel that will flush out any wobble. A handheld extruded post shape or stone is nice to work on one or two high points independently, whereas mesh powder works well for smoothing out lid seats. Sprinkle the powder on the lid seat, along with a little water, and then spin or rotate the lid until it's smooth.

Sharpening Stone Similar to the silicon carbide stone, a sharpening stone is great to clean off single high points.

Wooden Paddle When you are trying to remove wads that are more stuck or if a lid seems to be stuck on a pot, sometimes all you need are a few gentle whacks with a paddle. When hitting your wads, hit straight down to avoid chipping the bottom. When trying to loosen a lid, don't hit it right on the lip (which is the most fragile point).

Diamond Grinding Pads These work similarly to sandpaper but last a lot longer. They come in many different meshes, but the ones I use most often are 120, 200, and 400 grit. There are two different versions of these pads: one that is thick and less flexible, and one that is thinner with a lot of flexibility. I prefer using the thinner pads because they are easy to wrap around the pot.

Wet/Dry Sandpaper I use the sheets in 120, 200, and 400 grit and the sponges in medium and fine grade. (Wet/dry sandpaper is actually silicon carbide.) I find the sponges work really well on edges. On a side note, I also occasionally use drywall sandpaper to help level out wobbling pots at the greenware stage.

Scouring Pad For a lot of raku and pit cleaning, this is all you need. A good scouring pad with mild, soapy water will successfully clean the surface.

Mineral Oil After all the grinding and sanding is done, I like to rinse off the piece, dry it, and then rub a very small amount of mineral oil on the surface. This deepens some of the colors and makes it presentation-ready. The mineral oil is not permanent and will wash off. Let it set for a couple of hours to a day before water rinsing your piece one last time.

Bowling Alley Wax This low-gloss seal gives pieces a nice sheen. The resulting colors will darken some with application. Use a clean cloth to rub on the wax and then buff it out with a separate clean cloth. Note that this wax is not food-safe and should not be used on pots you intend to use for food. Most commonly used on raku and pit-fired pots.

CLEANING KILN SHELVES

Due to either glaze drips or the atmosphere in the kiln itself, you will eventually find yourself cleaning kiln shelves. In this section, I detail the tools I use to clean a shelf after a wood kiln firing. However, the basics of this process can be applied to any shelf that needs to be cleaned. Note that working to keep your shelves free from glaze drips will prolong the life of that shelf. If glaze drips go unchecked, they will corrode further into the shelf, making a weak spot that is more likely to crack.

There is a big difference between a silicon carbide and clay shelf. With a clay shelf, most of the cleaning required is on the top side of the shelf. With a silicon carbide shelf, the whole shelf can react to the atmosphere in the kiln, making it necessary to grind the bottom, sides, and top.

An important point I want to mention before discussing the tools I use to clean kiln shelves is the need to brush on a refractory kiln wash before firing. If you are using any glazes or firing atmospherically, always brush a wash on your shelf. This will make cleaning the shelf and grinding or popping off glaze much easier. You can buy premade washes in various weights that work great. The wash I have used for years is equal parts alumina hydrate and Edgar Plastic Kaolin (EPK). I don't weigh anything, but rather mix an equal number of scoops of each. The key to this wash working well is a relatively thin application. The first time you wash your shelves, they may need several coats. Make sure the first

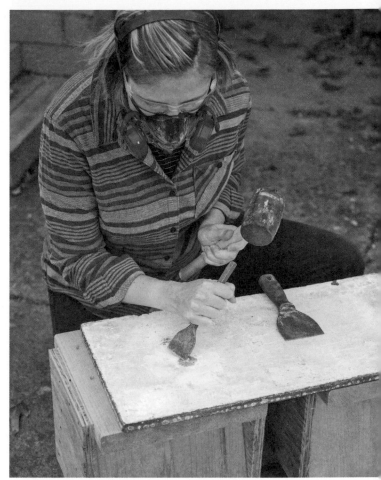

Here, I am using a chisel and rubber mallet to remove wood ash drip from the last firing.

coat is dry before adding a second coat. If the wash is peeling or flaking off before firing, you might be applying too thick of a coat. If you are not able to solve this and it keeps happening, try adding calcined EPK for some of the EPK. Keep the recipe equal parts alumina hydrate and EPK, simply add calcined EPK as a portion of the EPK equal part.

When washing your shelf, you do not want any drips down the side of the shelf. If it drips while you are brushing it on, simply use a wet sponge to wipe it off the edge. This is important because as you load the kiln and place one shelf next to another the sides are going to touch and rub against each other. If there is kiln wash on the side, it could rub off and fall into one of the pots on the shelf below and ruin that pot.

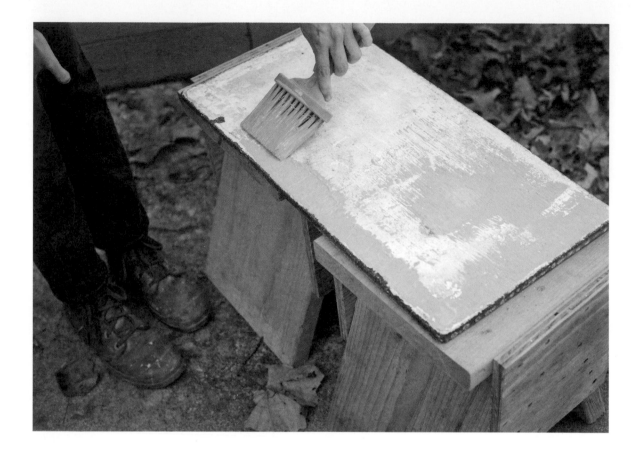

Once you have a good base coat of wash, each subsequent application will typically be one thin coat and only applied if necessary. The thing to avoid as you continue to use, clean, and wash your shelves is a varied surface on the top of the shelf from the repeated application of wash. If you find that your shelf's surface becomes too varied (e.g. could be a topographical map), simply grind it back with a silicon carbide rubbing brick to a relatively smooth surface and, if needed, brush wash on. This is important because the uneven surface could create warping in your wares.

TOOLS

Putty Knife (1.5 to 2 inches [3.8 to 5 cm] wide) The first thing I do is turn to the back of the shelf and pop off the wadding that was used to more easily separate the shelf from the furniture. A quick few taps of a narrower putty knife angled at the base of the wads should pop them right off. I generally tap with a rubber mallet. The putty knife works great for getting small glaze drips off the shelf quickly. The key to popping debris off the shelf with a putty knife or a chisel is to avoid chiseling toward the edge of the shelf. The corner of the shelf is much more likely to chip off if you chisel toward the edge.

Masonry Chisel When the glaze glob, ash drip, or debris is too big for a putty knife, which has some flex to it, I go to the chisel. I like using smaller chisels and often use the corner edge to really dig into whatever I am trying to pop off. I also use the rubber mallet to tap the chisel.

Silicon Carbide Rubbing Brick After the major chunks are worked free from the shelf, I go over the whole shelf with the rubbing brick. This easily grinds the shelf surface down and smooths the topside.

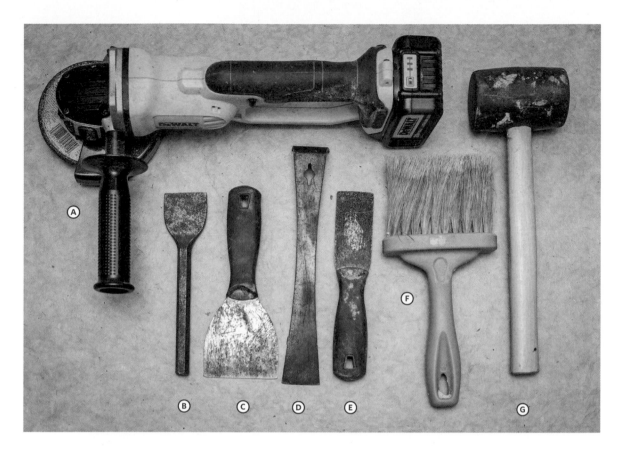

Angle Grinder with Silicon Carbide Disk

Only in the rarest of cases is an angle grinder needed. But when you are faced with one of these cases, boy are you glad to have an angle grinder. They work incredibly fast and eat through the shelf with zeal. Make sure you remove as little of the shelf as you can.

Dustpan and Brush Of course, there is the ever-handy dustpan and brush. After all the grinding, gently brush off your shelf and get it ready for a wash application.

Asphalt Brush This is the brush I use to apply kiln wash (if needed) to the shelves after I have cleaned them from the previous firing. It works well because it is a thicker brush with coarse bristles. I have used a paint roller but prefer the control this brush gives me over wash thickness. It is also much easier to clean than a roller.

TOOLS THAT I USE WHEN CLEANING KILN SHELVES

A Angle grinder
B Pry bar
C 3" (7.6 cm) putty knife
D Masonry chisel
E 1.5" (3.8 cm) putty knife
F 4.5" (11.4 cm) asphalt brush
G Rubber mallet

WOOD STORAGE & SOURCING

There are many ways to store wood, and depending on the climate you live in, some ways work better than others. I have come full circle when it comes to how I manage my wood and have settled on leaving it outside stacked on pallets to help absorb less moisture from the ground. It takes zero maintenance and dries out enough between the rainy days that the kiln fires off just fine. Here are the three main options:

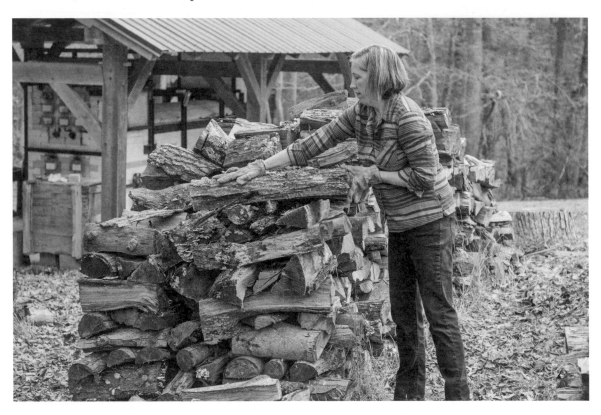

- **Stacked and covered with a tarp** A tarp does a great job keeping rain from getting in, but it also does not let any air in. Just like clay that has been wrapped in plastic for too long, wood can get moldy and take forever to dry. If you use a tarp, try to air out your wood on sunny days and tarp it on the wet ones.

- **Built shelter** Having an open shelter or roof over your wood stack is great. It is the most expensive option, but a permanent one. It is so nice to be able to store your wood and not have to worry about it getting wet. Not to mention, during a firing when it's raining, you can stay dry while getting the wood.

- **Improvised cover** Place corrugated roofing, siding, a folded tarp, or other stiff, lightweight waterproof material just on the top of the stack. This eliminates rainfall from above while letting the stack air out at the same time. This works best on stacks that are flat-topped. I find that my stacks might start flat, but never stay that way for long. If I decide my wood needs to be a little dryer because of the wet climate that I live in, this is the method I will go back to.

If you plan on cutting down your own trees as your main source of firewood, it's best to cut in late winter. When the moisture content

in the tree is low, it is too cold for mold to grow, and you get the longest drying season. Split the rounds in early spring and season it through the summer. The key is making sure you split it early so the moisture is able to release.

Another way to find a good supply of wood when you first start wood firing is to call local tree services. Often, they must pay a fee to dump the trees at the green waste lot of a dump and are more than happy to leave them with you for free. At the same time, some of these businesses resell the wood as firewood and mulch. I have found the best-priced firewood comes from the guys already getting paid to cut the tree down. They also seem to know their trees better, and you have better luck asking for hardwood or pine and actually getting it. If you have a pickup truck, you could also check out the green waste lot at the dump. There is generally a fee to leave with a truckload of wood, but it is negligible.

Stack your wood in a manner that allows for good airflow and minimal moisture absorbtion from the ground. A good simple wood stack starts off lifted from the ground somehow (e.g. pallets) to prevent ground moisture from too quickly rotting the bottom of the stack. Make it no taller than is comfortable for the user to retrieve the wood (just above that person's height) and no wider than two pieces of wood, making both the front and back of the stack easy to access. It is stable and freestanding. An easy way to keep your wood stack from turning into a triangle shape, rather than maintaining a flat top as you build your stack, is to chimney stack the ends. To do this, stabilize the sides by placing two pieces of wood perpendicular, rather than parallel (like this: Ⓐ), before proceeding with the parallel pieces of wood. Only do this on the ends of the stack. Without this type of cross stacking, the stack will get too tall too fast and is not helpful for the overall structure.

You should not fire a kiln with any laminated or pressure-treated woods. Both are

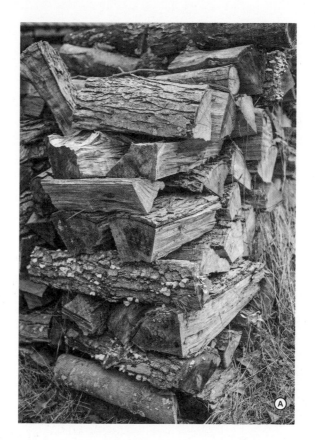

treated with chemicals and release toxic fumes when burning. Also, if you are sourcing wood from neighbors or other people who cut down trees because of beetle kill or disease, make sure you do not inadvertently get your own healthy trees sick. Store and stack a good distance from your healthy trees or selectively accept wood that you store.

Note The byproducts from using wood as your fuel source can also be utilized. Wood ash can be made into a glaze, used in your garden, or made into soap. It is caustic, so take precaution when you are cleaning or using it.

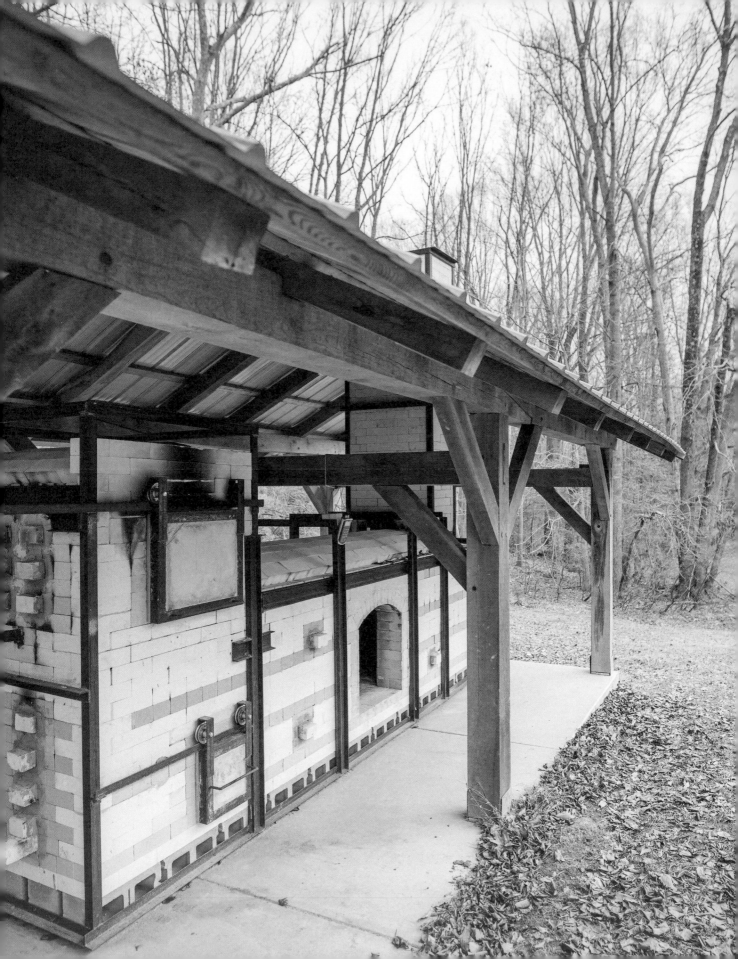

2

KILN FUNDAMENTALS

THE KILN IS ONE OF THE MOST INTEGRAL TOOLS of the ceramic artist. In order to change the physical state of clay, it must be fired. As you progress and continue your ceramics practice, you will no doubt become increasingly curious about what happens inside the kiln.

This chapter will help you understand more about the kilns we'll use in the chapters that follow and give you a basic understanding of how all combusting kilns work. It might be tempting to jump to another chapter and get started, but by understanding these fundamentals, you will be able to make better decisions during the loading and firing, and experiment more in general. Even if you're not planning to build your own kiln, this knowledge will help you better participate in firings at workshops and communal studio settings too.

Note that for the content in this chapter, I am mainly drawing on my experience with brick kilns. However, you can apply many of the same design principles in inventive ways with other materials. As referenced elsewhere in this book, some of the other materials used are trash cans, earth, clay, and even a recycled 55-gallon (208.2 L) drum. You also may repurpose or invent something new, working with materials you find, such as corrugated metal, metal mesh, or an old electric kiln.

KILN ANATOMY

All combusting kilns have a ware chamber, where you load your pottery; a firebox, where the fuel combusts; and a flue or chimney, to release the heat. These structural elements and how they are organized is the first step toward understanding how kiln design will influence the flame path and the pots and sculptures being fired.

WARE CHAMBER

The bigger the ware chamber, the more fuel it takes to fire it, the more pots it takes to fill it, and generally, the longer it takes to fire it. It can be a mistake to build too big or too small. When a kiln is too big and there is too much time between firing, you'll rely on a bigger crew, and loss can be significant. Too small, however, and it is uncomfortable to load, there is not enough space for experimentation with your work, and you might be let down by the results for other reasons. Aside from size, the other critical consideration is shape. The shape of the ware chamber helps direct the flame (see page 47) and influences your loading pattern. In general, in the case of a wood fueled kiln, softer or more rounded transitions direct the flame better than square or angular transitions. If there are corners in the top of the kiln, these spots can be dry or cold. In the case of a pit kiln, the pit is the ware chamber and the firebox. The two elements are less separated than they are in most other types of firings.

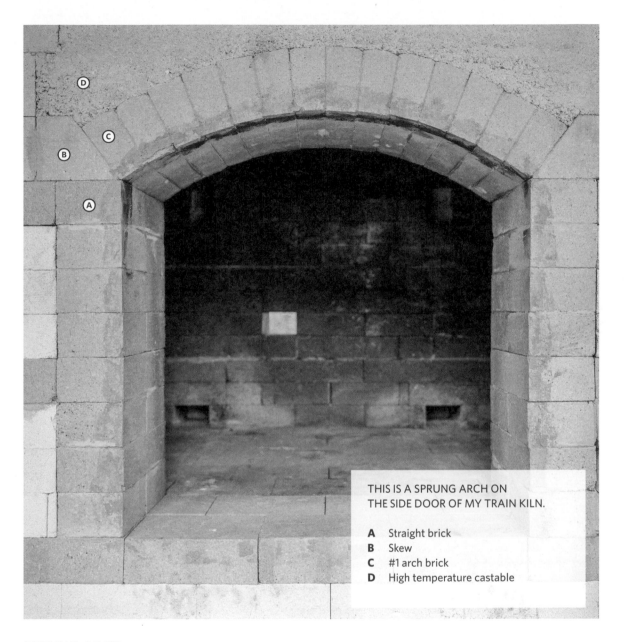

THIS IS A SPRUNG ARCH ON
THE SIDE DOOR OF MY TRAIN KILN.

A Straight brick
B Skew
C #1 arch brick
D High temperature castable

SPRUNG ARCH

A sprung arch is an arch that starts from a skew in a straight wall. A sprung arch is shorter or flatter than a catenary arch. In terms of building, it does mean you will have to support the kiln walls that the arch is sprung from. If those walls shift outward too much, the arch will fall. In terms of loading, you have about 12 to 15 inches (30.5 to 38.1 cm) from the last shelf to the top of the arch, making it easier to fill than the taller catenary arch. In terms of results from wood firing, they tend to be more directional. Depending on the length of the kiln, the results will soften, but in general, a sprung arch, tube-shaped kiln will yield more pieces with a clear back and front than a taller catenary arch kiln. You may see this kiln type for wood or gas kilns, and they can be built at a smaller scale for raku firing too.

CATENARY ARCH

A catenary arch is self-supporting, although you will still want to brace the arch. It is much taller than the sprung arch, which makes it easy to maneuver in when loading. The downfall to such a tall arch is that the loading can be a bit tricky. A little more negotiation of pots and shelves is required to fill the arch space. On longer cross-draft kilns, it makes a beautiful almond or teardrop shape that works nicely in softening the flame directionality. Catenary arch kilns are most commonly used in wood kiln designs.

TOP HAT

This type of kiln is most commonly a raku kiln. As the name suggests, the top of the kiln lifts off, giving you good access to the ware chamber. The drawback to this type of kiln is how much heat is released every time you open it. The lid, or top of the kiln, is also very hot and not easy to lift. Often you see these kilns oriented with a pulley system. Because of the pulley system, even though it is a smaller kiln, it needs a permanent location. This is an updraft kiln, with the firebox below the ware chamber.

CAR KILN

These are some of my favorite kilns to load, though they tend to be gas or electric. The ware chamber is pulled in and out on a set of tracks. There is something so satisfying about loading in the round: great visual, easy on your back, and the satisfying end, where all you need to do is push the wares on the track system with the door of the kiln. These ware chambers are generally pretty square and can be either updraft or downdraft. If you are thinking about working with pots in saggars, they can get heavy fast and this loading style would be ideal.

FIREBOX

Just like it sounds, this is where the fire begins. It is a space in the kiln for the fuel to combust—gas, oil, wood, or other combustible. Depending on the fuel you are using, the size and dimension of your firebox will change. It should be noted that the position of the firebox in relation to the ware chamber has a huge impact on the results.

Below the ware chamber If you're using wood, there will be less ash deposit on your wares when the firebox is directly below your wares. When it is under the ware chamber in a cross-draft situation, like in a Manabigama or groundhog-style wood kiln, glaze wares are still a good idea in the back of the kiln as the back of the kiln gets the least amount of ash during the firing. Below the ware chamber is a very convenient way to introduce fuel for smaller kilns and get away with using one burner, like the trash can raku kiln. If you are building a brick raku kiln, it is similar to the design of the trash can kiln: the firebox (wood or gas) is under the ware chamber. You'll leave the top of the kiln open to fit it with an insulated, lightweight, appropriately sized lid.

Level with the ware chamber The pots closest to the firebox will get hotter faster. Yes, this is the case with any firebox configuration, but is amplified in this situation. With this type of kiln, it is not uncommon to start the fire outside the kiln and slowly work it into the firebox. It is important to design some sort of deflection or bag wall (see page 170) to help create a more even firing or accept the temperature variation and make work accordingly. If firing with wood, the pots closest to the firebox will have more wood ash surface development.

Above the ware chamber I cannot think of a time I have seen this in any scenario aside from a wood kiln. The basic idea behind

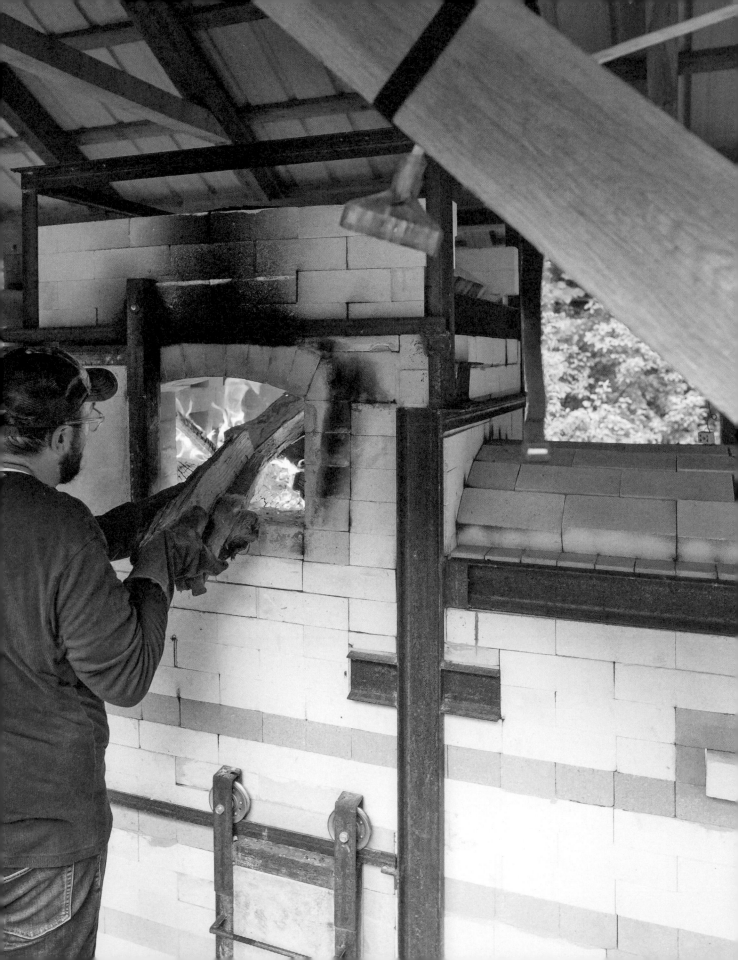

raising the firebox is getting more fly ash for the amount of wood you are putting in. By raising the firebox, you are working with gravity. As the wood combusts and ash falls, it is more easily carried with the flame across the pots. The result is a heavier ash deposit in less time than with a firebox lower or on the same level as the wares produces.

Bourry Box A Bourry firebox is a type of fire box that is named after Emile Bourry. In a Bourry box, the firebox is more separated from the kiln, is often fed from the top of the box, and works in cross-draft and downdraft kilns that have chimneys. It works best with taller chimneys to help create the draw needed to pull the flames from the box. The raised firebox in a train kiln is often referred to as a raised Bourry box. There are other designs of wood kilns called Bourry box kilns, like the one featured with kiln builder Donovan Palmquist on page 42.

CHIMNEY

I am sure there is a graph out there that suggests chimney height based on the dimension of the kiln and firebox. To keep things simple, I'll offer basic guiding principles. The taller the chimney, the stronger the draw; the smaller the flue to the chimney, the easier it is to add too much fuel and choke a temperature climb. Smaller kilns and smaller flues prefer smaller stokes more frequently. Generally, chimneys are always layers of single brick laid lengthwise, and if you have brick seconds, this is a great place to use them. The chimney on my train kiln is 13 to 14 feet (396 to 427 cm) tall.

Shelves The two most common materials for kiln shelves are silicon carbide and clay. Silicon carbide shelves come nitride bonded and oxide bonded. I have been testing both bonds in my wood kiln to see if one proves to be a longer-lasting shelf and to date, I have found they behave very similarly. The nitride-bonded shelves are thinner and lighter. Clay shelves come in a variety of sizes and thicknesses, and there is a newer CoreLite shelf that is lighter. Friends of mine who have tried the CoreLite shelves in the wood kiln have found they are prone to cracking in the zones that get hotter than cone 10. Standard clay shelves work great as dampers, as well as shelves in raku and low- or mid-range firings, but can be tricky in high-fire atmospheres. With clay shelves, I have found that the thicker they are, the longer they last. But thick shelves are no fun to load.

Furniture Use the extra bricks from your kiln build to make your kiln furniture. A good mix of furniture sizes to cut from a full 9-inch (22.9 cm) brick include one-quarter of a brick (referred to as "soaps"), half brick, three-quarter, and then the full brick. For raku, you can post with soft brick in a similar size range. Alternatively, you can buy clay furniture, but they will be smaller in width.

Donovan Palmquist | The Bourry Box

Saw set up to cut skew backs for arch. *Photo courtesy of the artist.*

A Bourry box is a versatile kiln that can be fired many ways. It's small enough that you can fire with a two- to three-person crew, and it uses wood efficiently so you can fire it in as little as twelve hours for glazed work or twenty-four to thirty-six hours for more ash and flash. Depending on the firing length, it will use one to three cords of wood. A Bourry box kiln also produces very little smoke for most the firing.

I like the Bourry box because it is easy to fire in different ways. I can get nice glazed pots as well as traditional wood-fire surfaces. It's a great kiln if you do more surface decoration and don't want it destroyed by melted ash. You can also load it for heavy ash effects. This kiln is easy to fire and rarely stalls.

I get great results throughout the kiln. I put porcelain and high-fire bodies close to the front and high-flux bodies and stoneware in other areas. It requires less labor to fire than other wood kilns. It's easy to load because you are not climbing in the kiln, bending over like you would in an anagama or train kiln.

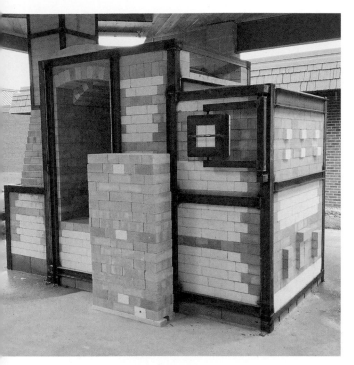

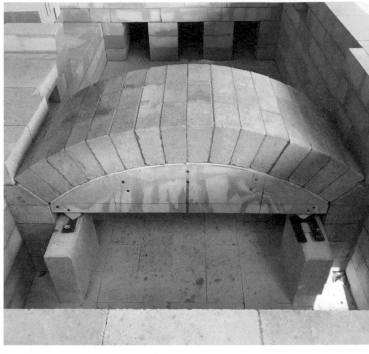

Finished Bourry box kiln. *Photo courtesy of the artist.*

Throat arch in place. *Photo courtesy of the artist.*

FIRING SCHEDULE FOR THE 50 CUBIC FOOT (1.4 m³) BOURRY BOX KILN

We typically start a fire in the late evening and get the temperature to around 500°F (260°C) in about six hours. We then bring the temp up to 1100°F (593°C) and hold it there for eight to ten hours or so. This allows the heat to penetrate the work throughout the kiln. When we hold it at this temperature for a long period, it allows us to get more even temps throughout the kiln. If I fire faster, the thermal gradient is larger and I have much more underfired work in parts of the kiln. I also believe that some atmospheric effects begin to develop at this phase of the firing. The kiln usually takes off once it reaches 1300°F (704°C). We then bring it to cone 010 and put it into a moderate reduction by using a combination of the passive (barometric) dampers and the active damper.

After about three hours of moderate body reduction, we begin to take the kiln up in temp. It takes another five to seven hours to get it to cone 7 or 8. From there, we hold the temp at cone 8 for six to eight hours. We don't usually make many damper adjustments once we get to cone 8. When we do, it is to move heat up or down or from side to side. The rhythm of stoking causes the kiln to oscillate between oxidation and reduction. We finish the firing by taking the temp up so that cone 11 is bending well, but cone 12 is not soft. That usually takes four to six hours.

You can fire this kiln in as few as twelve hours, with the best results coming in at twenty-four to thirty hours.

KILN MATERIAL CONSIDERATIONS

While I will be covering a lot about bricks, there are three important considerations when it comes to what materials you are building your kiln with, brick or otherwise:

- Is this noncombustible material able to safely withstand the long-term wear and tear of the temperature I plan on firing?

- Is the material relatively easy to build and work with?

- Is the material affordable and easily available?

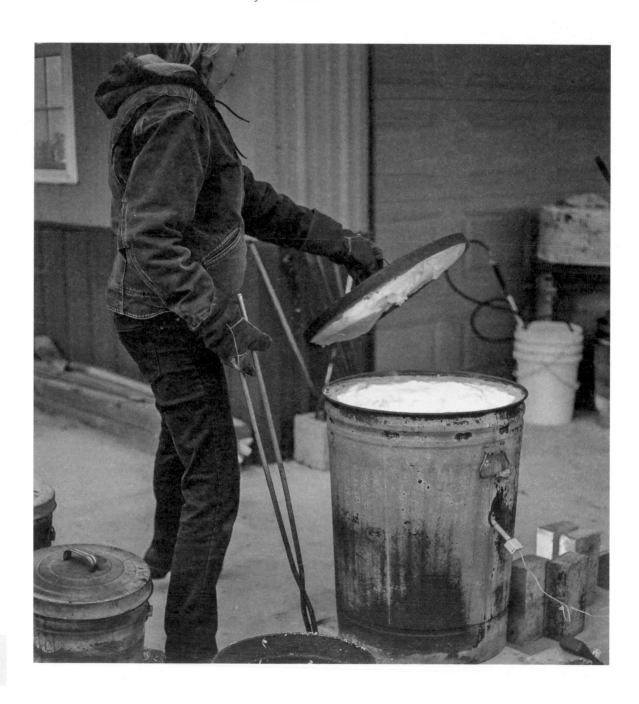

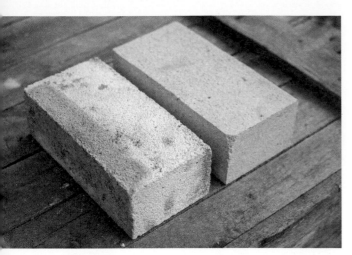

Both bricks measure 9" × 4.5" × 3" (23 × 11.5 × 7.6 cm). The one on the left is an IFB and the one on the right is a super-duty fire brick.

BRICKS

Bricks come in many different shapes, sizes, and firing ranges. The most commonly used straight bricks are 9 × 4.5 × 2.5 inch or 9 × 4.5 × 3 inch (22.8 × 11.4 × 6.3 cm). Beyond straight bricks, there are arch bricks, wedges, skews, and keys to name a few. If you find yourself in a situation with a good quantity of bricks that don't fit the standard straight design, it could be a fun experimental kiln. Raku and pit kilns both work great in the round. Who knows, you might be on to something. Most kiln constructions employ straight bricks, arch bricks, and a brick saw to cut any specialized sizes.

Brick Types

- **Common** The common red house brick is rated to a maximum temperature of around 1800°F (982°C). It is more porous and not as strong as a firebrick and for that reason does not hold heat as well. While you might be able to get away with common brick for a pizza oven, in terms of kilns, I only recommend using common brick if you want to build an aboveground sawdust fire pit. In general, these bricks don't last as long as the low-duty firebrick (that is a similar heat rating). The advantage to using these bricks is that they are cheaper and easier to find for free.

- **Firebrick** Firebrick come in low-duty, medium-duty, high-duty, and super-duty. This brick is stronger and more dense than common brick. It is made of fireclay, silica, and alumina. Because of its density, it holds heat well. It is rated for temperatures from 1800°F (982°C), 2700°F (1482°C), 2850°F (1565°C), to 2900°F (1593°C). The standard in high-fire kilns is to use high-duty or super-duty. Low-duty or medium-duty would work well for a bricked pit or raku kiln. Definitely double-check with the brick manufacturer about the maximum temperature ratings, as those numbers may vary slightly depending on where you get them.

- **Insulating** IFB, or insulating firebrick, is also called soft brick because it is lightweight and porous. This brick is used as a second layer of brick on a kiln to help reflect the heat and insulate. These bricks are also great to use in the spyholes or peepholes. When firing a kiln and pulling the soft brick to look at the cones, the soft brick will be red-hot on the kiln side, and because it is so porous, you are able to hold it with a glove. It comes in ratings from 2300°F (1260°C) to 2800°F (1538°C). The lower temperature ratings are more porous than the higher temperature rating. The standard IFB is 2300°F (1260°C) and unless you plan on firing hotter, should be enough. They are fragile and crumble and crack over time. It is worth buying a few extra to have on hand.

- **Homemade** Another brick option for your kiln is to make your own bricks. This could be a fun project to work on with family members and is an opportunity to create fun decorations, memorabilia pieces, or bricks that you can incorporate into your

landscaping, as well as your kiln or kiln structure. Depending on what temperature you want to fire your kiln to, test the temperature your brick clay can go to before committing it to use in your kiln.

INSULATION

Insulation keeps the heat in the kiln. The original insulation used in pit fires was, you guessed it, the earth. Many kiln designs today, which are partially or wholly underground, still utilize the insulating elements of the ground. For example, if you want to dig a kiln for sawdust firing, the ground helps eliminate air and acts as an insulator. Not to mention, by using the ground, you save money that you would have otherwise spent on bricks. Anagama wood kilns are built partially underground utilizing natural slopes in the ground for the same insulating properties. One key to using the ground is to make sure you are not in a situation that will flood or be changed by water regularly.

Insulation Levels

- **Single brick** A single brick layer works well if you want to ensure there is good airflow into the kiln for combustion and you don't need the additional insulation of a second layer of material to get hotter than low-fire temperatures. This level of insulation works well for raku firing, pit firing, and sawdust firing.

- **Single brick plus** Arches are often a single layer of bricks. In order to help retain the heat and eliminate airflow, the single layer of brick is then blanketed with additional insulation. Most commonly used is ceramic fiber insulation blanket, soft brick, and/or a clay and castable insulating mixture. If you are building an updraft raku kiln with a removable lid, you might experiment with the inverse of this, instead lining the

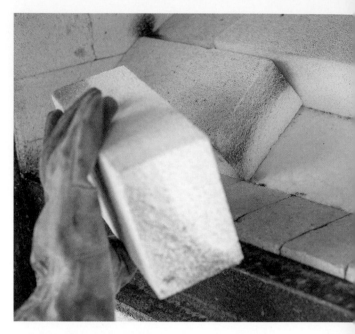

Removing the top layer of IFB brick shows the ceramic fiber insulation blanketed beneath.

inside of the single layer of bricks with ceramic fiber insulation.

- **Double brick** In brick kilns, two layers of bricks are often used: firebrick on the interior and IFB on the exterior. The inside firebrick can handle the wear and tear of the kiln atmosphere, while the exterior IFB helps insulate and keep the exterior cooler and more approachable. When you use two layers of bricks, it is common practice to offset the brick seams (front to back) to help eliminate airflow. However, to prevent the two layers of bricks from separating, about every fourth to sixth row up is a locking row of just hard brick.

- **Double brick plus** In special circumstances, you might want a truly thick kiln to better insulate and/or create a slower cooling cycle. This thick wall design is determined by your firing and pottery interests. The one kiln that comes to mind when I think about this is the kiln that Judith Duff in North Carolina built for her Shino research. That kiln has 18-inch (45.7 cm) thick walls.

FLAME PATH

When fuel combusts with air to create a flame, the flame then travels around the kiln, following the easiest path, or paths, out of the kiln. The kiln is, in large part, designed with the flame in mind. Aside from the shape of the ware chamber, the draft of the flame (also called the flame path) is the biggest "tell" in the design for how the results will turn out.

Courtney Martin's catenary arch kiln and her cleanly-stacked wood.

UPDRAFT

An updraft kiln has fuel entering low in the kiln or at the floor of the kiln and a flue at the top or roof. The raku trash can kiln mentioned in chapter 1 is an updraft kiln. This type of kiln does not need a chimney to help create a draw and is relatively easy to design, but it is also considered the least efficient kiln construction. If you were firing with wood, you would use it primarily as a fuel source because you are not going to get good ash surfaces on your wares. Most, if not all, of your work would be glazed. This kiln can also be difficult to load because of how it stresses the bottoms of pieces. One of the frequently mentioned historic updraft kilns is the beehive kiln.

DOWNDRAFT

A downdraft kiln has fuel entering low in the kiln and a flue to the chimney low in the kiln. The idea is that the flame enters, goes up toward the roof, and then circles back down to the flue to escape. These kilns have chimneys that help draw the flame (unless forced air burners are used, which eliminate the need for the chimney to create draw), and the overall shape is pretty square or high-arched. If you were firing with wood, the ash would be deposited on the shoulders or top of a pot, as the flame circles back down to the flue. Because of the nature of the draft, there are dry spots lower in the kiln and it would be easy to incorporate glaze work. When I think of well-known downdraft kilns, I think of a noborigama kiln or cat (catenary arch) kiln.

CROSS-DRAFT

A cross-draft kiln has fuel entering on one side of the kiln, and the exit flue is on the opposite side. The flame travels across the pots, and a chimney helps create the draft. Now, you might be thinking, wait, some downdraft kilns can fall under this same category: fuel on one side, exit flue on the other, chimney helps the draw. This is true. I differentiate the two by considering what the major flame path is in the kiln: down or across. In general, cross-draft kilns have much longer continuous ware chambers than downdraft kilns. If firing with wood in a cross-draft kiln, your pots will have a front (flame side) and a back (chimney side). The ash deposits on one side, the flame wraps around, and blushed clay develops on the back side. Examples of a cross-draft kilns include the very popular anagama kiln and train kiln.

READING TEMPERATURE

**THE THREE MOST COMMON WAYS OF READING THE TEMPERATURE
IN A KILN ARE COLOR, PYROMETER, AND ORTON CONES.**

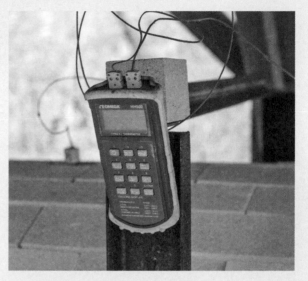

Color As the kiln begins to heat up, it goes from black, or no color, to a deep rosy red. As the kiln continues to get hotter, the color transitions from dark red, red, red-orange, orange, bright orange, bright yellow, bright white, blindingly bright, to sunshine. The brighter the color, the hotter the kiln. To protect your eyes from long-term damage, it is important to wear welding goggles/glasses as your kiln gets to these brighter heats. It is a great tool to be able to read the color of the kiln, but it is not as accurate as the cones or pyrometer and should be used in conjunction with one or both of the other methods.

Pyrometer Depending on the size of your kiln, you may have more than one pyrometer. Generally, one pyrometer can read two thermocouples. A commonly used pyrometer that works for both low and high firing range is a Type K. What is nice about using pyrometers is that you can see the small changes. You will know relatively quickly if you are

using enough fuel to achieve a temperature increase. You can read what is happening in the kiln instantly. If you plan on stalling your kiln or down firing, you really need a pyrometer. In general, it is highly worth the small investment and very helpful.

Cones As mentioned in the Getting Started chapter, Orton Cones are made of clay, and helpful to use in your kiln because clay reacts to time and temperature. I like to use cones to help keep track of how even the train kiln is firing front to back, placing the cones lower in the kiln than the thermocouples. Not to mention, Orton Cones are universal. If you find yourself in a conversation with someone who uses the centigrade scale, and you don't have your conversion chart handy, you can still successfully talk about temperature as it relates to Orton Cones.

AIR

It is all around us, but it's a very important component of firing. Air and fuel are the two elements you are forever balancing during a firing, no matter what the type of firing. Without the appropriate amount of air, your kiln will not get hot enough. Each kiln has different sensitivities (you will learn with firing experience) to the balance of fuel and air.

Reduction refers to an atmosphere in the kiln that has more fuel than oxygen. In practice, it is also referred to as fuel-rich, reducing, or dirty. When looking into the kiln, you might notice less visibility and a softer, or snakelike, flame. There might also be backpressure in the kiln, with flames flicking out of the various ports.

Oxidation refers to an atmosphere in the kiln that has more oxygen than fuel. In practice, it can also be referred to as oxidizing or clean. When looking onto the kiln, the kiln atmosphere might look really clear. In some cases, you can easily see to the opposite wall of the kiln. In general, in an overly oxidized environment it is hard to fire a kiln evenly. There is also a circumstance referred to as "oxy hot," in which you get a jump in temperature by letting the atmosphere clear.

- **Primary** Primary air ports are located in the firebox (in wood kilns) next to where the combustion happens. They are referred to as "primary" because they help the combustion. If you design a kiln in which you shift the primary firebox area, like the train kiln design, then what you think of as your primary air changes too.

- **Secondary** Secondary air ports are other areas in the kiln where you are able to introduce air. A secondary air port does not directly relate to the fuel combustion, although it affects the amount of fuel needed to gain temperature. Examples of secondary air ports include stoke holes and air ports removed to burn down high coal beds or improve temperature gain.

- **Damper** The damper is how you adjust the hot air or exhaust leaving the kiln. When you push a damper in, you lessen the draw of the chimney and hold in the heat at the same time. It directly affects the ferocity of the fuel's combustion. The damper can be a configuration of one, two, or more (as many as you need to cover the flue) refractory slabs or other material that can handle the heat with repetitive use. Generally, these are configured horizontally and low in the chimney so they are easy to reach and slide to adjust. However you set up your damper, it is important to consider how it will affect the kiln draw left to right. You want to ensure that the damper does not create any unevenness in the ware chamber. For example, if you are using two dampers, have them meet in the middle. I have seen vertical dampers used at the end of a firing to completely close off the kiln and slow down the cooling. There are also times that people simply put shelves on top of the chimney, either because the actual damper broke or there was some other really, really good reason to climb on top of a kiln. Materials you can use to make a damper include clay shelves, sturdy metal sheets, and thick fiberboard.

PERSONAL CONSIDERATIONS

If you've decided to build your own kiln, you might think that the type of work you make and the results you want come first. However, something even more important comes first: your own body's capabilities and your health.

As previously mentioned, try firing a kiln similar to the one you want to build. It might be that a few easy adjustments in height and width can make a kiln suit your body better. For example, I am 5' 9" (175.3 cm) tall, middle career, and have a shoulder injury from years ago that limits the strength and range of my left arm. What this translated to when building my kiln was ensuring the firebox height was comfortable, that I could easily maneuver inside the kiln with wares and shelves, and that the shelves were as light as possible. This means my shelves might not last as long as some of the heavier shelves available, but I can load the whole kiln without needing any assistance with the shelves.

Also, keep in mind that kilns last a long time. I am sure I'm not the only one who enjoys visiting kiln ruins that are thousands of years old when I happen to be in the neighborhood. If you don't have a move in your future and you take good care of your equipment, the chances that your kiln could outlive you are high. If there is one area that is sometimes overlooked when building a kiln, it is our own aging. If your kiln is too big for your needs, it will feel like a beast to load and fire and might end up feeling like a burden. With that said, it is also possible to go too small and feel that you lack room to develop. In terms of body health, there are small modifications that can be made to adjust to growing pains, and it is worth thinking about as you build. A few easy adjustments include the following:

- Trying to limit the number of ups and downs on your knees for loading or peeping at your cones (possibly raise your bottom peeps for more comfortable viewing)

- Limiting your firebox scale so your wood does not need to be mammoth to fill it

- Ensuring that the door of your firebox is at a comfortable stoking height

- Making the ware chamber tall enough to sit or kneel or stand comfortably in; also, if loading from outside the kiln, adjusting the height of the kiln so that you are not leaning awkwardly

- Making sure all doors slide or open easily and are a comfortable weight

Of course, there is the practical matter of money, which can be a health stressor for a whole other set of reasons. A kiln is often an investment. If the kiln you want to build is a big expense and you are asking yourself "Is it worth it?", do the math. Take the time to budget out the project and assess if you have the funds as part of your serious hobby or if you will be able to sell your artwork within a reasonable timeframe to start making a profit. Maybe the answers to these very practical questions will change the kiln you want to build and your timeline for building. Planning ahead will help you save money. There are often opportunities to buy brick seconds from companies or extra bricks from potters who bought too many for past projects, getting them cheaper if the brick price has gone up since then. Sometimes, there are even pallets of free bricks available from individuals or companies that are shifting interests or going out of business. Or, maybe you want to try making your own brick from the clay in your backyard. By planning ahead and taking the time, you can take advantage if such fortune arises.

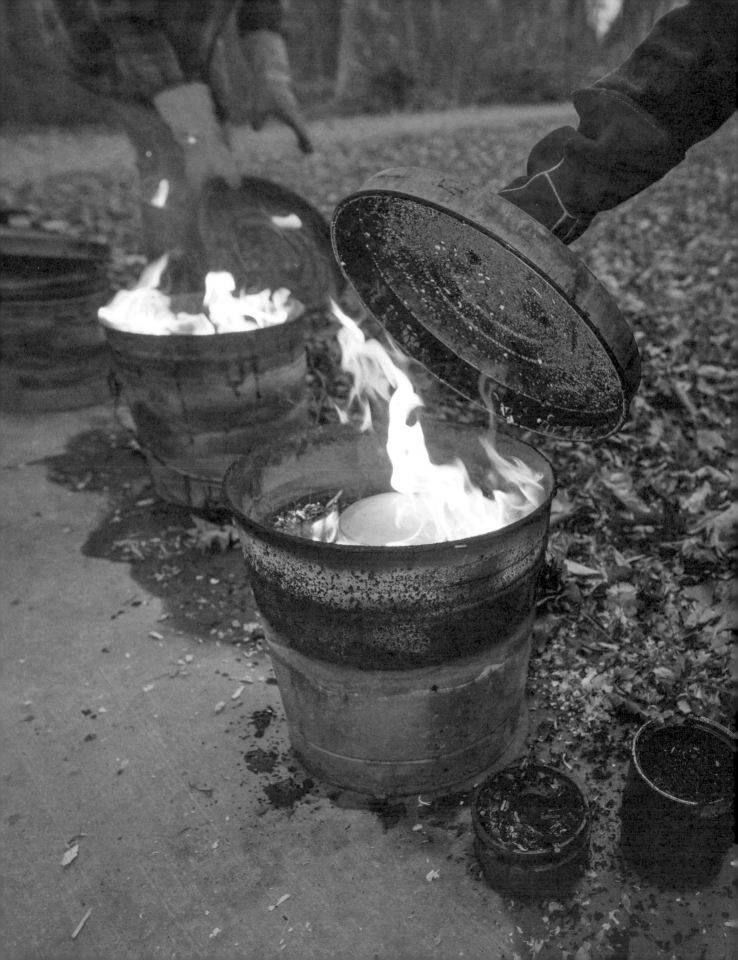

3

RAKU

THE FIRST RAKU KILN I EVER USED WAS LOCATED just outside the back entrance of my ceramics classroom in college. It was in a small kiln yard sequestered by the red brick building and a chain-link fence. I can still remember the clear spring afternoon when our class of about twelve students was gathered around the kiln as our professor explained how to safely use these unwieldy tongs to pull out a hot pot.

Raku kilns introduced me to the firing process, so perhaps it's no surprise that my memory of pulling those first pots out of the reduction chamber is as clear as if it happened yesterday. There was such a sense of *wow!* I remember lifting the lid on the raku kiln full of bright hot pots, nervously carrying a hot pot out, and gently (yet clumsily) dropping it on top of a newspaper sawdust mixture in a galvanized trash can. Then, I shut the trash can lid on a pot as it was covered in flames. Shiny colorful coppers, matte blacks, and white crackle glazes emerged. I could not wait to try it again. This was ceramics? And so began my lifelong journey as a potter.

While raku started me down the ceramics path, I am now known as a wood fire potter (see page 125). What I share with you in this chapter is in large part due to the generosity of Ray Bogle. He has been firing for nearly thirty years and has a wealth of knowledge on the subject. He regularly teaches raku workshops in his home studio and earnestly wants to demystify the process for interested makers. To learn more about Ray, see his artist feature on raku (page 67).

MAKING WORK FOR RAKU

When you are making work for the raku kiln, there are two main considerations to keep in mind. **First, the wares will not be watertight.** For this reason, they should not be used to hold water or with anything wet on a regular basis. This firing process does not get hot enough to vitrify the clay. The clay remains porous and is also more fragile. Yes, there are ways to seal the pot after the firing and maybe there are raku glazes available that claim to be completely watertight. I still suggest that you avoid using your wares for anything wet—especially food and drink. The seals are never perfect. Bacteria will grow in trapped moisture, and over time, moisture will change or damage the pot faster.

Bisqued wares organized for raku: kaolin sig, Redart sig, and bare clay.

While some may see this as a negative, making more decorative work for raku can also be seen as a positive way to evolve your studio ideas. It is a new challenge to work with, rather than be hindered by! The lower temperatures mean your clay will not get hot enough to warp and your firings are incredibly fast. Another bonus with working at this temperature is that a pot can be refired and come out looking completely different. While the results can be improved, the one catch to refiring is that the pot is more prone to cracking, so refire wisely.

Second, you need to be able to pick the pots out of the kiln while they are hot. In other words, make pots the right size. You need to safely lift them with tongs. Also, if you are making an object that has a lot of fragile attachments, is really heavy, or is difficult to pick up for another reason, it's a good idea to practice picking it up before it is game time.

That said, there are ways to engineer an easier lift. For example, you can create a frame with nichrome wire that assists with lifting a larger piece, wrap high-temperature insulation on your tongs for a softer touch (not recommended for a glazed piece), reconsider how it is placed in the kiln to help with the draw, load it higher in the kiln, or use high-temperature, heat resistant Kevlar gloves instead of tongs. If you make a lot of closed forms, it might be advantageous to put the tongs on the inside of the form and spread them, lifting it from the kiln and avoiding the glaze all together. Taking the time to consider how you will safely pull your pot from the kiln will decrease the number of pots you lose.

CLAY FOR RAKU

Cracking is the main reason for loss when raku firing, whether from dropping or thermal shock. Cracking due to shock can happen when pulling a hot pot out of the kiln into room temperature or when the raku kiln is fired up to temperature too quickly. We will talk about firing the kiln a little later; right now, let's focus on the thermal shock of the clay.

It takes practice to know your clay body and its resiliency in the raku process. You may be able to use your favorite clay, or you may need to switch to a clay body that's a better fit for raku. Raku clays generally have a large amount of sand or grog in them to make them more porous and thus better at coping with thermal shock. There are many premade raku bodies on the market, and it should be relatively easy to find one at your local clay distributor or online.

I also suggest trying clays that are not marketed specifically as raku bodies: simply look for clays that have at least 30 percent sand or grog in the recipe. By testing clays outside of raku clays, you will have a greater variety of surfaces to start from and that might lead you down a new or different line of work.

Note A bonus of working with clays that are more sandy and groggy is that they dry faster than tighter-bodied clays and will crack less frequently if you need to speed-dry them.

If you are interested in making and testing your own raku clay body, it is not difficult to find many options with a quick search online for a recipe. Or, perhaps you also make stoneware pieces for a gas kiln and would like to use the same clay body to simplify your studio inventory. To adjust that stoneware body for raku, you can simply add sand or grog to the recipe. A good starting point is about 30 percent (it should be noted that I am referring to 30 percent of a dry mix, not a premade clay that already has water adding to its overall weight), adding or removing some if needed based on your clay body needs. Experiment with the coarseness of the sand and grog by adding a mixture of meshes. Other materials that can help with thermal shock are vermiculite and kyanite. You could wedge in organic

From left to right, top to bottom: pit fired with Redart sig, naked raku, raku with turquoise glaze, naked raku, raku turquoise glaze, pit fired nestled in sawdust, pit fired with cobalt sulfate, pit fired with kaolin sig, raku fired with Redart sig and turquoise glaze, raku fired with clear crackle glaze, pit fired, pit fired with ferric chloride wash, pit fired kaolin sig, bisque fired bare clay lines masked off from kaolin sig, naked raku, pit fire.

materials, like coffee grounds or sawdust, which will burn out during the bisque firing and aid in porosity, increasing its resistance to thermal shock. If you intend on making really thick-walled pieces, it might be a good idea to wedge in an organic material that will burn out. The thicker you work, the more thermal shock resistance the clay must have.

You may be thinking to yourself, "How do I know if a clay has good thermal shock capacity to begin with?" The two key things to look for are lots of sand and/or grog in the recipe and a high-fire clay or clay with a broad firing range. Many of the premade raku bodies can be fired up to a mid-range temperature. In general, I suggest steering clear of lower-temperature clays because even though you will not be firing them hotter than their suggested peak temperatures, a lower range implies the clay is closer to verification at a lower temperature and would seemingly be less porous, less able to handle the thermal shock, and less able to react to the reduction chamber. Here is an example of clay suitable for raku that gallery artist Marcia Selsor has relied on:

MARCIA SELSOR RAKU CLAY RECIPE

Kentucky Ball Clay	20
#6 Tile Kaolin Clay	50
Wollastonite	8.5
Talc	1.5
Grog: Medium and Fine	17
Kyanite	3 to 5
or an additional 3 to 5 for large slabs	
Bentonite/Macaloid	0.05

Bisque firing your clay body correctly will also improve its durability when it comes time to raku fire it. The temperature you need to bisque to will change depending on your clay and the temperature to which you fire for your glazes. However, a good starting point is cone 08 and generally, never hotter than cone 04 to 03.

The color of the clay you use is a personal preference, but generally, a lighter clay body is less subtle than a darker clay body. Interestingly, the darker clay bodies are naturally more vitreous than a lighter clay body because iron is a secondary flux. In fact, a Redart terra sig often stays red after the reduction chamber because its surface is slightly too tight for the smoke to penetrate and create the black surface associated with raku.

PREPARING WORK FOR RAKU

There is a wide variety of raku glazes. You'll find most glazes that are considered raku glazes fall into a few general categories: copper, turquoise, clear crackle, and basic store-bought, low-fire glazes. With that said, test all glazes. Just like clay bodies, you never know. There could be something really nice that happens to a high-fire glaze when you underfire it. It could be as simple as layering it with a clear low-fire glaze to seal it. I know many potters who overfire and underfire the glazes they use for specific effects; it is no different with raku glazes. Even within these general categories, there is a lot of variation in surface and glaze behaviors. Some glazes can be really tacky and runny, while others are more stable.

Glazes can be dipped, sprayed, brushed, or poured. In all the examples you see of my work in this book, I have brushed on the glazes. This is for a few reasons. By brushing on a glaze, you eliminate the need for the large quantity of glaze necessary for dipping or pouring in a big bucket. You can keep a smaller amount of glaze on hand. Brushing also allows for better control of the thickness of the glaze you brush on. Some glazes like to be thinly applied, while others prefer to be thicker. A general rule is that the thicker you apply a glaze, the more it will crack. For example, clear crackle glaze is applied relatively thickly. It is also a good habit to apply the coats of glaze in opposite directions. For example, if you are using a commercially bought low-fire glaze and it asks for three coats: apply the first coat left to right, the second coat top to bottom, and the third coat diagonally.

Note *While raku kilns fire to a peak temperature of roughly 1850°F (1010°C), raku glazes can vary slightly from that. Some glazes like to mature just a little hotter, while others are more reactive at a lower temperature. Just like the thickness of a glaze application can signifi-cantly change the surface, so can the temperature.*

GLAZES

Copper These glazes range from glossy to matte. Generally speaking, glossy glazes are more stable over time than matte glazes, which can lose their iridescence. If you notice that you have this problem, you can try sealing it or experiment with other ways to stabilize the glaze. (This is a bigger issue if you need consistent results and are selling your wares.) Copper glazes offer a variety of colors from purple, pink, red, and blue to black. The black surface occurs wherever the combustible touches the glaze in the reduction chamber. For best results, move the ware quickly to the reduction chamber, as these glazes like a good reduction.

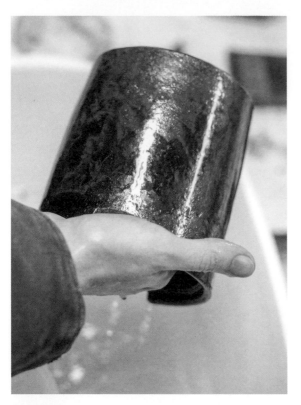

Copper glaze.

Turquoise glaze.

COPPER/BLUE RAKU GLAZE (1800 TO 1850°F [982 TO 1010°C])

This produces a satin-finish copper glaze with flashes of blue, gold, and green. Replace bone ash with custer feldspar for a gloss finish, rather than satin.

Gerstley Borate 80.0%
Bone Ash .. 20.0%
Add
Copper Carbonate 5.0%
Cobalt Oxide .. 2.5%
Tin Oxide ... 1.3%

Turquoise These glazes have a similar base to the copper glazes. The main difference is the amount of oxygen the glaze receives before it is put into the reduction chamber. After pulling the pot, hold it for a little longer and watch the surface change. You can see the blue start to appear. Then, place it in the reduction chamber. The blue occurs because of this extended time in the air before being closed off in the reduction chamber. This glaze also tends to be black where it comes into contact with the combustibles.

RICK'S TURQUOISE (1750°F [954°C])

In the beginning of using this glaze, it would be a good idea to time how much air you allow before shutting the lid on your reduction chamber. This way, you can perfect your turquoise.

Gerstley Borate 39.0%
Lithium Carbonate 21.0%
Spodumene ... 20.0%
Nepheline Syenite 20.0%
Add
Superpax ... 19.0%
Copper Carbonate 2.6%
Epsom Salts ... 0.6%

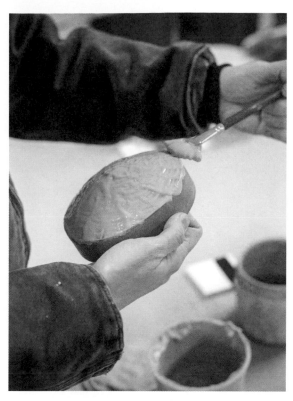

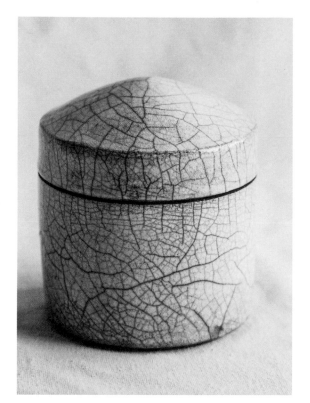

Clear crackle glaze.

Clear Crackle These are some of my favorite glazes for raku. A good crackle glaze reminds me of a beautiful patina surface, the result of years of wear. The cracks in the glaze look black from the reduction, and where the glaze remains intact, it is usually the color of your clay body. If you use a white clay body, it will be white. On the other hand, if you use any colored slip or Redart slip, the color of that slip will show through. To help promote cracks, this glaze is thickly applied in a stippling method. Think of it as globbing or dabbing it on. This glaze likes to cool, or breathe a little, before being shut in the reduction chamber.

CLEAR CRACKLE (1800 TO 1850°F [982 TO 1010°C])
As mentioned, this glaze likes to be applied thickly, think about a consistency similar to yogurt or sour cream.

Gerstley Borate... 80.0%
Custer Feldspar 20.0%

Commercial Low-Fire Glazes: I've found that store-bought raku glazes are true to how the manufacturers say they will look. One thing I have noticed with these glazes is there might be more cracking than suggested (because of the quick cool). Follow the instructions suggested by the retailer and go from there. If you want to test what else you could do with the glaze for variety, start by using more or fewer coats than the manufacturer suggests.

Brushing on the copper glaze.

RAKU REMIX

After you have found raku glazes that call to you, there are additional techniques you can use to bring out the best in a particular glaze, layer textures, or achieve other goals. Here are a few ideas.

Sodium Silicate Do you want extra crackle? Consider this material, which can easily be found at your local clay shop or online. After throwing or building your piece, brush on a thin application, quickly dry it with a heat gun, and then stretch out the surface. The more you stretch the surface, the more significant the cracking will appear. It is important to note you cannot touch the surface you are stretching. For example: throw a cylinder, brush the sodium silicate on the outside, dry the outside with a heat gun (until it changes from wet-looking to dry-looking), and with your hand inside the cylinder, push out, creating a more voluminous globe shape. Additional

ways to play with this decorating technique include using colored slips, drawing or ribbing additional textures, or masking off an area that does not get treated with the sodium silicate to create a cracked/non-cracked pattern. Obvara is a raku technique that is commonly used with textures created from sodium silicate. Gallery artist Marcia Selsor has shared the Obvara recipe she uses in the back of the book.

Terra Sigillata If you're looking to compress the surface of your pot and bring out the shine after firing or layer color through a slip-like application, turn to terra sigillata (also called terra sig). After your pieces have dried to leather hard and advanced leather hard, brush on a terra sig. Terra sig can work on bone-dry clay, but the chance of surface cracking increases with the sig. Terra sig creates a smoother finished surface on its

Cleaning the lid seating of any excess copper glaze.

own, but if you are looking for an even shinier end product, you could burnish the terra sig (see sidebar at right). Another aspect of terra sig that would be fun to play with is adding colorants to the basic white sig. If you intend to glaze the pot with anything beside the clear crackle, there is no need to terra sig or burnish; the glaze will completely cover up all your hard work.

Masking Wax resist, painter's tape, latex, damp paper, stencils, and stickers are all ways to mask your work to create hard lines and patterns. Resists can be used with terra sig, slip, or glaze. They can be used before you bisque and/or between bisquing and glazing. When considering how to decorate your piece for the kiln, the transitions from glazed and unglazed or slipped to non-slipped surfaces are best when there is a clear demarcation. Which masking technique to use directly relates to what you are trying to do. Painter's tape comes in a variety of widths and is great for masking lines. If you are using the 1 or 2 inch (2.5 to 5 cm) painter's tape, you can also cut it into various shapes and use those shapes to create a pattern of glazed and unglazed on the surface. It is important to remember to remove resists before you fire the piece. The only exception is the wax resist, which will burn out in firing the process. The others will also burn out, but it produces a cleaner mark if you remove them beforehand. It also keeps your raku kiln environment clean.

ALL ABOUT BURNISHING

Burnishing is the term used for polishing your pot once it is in an advanced leather-hard state. Depending on your level of patience, the tools you have on hand, and how glossy you want your burnished surface to be, this process can be very quick or take several hours, working in stages.

For an easy one-step burnish, brush on several thin coats of terra sigillata. Once the terra sig changes from wet-looking to a bit dull and you are able to touch it without leaving a finger mark, wrap a microfiber cloth around your hand or a wide spoon and begin to polish your piece. I recommend working in small circles, slowly, across the whole piece. Other tools that are common for burnishing are very smooth stones, polishing cloths, plastic bags, and bare spoons. If, after looking at the results from this method of burnishing, you are not satisfied with the reflectiveness, here are a few other suggestions:

- When you are done throwing or coiling your piece and while it is still wet, smooth it with a metal rib.

- After you trim a piece, use a metal or rubber rib to compress and smooth the area you just trimmed.

- Apply a small amount of vegetable oil to the area to be burnished. This moistens the area and allows for better compression and smoothing.

- Reburnish the piece over and over, gaining a higher polish with repetition.

- Reburnish the piece and change the tool you are burnishing it with. The harder the tool, the more compression you can achieve.

Ray Bogle | Naked Raku
A Sacrificial Technique

My first exposure to the world of naked raku was not good. I mixed up a glaze and a slip, applied it per the instructions, and fired my pot to the instructed temperature. I then pulled it from the kiln and put it in the reduction can, where it sat for the required five minutes. I pulled it from the can and doused it with water, only to have none of the glaze come off. After thirty minutes of attempting to chip the glaze off, I gave up, vowing to never try it again. Unfortunately, I often hear a similar story from others that have tried naked raku.

Over the years, I was continually drawn to naked raku pieces, with their bold black-and-white designs and often accentuated crackle patterns. Memories of my first experience

After pouring the slip and letting it dry, I pour the glaze and let it dry. *Photo courtesy of the artist.*

stopped me from further attempts until I came across a book titled *Painting with Smoke* by David Roberts. I read this book from cover to cover and decided to give naked raku another try. I followed the clear instructions: I used his slip and glaze recipes, fired my piece to the correct temperature, and left it in the reduction can the exact amount of time required. I pulled the piece from the can and poured water on it. This time, *all* the glaze fell off, leaving an awesome naked raku piece. I was immediately hooked and moved forward to refine my understanding of the process dynamics unique to naked raku firing, which is the only technique in which glaze doesn't decorate a pot. Instead, the glaze sacrifices itself as it blocks smoke, leaving unique and random trails of smoke behind.

The fundamental concept of naked raku is simple: to somehow get the glaze to not stick to the pot. This is accomplished by first making sure your piece is smooth and without texture. Many naked raku pieces have terra sigillata applied and are burnished to assure a smooth white surface. On the bisque fired piece, a thin slip is evenly applied by brushing or pouring it over the piece. This slip is the ultimate naked raku secret, as it is critical that the slip is applied to any area where you want glaze to come off. Without the slip, the glaze will stick to the pot, as it does with any other firing technique. The slip dries quickly, and then the piece is ready for the glaze. The glaze is brushed or poured on and allowed to dry. If brushed on, it is important to not brush through the slip layer, which would allow glaze to be in direct contact with the piece.

After the slip and glaze are applied to the piece, it is ready to fire. Unlike traditional raku firing, the temperature is brought up to

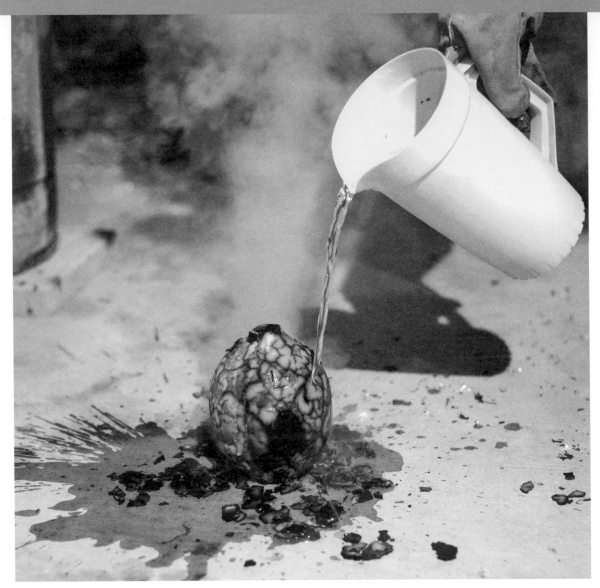

Pouring the water on a pot after the reduction chamber. *Photo credit: AE Landes.*

approximately 1700°F (927°C), slightly less than is required to fully mature the glaze but enough to allow the glaze to block smoke. Higher temperatures increase the risk of glaze sticking to the pot. The piece is then removed from the kiln and placed in a reduction can, allowing it to quickly cool—thus creating cracks in the glaze and allowing smoke to reach the pot's surface.

Pieces are removed from the reduction cans after approximately five minutes and immediately doused with water, causing the glaze to release

from the pot. When the piece is cool enough to touch, the pot is scrubbed to remove residual glaze and slip. When the piece is completely dry, a light coating of paste wax is applied to give the piece a soft sheen that is pleasing to touch and view.

Following these basic instructions and using these provided glaze and slip recipes should allow you to have a successful first experience with naked raku and to begin exploring other ways of letting glaze sacrifice itself to leave your pots naked.

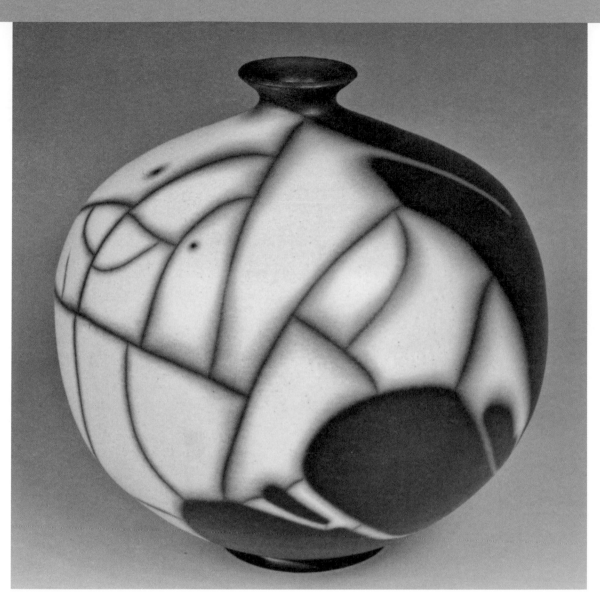

Ray Bogle, naked raku. *Photo courtesy of the artist.*

DAVID ROBERTS NAKED RAKU SLIP RECIPE
3 parts EPK
2 Parts Silica

Note *The Specific Gravity should be 1.21 after mixing with water.*

DAVID ROBERTS NAKED RAKU GLAZE RECIPE
85% Frit 3134
15% EPK

Note *The Specific Gravity after mixing with water will affect the cracks on the piece. Thin = SG 1.45 (Smaller cracks); Med = SG 1.65 (Larger cracks); Thick = SG 1.85 (this is too thick to pour and used for splatter/squirt applications).*

 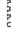

THE REDUCTION CHAMBER & COMBUSTIBLES

Before we get into making a raku kiln and raku firing, we need to discuss the reduction chamber since this is where the magic happens. The keys to a good reduction chamber are that it is flame-resistant, is an appropriate size for what you want to reduce, has an easy-to-use lid that fits relatively snugly, and is full of a dry combustible. It is also important to have the reduction chambers in close and convenient proximity to the kiln. Getting pots from the kiln to the reduction chamber needs to be a very quick process.

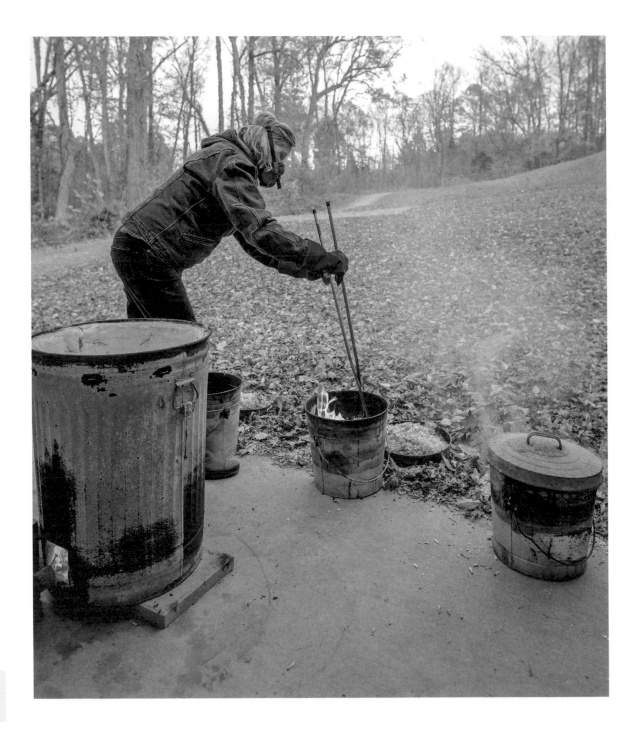

Galvanized trash cans work great as reduction chambers. They come in a variety of sizes, they are easy to find, they are lightweight/transportable, and the lid is included. When I started raku firing, we used a large trash can, placing the wares in sawdust and closing the lid. All glazes and pieces were essentially treated the same. Now that I know a little more about the process, I suggest fitting the chamber to the piece or number of pieces you want to reduce. The smaller the chamber is in relation to your wares, the better reduction you will get. If you want extremely consistent results for one project—let's say you are working on a series of some kind and want them all to look the same—try to fit them into the same reduction chamber at the same time.

Small galvanized trash cans generally work for the smallest size of reduction chamber you need and offer good reduction. However, another option to increase the reduction and create an even smaller chamber is to create a chamber within a chamber. Make a layer of combustible in your chamber. Then, add a wooden block to set the pot set and cover the pot with a glass bowl. The glass bowl should not touch the piece, but creates a smaller chamber.

The lid on your chamber should be easy to use and should fit snugly. The better the lid fits, the less smoke will be able to escape. Beyond creating a good reduction chamber, it is also nice not to have tons of smoke coming out of the trash can, in terms of breathing during the firing. (Remember to always wear your particulate respirator when around smoke.)

Note *You can place a good amount of combustible on the lid, which makes adding more combustible to the reduction chamber seamless. Place your wares in the chamber, quickly sprinkle additional combustible from your lid, and then shut the lid.*

Smoke escaping from the reduction chamber while a pot cools inside.

Note that you want to keep your raku kiln and reduction chambers away from other flammable materials. We will discuss more about the raku kiln later in this chapter. Make sure your reduction chambers are sitting on gravel, concrete, or other noncombustible material. If it is a really windy day, maybe postpone the firing. If you are not able to postpone the firing, take extra precautions in case of an unforeseen accident. Precautions could include placing a fire extinguisher in your studio, keeping a water hose nearby, and double-checking the placement of the reduction chamber in consideration of the direction of the wind.

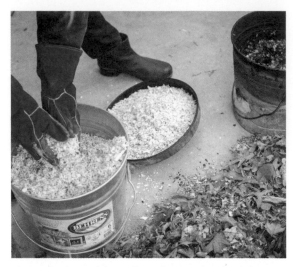
Placing fresh sawdust on the reduction chamber lid.

Slightly smoky reduction chamber after removing the cooled pots.

COMBUSTIBLES

Your reduction chamber is only half of the equation. You also need combustible material such as newspaper, straw, grass clippings, and sawdust. Wet combustibles will not work. They don't burn well enough, and depending on how your wares come into contact with them, they can leave big globs on the surface of your piece. If you want to experiment with fruit peels, flowers, or other interesting burnables, *make sure they are dry*. Leaves and pine needles are okay, but they burn quickly and tend to create ash that flies away easily. I understand the desire to clean the yard a bit and aid in your pottery making. However, I suggest using these materials in combination with sawdust, if not sawdust alone. The same holds true for shredded paper. It is a fun way to get rid of your office waste, but it works best when combined with sawdust.

Note *I have not noticed a substantial difference between magazines with colored pages or black-and-white newsprint. It all burns the same, and there is not much discrepancy in visual result. Where you will notice a difference sometimes is in the smell of the smoke.*

Regarding the amount of combustible, a good starting point is just under half the overall reduction chamber. In a small galvanized trash can, you want to have a base of about 4 to 5 inches (10.2 to 12.7 cm), with an additional bank on the sides. The pot should be able to sit upright with the lid closed.

You can simply place your piece on top of this layer, or you can place it on top of the layer and then cover it with additional combustible material. The difference between these methods is surprisingly significant. Some glazes like one over the other, and you might find that you like one versus the other on different glazes. In other words, you might do both, depending on the glaze and the result you hope to achieve.

I've been asked many times whether you can reuse sawdust from previous firings. Yes, you can. It is a good practice to simply add a bit of fresh sawdust on top of the old sawdust and make sure there is enough combustible for the size of the chamber you are using.

KILN DESIGN & FIRING TECHNIQUES

The most common raku kilns you will come across are top hat kilns, brick kilns, and trash can kilns. In this tutorial, we focus on the trash can kiln. It is affordable, easy to construct, and works great.

 The trash can kiln starts with a standard-size galvanized trash can. These can be found at most local hardware stores. As long as you keep the trash can dry, it should last a long time. If the can is exposed to the elements and rots out, it is easy enough to remove the interior layer of ceramic fiber insulation and place it inside a new trash can. While this kiln is lightweight and easily portable, the drawback is it is not overly efficient. The hottest you should need to reach is about 1900°F (1038°C). Because of the kiln's size, you are limited to stacking with one shelf. If you have more than one shelf and you have too much thermal mass in the kiln, it won't properly heat up. On that same note, use only soft bricks when you prop up anything. This kiln does tend to get hotter on the side opposite from the burner port (back side). You can offset this by placing deflecting soft bricks in front of the burner port, but also plan your load accordingly. When you get to know your glazes, you will find that certain glazes like the back of the kiln, while others like the front.

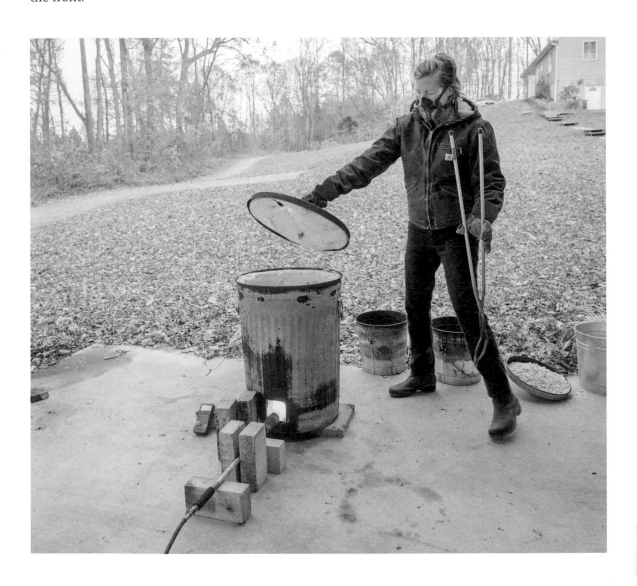

TRASH CAN KILN CONSTRUCTION MATERIALS

31-gallon (117.3 L) galvanized steel trash can (and lid)

13-inch (33 cm) round ceramic shelf

Weed burner with propane tank

20 feet (6.1 m) of 17-gauge high-temperature nichrome wire

3 to 6 standard soft bricks (see page 78)

3 to 6 standard common or hard bricks (see page 45)

Miter saw, chop saw, or handsaw

1-inch (2.5 cm), 8-pound (3.6 kg) ceramic fiber insulation (*Note: When you are working with insulation, always wear gloves and a respirator.*)

Drill with bit just larger than nichrome wire

Aviator snips

Wire snips (optional)

Utility knife

Sodium silicate (optional)

Measuring tape

Permanent marker

Needlenose pliers

3 to 4 cinder blocks

Yardstick or straightedge (optional)

Thermocouple**

Pyrometer**

Handheld torch or flint-spark lighter

** These items can be considered optional if you want to save a little money to start out. As Ray explained to me, when he started out he simply placed an 06 cone on the shelf where he could easily see it. When the cone started

to bend, he knew he was at temperature. On that same note, if you look at how the glazes are behaving in the kiln, they can give you a lot of information. Some glazes will start to bubble and then go shiny when they are ready to be pulled for the reduction chamber. As you fire, you will get to know the look of your glazes when they are ready to be pulled.

BUILDING THE TRASH CAN KILN

Let's start with the trash can. Measure 2 to 2.5 inches (5 to 6.3 cm) from the bottom of the trash can and mark and cut a 4 × 4 inch (10.2 × 10.2 cm) burner port hole. To do this, use a large drill bit to drill a hole for a starting spot for your aviator snips. Use the snips to cut the hole. Ⓐ Next, measure roughly 2 inches (5 cm) from the edge of your lid, and mark and cut a 4 × 4 inch (10.2 × 10.2 cm) flue hole. (When cutting metal with your aviator snips, be sure to wear gloves. The metal is very sharp.)

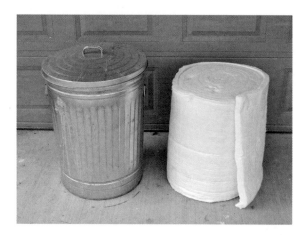

Ⓐ

Now, we are ready to drill hole sets, about ½ inch (1.3 cm) apart, that will be used to thread the nichrome wire through to secure the ceramic fiber insulation. Starting at your burner port, drill a set a few inches (7.6 cm to 10.2 cm) from the left, right, bottom, and top sides. Then, evenly spaced, drill two more sets above the burner port, including one at the top of the can. Now, on the back side (opposite burner port) of the kiln, drill four sets of holes, evenly spaced, including one at the top of the can. Repeat this on the left and right sides of the can.

Between the rows of holes you just drilled, drill four more rows of three hole sets. Be sure to offset these hole sets from the holes you already drilled in the rows immediately to the left and right. Always drill one set at the top of the can.

For the lid, drill a set of holes on all four sides of the flue hole and then, evenly spaced over the whole lid, approximately another eight sets. Overall, you will have roughly forty hole sets.

Cut forty 5-inch (12.7 cm) pieces of nichrome wire. You can use your aviator snips for this or wire snips if you have them. Bend each piece of nichrome wire in half, making a U shape. The bottom of the U should be flat instead of round.

Now, you're ready to start cutting the ceramic fiber insulation! Wear a mask and gloves, as insulation can be an irritant to your hands and throat. The insulation will cover all the interior sides, top and bottom included. Let's start with the lid first. Place the lid as close to two edges of the insulation as you can and trace around it with the permanent marker. Cut on the line with the utility knife. You'll want a good clean edge on the insulation, so be careful not to tear it.

Turn your trash can lid over, bottom-side up, and firmly press the insulation into place, paying special attention to the lip of the lid—make sure you press the insulation into

Notice the hole sets on all sides of the flue with the nichrome wires in place.

this corner. Secure the insulation with the nichrome wire. Holding the insulation in place, feed the nichrome wire through the trash can and insulation. Each end of the U should go through one of the holes in the set. After fully feeding the wire through, tightly twist the wire to secure the insulation to the lid. Repeat this step for the rest of the hole sets. If you find that you are not able to twist the wire tight enough with your fingers, try using needle-nose pliers to get a better grip and tighter twist. Ⓑ Ⓒ

The last step on the lid is to cut the flue out of the insulation. With something supporting the insulation, use your utility knife to cut a hole in the insulation that matches the 4 × 4 inch (10.2 × 10.2 cm) flue hole. After the insulation flue hole is cut, press the insulation back gently from the flue edge Ⓓ, but be careful around the sharp metal edge. Alternatively,

you could cut an X in the insulation and simply fold those pieces back on itself, making sure you put a nichrome wire through those four pieces too. Congratulations! Your kiln lid is done!

Just like you started your lid insulation, place the trash can upright on the insulation to outline the circle of the bottom. Make sure you nestle that circle into the one you already cut out for the lid. (We want to be as efficient with our material use as possible.) Once the bottom circle is outlined, cut it out and gently push it into the bottom of the can. Ⓔ Ⓕ

For the main body of the can, cut any thin, floppy insulation pieces free. Starting with the cut edge of the roll, loosely roll the insulation up to be able to easily set it in the can. Starting with the clean edge, line the can walls, adjusting the insulation roll until it is nestled against the can wall. There will be an area where the insulation overlaps and is two layers thick. You want the whole can to be one layer thick. Using the insulation seam as a guide, you can cut it one of two ways. One option is to cut it upright in the can. Take your utility knife and, by feel and visual, cut 1 inch (2.5 cm) longer than where the layers double

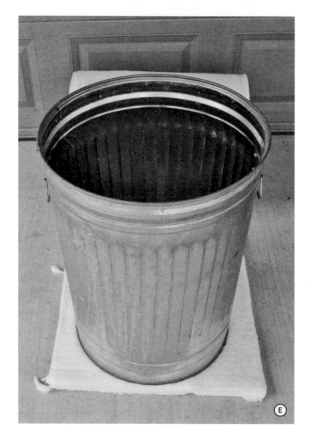

up. After the extra insulation is cut free, firmly press the seam together. This extra one inch (2.5 cm) will help create a snug fit. If you find that method difficult (because you are leaning into a trash can), use a yardstick or other long straightedge to mark where you want to cut with a permanent marker, remove the insulation, and lay it on the floor to make the cut. ⑤ When making the cut on the floor it is a good idea to press with the straightedge both to hold the insulation and as a guide for a straight cut (this is my preferred way to cut).

After cutting, put the insulation back into the kiln and press the seam closed. Just like you did for your lid, feed the remaining 5-inch (12.7 cm) pieces of nichrome wire through the hole sets and secure the insulation to the wall of the can. I find that it works best to secure the insulation to the can clockwise or counterclockwise, instead of jumping from one side to the other. This makes it easier to keep it snug against the can. Finally, cut the hole in the insulation after it is fully secured to the can wall. After you cut the hole, gently press the insulation back, making sure it does not impede the burner port. Last but not least, drill a hole for your thermocouple. This hole should be placed about the middle or just above the middle of your trash can. It should not be right above the burner port. The thermocouple should be about 45 degrees to the left of the burner port. Congratulations—your trash can has turned into a kiln!

A Few Things to Note

If you are having problems with your insulation feeling like it is not holding itself up against the wall of the kiln while you are working in the nichrome, try brushing sodium silicate on the can to help act as an adhesive for the insulation.

If you find the nichrome wire is not secure enough by itself, it is not uncommon to use ceramic buttons to help add additional pressure to secure the insulation. I have not found

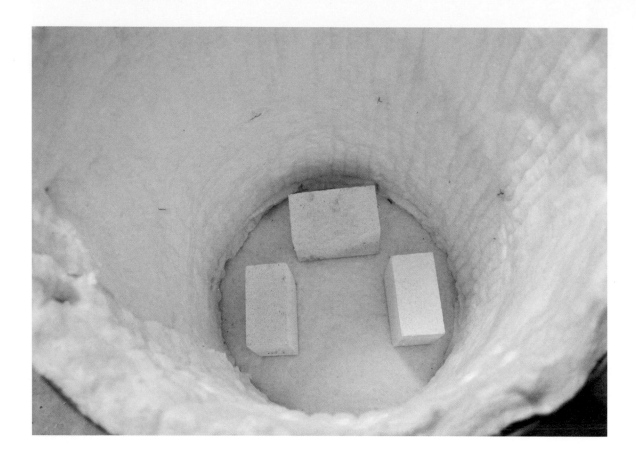

this to be necessary, but it is common practice. The buttons are generally about 2 inches (5 cm) in diameter and can be made from the same clay you are going to raku with.

PREPARING THE SOFT BRICK

To prepare your soft brick for kiln furniture, cut two soft bricks in half crosswise, yielding four half-brick pieces. You will use three of those half bricks to prop up the 13-inch (33 cm) round clay shelf. It is important that when you place the three soft brick pieces to post up the shelf you do not put one directly in front of the burner port, as shown above.

The additional soft bricks should be cut to what best suits your needs in terms of loading the kiln or propping and securing your burner. (We'll talk more about securing your burner in the burner section that follows.)

There are several ways to cut the bricks with less dust if you do not have a brick saw handy. I found my preferred way through a video of Ves Oil Guy on YouTube: Submerge your brick in water for a couple of minutes and then let it dry out for five to seven minutes. This creates a damp brick. It should not be dripping water, but will be considerably less dusty when you saw it. You can cut the brick with a handsaw, chop saw, or miter saw. In all cases, use a blade that you don't mind subjecting to wear because the brick will quickly dull a good blade. If you use an electric-powered saw, be sure to double-check that no water is dripping anywhere. If so, stop and let the brick dry out more. Let the bricks dry at least twenty-four hours before firing them in your kiln.

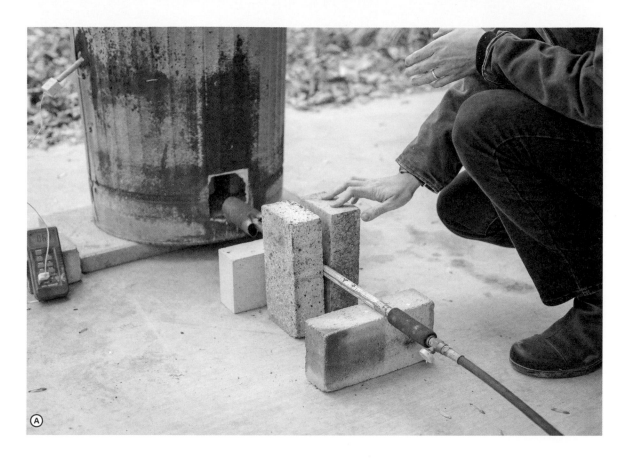

SETTING UP AND USING THE BURNER

Weed burners work great and are readily available. If you want to invest in a venturi burner, both the MR-750 and MR-100 are good compact options. However, I recommend starting with the cheaper weed burner option, and if you find that it doesn't suit your needs, upgrade to the slightly more expensive venturi burner. I am a big fan of tools that can be utilized in more than one way. In this case, a weed burner can be used in your studio to help dry pots quickly, for your raku and pit kiln, and, of course, to burn weeds.

To prop your weed burner to the kiln, you want to ensure that it will not roll around, that it is parallel to the ground, and that the end of the burner is centered toward the lower half of the burner port, roughly an inch (2.5 cm) away from the kiln. I recommend resting the burner on a soft brick that is closest to the kiln. To

keep it from rolling around, place any hard or common brick on the left or right side further from the kiln Ⓐ. If you find that wind is an issue, either blowing your burner out or making it longer to get the kiln to temperature, use another spare common or hard brick to build a barrier wall around the burner port to protect it from wind.

Propane cools as you use it. If you are firing your kiln in cooler weather, getting down to the forties (around 4°C), a 20-pound (9 kg) bottle that's half-full will start to ice up. If it does ice up, it loses pressure and your kiln may not reach temperature. To help keep it warm, place the bottle in a large bucket of warm water before you begin. In cold weather, even if you are only firing your kiln once, I recommend always placing the propane in a bucket of warm water. Ⓑ

CONSISTENCY

One of the aspects that should be embraced with alternative firing is varied results. You will sometimes get results more beautiful than you could have ever imagined or planned. Other times, you will be disappointed. Consistency is relative: No two results will ever truly be the same, and isn't that one of the reasons we love handmade art in the first place? However, if your desire is to be as consistent as possible, take good notes on procedures, use a digital scale to mix your glazes, measure the amount of water you mix into dried materials if you make your own glazes, and whenever possible, place the wares in the same reduction chamber. Alternatively, enjoy the subtle (and not so subtle) variations that can still be considered a set or series of wares.

FIRING

When you load your raku kiln, do not put any pieces directly on the shelf. The shelf gets hot fast and will likely crack your pots. Soft brick pieces are good shelf props. Working with one shelf to get as many pots in the kiln as possible can be a bit of a puzzle. You want to think about being able to easily pull the pieces out with tongs, the area of the kiln where the glaze looks the best, and the overall shape of the pot. In other words, some pots should be posted higher or lower to help utilize the space and make it easy to pull. You can also lean pots onto the wall of the kiln, as long as no glaze is touching the insulation.

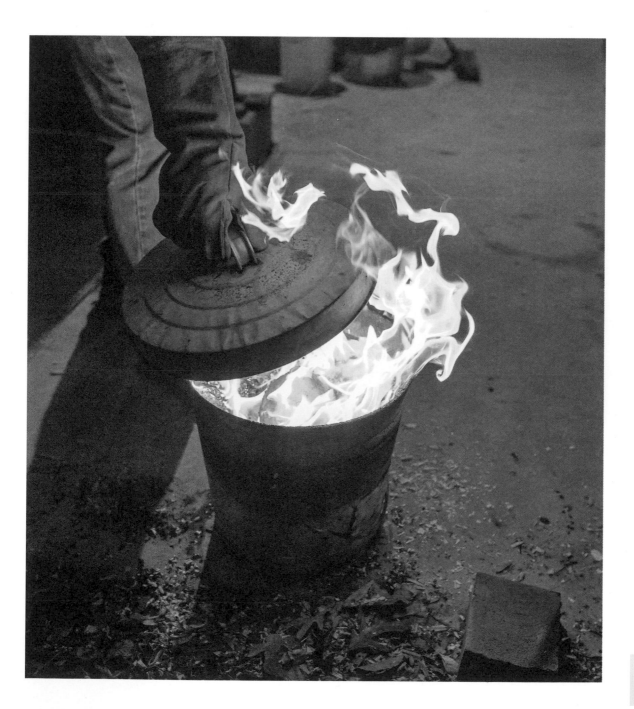

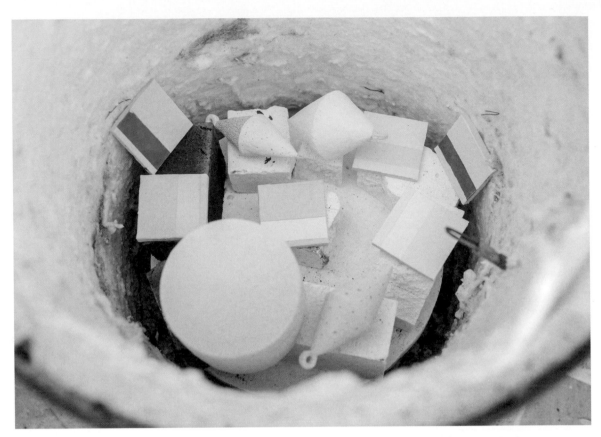

Notice how everything in the kiln is on top of soft bricks, away from the wall of the kiln, and the pyrometer is set.

Before starting your kiln, remember to place your pyrometer. It does not need to go all the way into the kiln, but it should be at least 4 inches (10.2 cm) into the kiln. You can let the thermocouple hang in place, prop it up with a brick on the outside of the kiln, or use a hanger wire over the lip of the kiln to hold it in place. All methods work, but propping it better ensures that it won't drop out. The wires from the pyrometer to the thermocouple should be kept away from the kiln and off the ground. Make sure it is easy to read the thermocouple during the firing and that it is not in the way of pulling pots and the reduction chambers. I recommend never pulling pots over the thermocouple wires.

There are three phases to increasing the temperature in the kiln. The key is not to heat the kiln too fast!

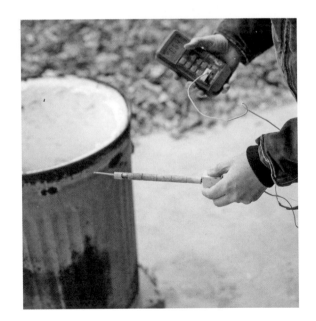

Turn the main valve all the way open.

Open the adjusting valve as well.

Phase one, 0 to 500°F (–17.8 to 260°C), roughly 10 to 15 minutes: Start the burner after you have everything in place and are ready to go. This is the phase in which most blowups happen, so do your best to follow the directions. First, check that everything on the burner has been turned off. Open the lid on the kiln and open the gas on the propane tank. Open it all the way—we will adjust the gas with the adjusting valve on the weed burner. Turn the adjusting valve several turns. Using a handheld torch or flint-spark lighter (I prefer a handheld torch), ignite the gas with the burner in place, by the burner port of the kiln. Then, adjust your weed burner for a flame that is noisy and yellow with a touch of blue.

Phase two, 500 to 1000°F (260 to 538°C), roughly 10 to 15 minutes: Increase the gas by opening the burners and adjusting the valve a few more turns.
You want a consistent blue flame for this stage.

Phase three, 1000 to 1850°F (538 to 1010°C), roughly 10 to 15 minutes: You can go a little faster in this phase but be careful not to overpower the kiln.

If you introduce too much fuel, you can stall the kiln. The flame should be dancing 3 to 4 inches (7.6 to 10.2 cm) outside the top of the kiln. Watch the glaze: you can easily look in and see the glazes. Around 1400 to 1500°F (760 to 816°C), you will notice glazes start to bubble. Depending on the glaze, you could pull pots anywhere from 1700 to 1900°F (927 to 1038°C).

PULLING POTS

Wear leather welding gloves or gloves that are equally protective against heat. When you first go to lift the lid, make sure it is loose. Then, using the lid handle, lift it, facing the hot side of the lid away from you. Do not set the lid directly on concrete; instead, lean the lid against the outside of the kiln, with the hot side facing the kiln.

Placing a pot in the reduction chamber.

Pick up your tongs and pull your pots! Ⓐ When you are done, place the lid back on the kiln. Every time you pull a pot, the kiln will decrease in temperature significantly. I recommend not trying to pull all your pots at once. Instead, pull pots in batches, reheating the kiln between pulls. This ensures that you are at a good temperature for every pot. For example, lift the lid, pull several pots, place them in a reduction chamber, close the reduction chamber, close the kiln, reheat the kiln, and then repeat. This ensures that the pots are hot enough and the reduction chamber is smoky.

Once you have successfully pulled all your pots and are ready to turn off the kiln, turn off the gas at the propane tank, let the flame go out, and then turn it off at the adjusting valve. Just like your gardening hose, you would turn off the water at its source, let it run out, and then close the hose head so you don't have water sitting in the hose. By turning the main valve off first, you ensure there is no fuel in the hose.

KILN CONSIDERATIONS

Remember: don't get too hot too fast! If you wanted, you could get the kiln to temperature much faster than necessary. While you don't have to obsess over the accuracy of this process and admittedly, how much you turn the adjusting valve varies from weed burner to weed burner, it is important to time the temperature increase and note the temperature when you pull the pots. If, for some reason, you are firing and need to step away for a moment, it is important to back down the fuel and hold the kiln at a slightly lower temperature. Otherwise, the glazes will start to mature and move off the pot, melting onto the soft brick.

If, during your first firing, you notice the back of the kiln got considerably hotter than the front, use a scrap piece of soft brick to act as a baffle wall in the center of the shelf posts to better direct the flame to the center of the kiln. You could also experiment with the

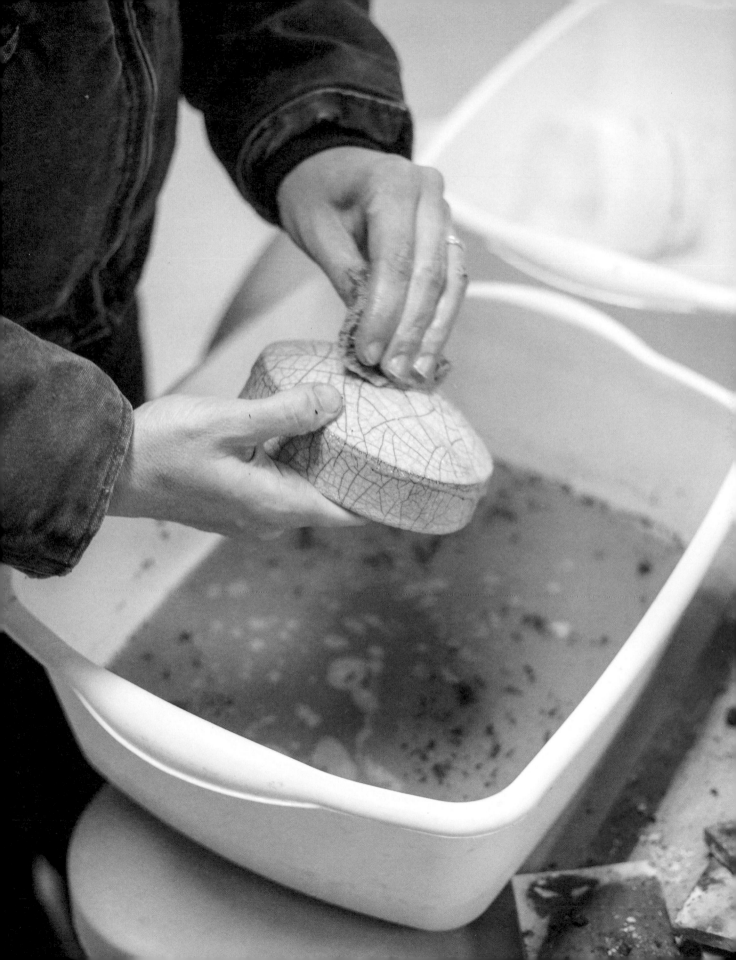

location of the flue in relation to the burner port. Start with the flue above the burner port; adjusting its location may alter where the kiln holds heat. If you're in a really windy area or time of year and it is affecting your kiln's ability to reach and hold temperature, in addition to placing the barrier wall at the burner port, try attaching a small stack on the flue, like a coffee can. If you do use a stack on the lid, remember to remove it before lifting the lid to pull pots.

CLEANING YOUR POTS

To clean the raku pots, you need a scouring pad, dish soap, and water. With a soapy scouring pad, wet your pot and scrub it like you would a dirty dish. Rinse it off and set it aside to dry. It is that simple and should not take much time at all. Certain glazes might take a little extra rub or two to fully clean and reveal their surface, but it is generally pretty quick. Once your pot is dry, you can finish any bare clay with a finishing wax, such as bowling alley wax. This will give your piece a nice luster and protect the surface.

Like with all ceramics, there is a plethora of additional cold-surfacing finishes you can experiment with: paint, flock, sandblast, colored epoxy, etc. You may also want to think about adding wooden, metal, glass, or other mixed-media elements to the piece.

HORSEHAIR

Try using horsehair to decorate the surface of your pot. After you pull your pot, place it on an elevated surface on top of a soft brick. Wearing leather gloves, drape several pieces of horsehair onto the pot at a time. This will take practice to get results you are happy with, and there is a pretty small window in which horsehair burns best. (Warning: Like you might imagine, it is stinky.) Make sure your horsehair is ready to go and easily accessible. Too much horsehair at once will obliterate any line you might be trying for and end up just looking black. The line will also read better if the pot has a terra sig on it (see page 64). This effect does not work on a glazed pot.

The horsehair decoration is rather fragile. To clean this effect, use a soft brush to lightly brush off any burnt hair that might be hanging on and then spray it with a clear sealant. Sealants can be bought in finishes from matte to glossy, whatever your preference. It's important to look for sealants that are non yellowing and quick-drying. Simply follow the application directions on the sealant.

GALLERY

All photos courtesy of the artists.

Ingrid Allik, *Messages*, naked raku.

Kate and Will Jacobson, *Flow*, raku.

Marcia Selsor, *Crusty*, obvara.

(opposite) Kate and Will Jacobson, *Tutu's Garden*, naked raku.

Brigitte Long, *Warrior*, raku.

Gaya Ceramics Design, *Molecules Platter*, naked raku.

Eric Stearns, *Birds-of-Flight*, raku.

Florence Pauliac, *Head*, Totem series, raku.

Andy Bissonnette, *Blue Jar*, raku.

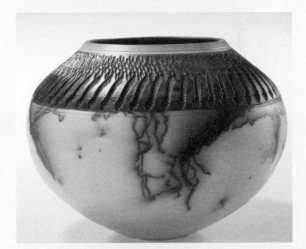

Al Scovern, *Chattered Pot*, horsehair and sugar.

David Roberts, *Binary Ripple*, raku.

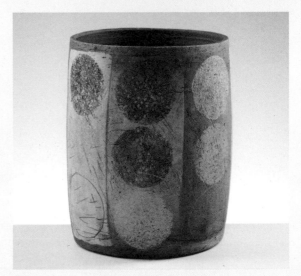

Kerstin Gren, *Vessel painted with foraged ochres*, raku.

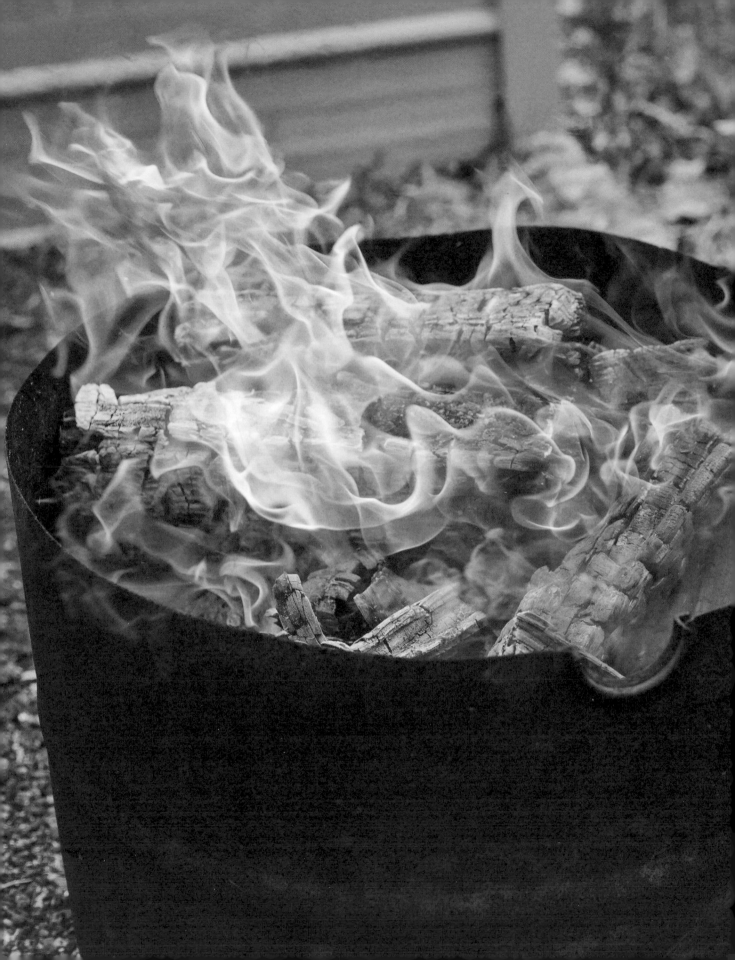

4

PIT & BARREL

WHEN I THINK OF PIT FIRING, I IMMEDIATELY think of the wares of San Ildefonso Pueblo potters Maria and Julian Martinez. Countless times I watched a video documentary of Maria's process of harvesting her own clay, burnishing her beautifully coiled pots with a shiny and rounded stone, and firing her pieces. They started with a soft bed of twigs, stacked on top of metal grates to help balance the pottery. They placed the pots on the metal grates and then they added a layer of twigs, sticks, and wood to fully cover the pots. The outer layer was metal lunch trays and on top of those, cow patties. Each layer of material was balanced on the layer placed before it. It seemed simple, but the truth is that it takes a lot of trial and error to be able to time a firing just right and know the amount of combustible material needed, what combustible works best, and how to not have everything tumble down as it burns. The ease of the recorded Martinez firing was the honed skills of makers who knew exactly how to read the fire so they could make the next adjustment for the results they wanted.

To this day, the traditions of pit firing are handed down through practice and are seemingly less technically researched than other firing methods. Because there is so much variation in the size and construction of "pits," combustible materials, and firing schedules, in some respects, it is harder to articulate the process you should use to fire that pit. Plus, you might be limited by available fuel sources. In this chapter, I use the term "pit" loosely, meaning it also includes barrel firings and sawdust firings. I use the term to include all kilns in which the wares and combustible materials are stacked together inside the structure or pit or the stacking or inclusion of these materials makes the kiln (though it looks more like an open fire). While I will outline a few basic pit guidelines, I imagine once the "fire is lit," so to speak, you will soon have your own list of questions and begin hypothesizing about how to make *your* pit and materials work better for your needs.

While researching for this book, I was surprised to find that many of the artists I thought were pit fire artists were using saggars in a gas kiln to achieve the varied results I associated with pit firing. Many of the combustibles being used in the saggars could also be used in a pit fire, but with a gas kiln, you have much more control over time and temperature and the results are generally more reliable. With this in mind, we will also cover the use of saggars.

MAKING WORK FOR PIT FIRING

When you are making work for a pit kiln, there are a few things to keep in mind to avoid any pitfalls. Start by keeping the wall of your pot relatively thin to reduce the chance of cracking. Thick, chunky wares will not do well with this firing method, even if they are bisqued beforehand. On that same note, I recommend that the whole pot is a similar thickness. In other words, don't have thick-to-thin spots on the same piece; keep the clay wall even.

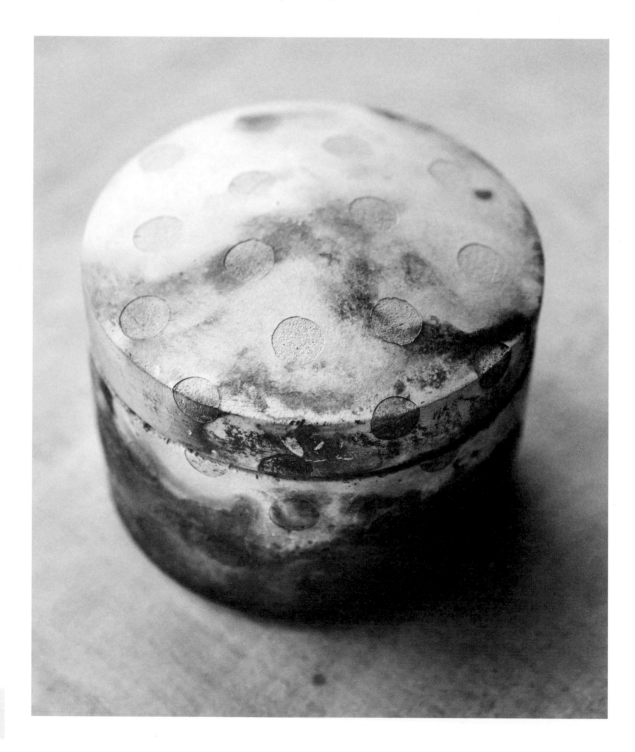

Wide, flat bottoms will crack more often than wide, rounded bottoms. However, wide can be generally difficult because of the heat differential from one side of the pit to the other. With that said, firing wide forms inside a saggar could help with some of the heat differential.

Closed forms (like a lidded container) will remain basically bare-looking on the inside. If you want to get any action on the inside of a lidded container, it should not be fired with the lid on. If you want to get any action on the inside of a closed form, like a bottle, try wrapping it with something or placing a combustible either toward the top or wrapped to the inside to get a little blushing inside. Also, as you load your pieces, place them on their side or upside down, to promote smoking on the inside.

Beyond making a pot shiny and smooth, burnishing also strengthens the pot by compressing the clay particles and possibly results in fewer cracks from pit firing.

CLAY FOR PIT FIRING

Unlike raku, where the thermal shock properties of the clay are the most important, in pit firing there is a wider range of possibilities because there is less consistency in the firing process and temperatures. Also, while the kiln will get to temperature rather quickly, you are not pulling hot pots from the kiln. A firing could be as short as four to five hours and as long as several days. When troubleshooting in pit firing, it is hard to know if cracking is due to the clay not working well with the firing or if your firing schedule or loading method is

what should change. Try stacking differently or a different combination of combustibles. Put a lid on the pit at the end of the firing to slow the cool and protect the pots from the wind. If your clay does crack with the first firing, try it several more times. Each time change something rather significant and see if that improves the results. For example:

THIS TIME	NEXT TIME
No burnish	Burnish
No bisque	Bisque
Cooled with no lid	Cool with lid
Make open forms	Make closed forms
No added additional fuel	Added additional fuel

These are just a few examples of significant changes worth testing. Do not make all the changes at once, but rather test them individually. If you continue to get more cracks, then change your clay body. If you are committed to a clay body because it is locally sourced, try a few more things: saggar (see page 98), slower firing, shorter firing, less tumble stacking. Make sure you are building thin enough with good compression and try not to have wide, flat bottoms. Try adding more sawdust. Instead of placing the pot on the sawdust, sprinkle more sawdust on top of the pot before using smaller pieces of wood. (Sawdust will create a slower, more consistent heat.)

Pit firing is a great firing method to test that local clay you have been wondering about. Dig it, process it enough to get it workable, make several small tests, and see how it goes. Depending on the results, you might have a free clay source that is beautiful and unique—every potter's dream!

You can try adding coarse or fine mica to your clay. The shimmery micaceous clays are best known from the pit fired wares of New Mexican pueblo pottery. However, there is locally occurring mica in other regions and the material can easily be bought online in different mesh sizes. It adds a beautiful shimmer to pit fired wares.

The lighter and smoother a clay is, like a burnished kaolin terra sig, the more distinctly it will show the colors and blushes from oxides and the minerals of the combustibles. For subtle, less distinct surfaces, mid-tone and darker clays work best.

The only clay I suggest not testing is porcelain. It is expensive clay and will not serve that expense in this temperature range. If you want to work with porcelain because you love the way it feels and looks, I suggest trying to find a way to fire it to its suggested temperature. There are beautiful porcelains both for mid-range and high fire.

PREPARING WORK FOR PIT FIRING

Here are a few techniques you can use to create additional points of interest on your pot before it goes into the kiln.

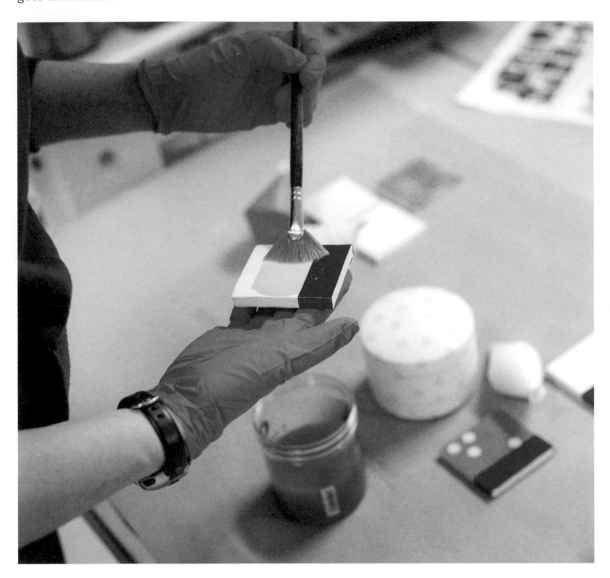

PRE-BISQUE

Terra sigillata and burnishing (see page 66) help show fuming effects from the pit kiln more clearly. You can paint the terra sig on your pot once it is leather hard. (Do not sig a bisqued pot.) You can sig the whole pot or mask your pot when using the sig to create a pattern. This will result in crisp lines on the pot with subtle transitions (if the sig and clay are the same color). You can see an example of this in the lidded jar (see page 92), which has a subtle polka-dot pattern. The polka dots are the clay body, while the negative space is the brushed-on sig. You can also add mason stains to your sig to achieve consistent color. You can use these new colors in conjunction with your original sig base to create interesting hard-edged shapes, or you can use them more like paint, creating a gradation effect.

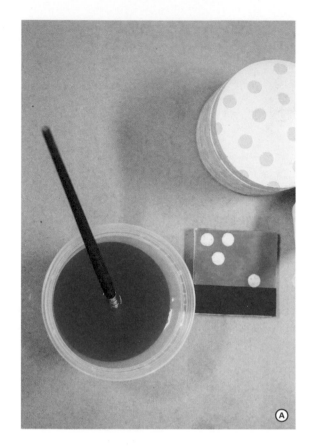

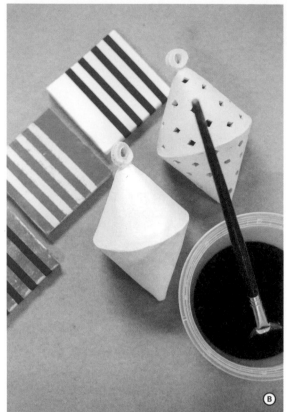

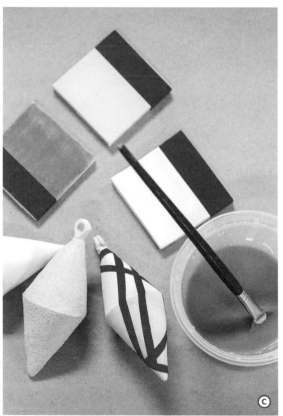

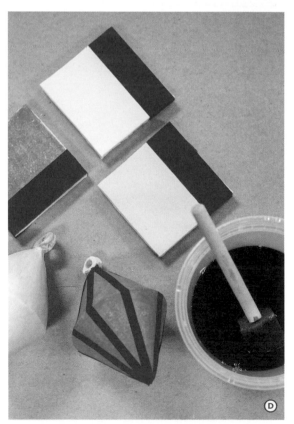

Ⓐ Copper Sulfate Wash
Ⓑ Cobalt Sulfate Wash
Ⓒ Iron Sulfate Wash
Ⓓ Ferric Chloride Wash

WASHES

It is a good idea to wear latex (or other protective) gloves when applying the following washes. All the colors mentioned are in regards to white clay. They will also work on darker clay, but the effect will be subtle and the colors will not be as noticeable. Note that fuming and blushing may occur on pots fired next to those on which you brush the sulfates and chlorides.

Copper Sulfate Wash **One-part copper sulfate to four-parts water (add more or less water to your preference)**
Brush on as a light wash. This is the subtlest of all the washes mentioned here, yielding an off-white, gray tone. Ⓐ

Cobalt Sulfate Wash **One-part cobalt sulfate to four-parts water (add more or less water to your preference)**
Brush on as a light wash for a light blue tone. Ⓑ

Iron Sulfate Wash **One-part iron sulfate to four-parts water (add more or less water to your preference)**
Brush on as a light wash for a lighter orange/tan color. Ⓒ

Ferric Chloride Wash **One-part ferric chloride to four-parts water (add more or less water to your preference)**
Brush on as a light wash. This is the strongest of the washes and turns orange. Note that this wash will stain your clothes terribly, fumes when burning, and is highly reactive to metal when wet. In other words, if you are considering making a foil saggar (see page 98) with something brushed with ferric chloride, make sure it is completely dry before wrapping it. And since most brushes have a metal component, apply it with a sponge brush. Ⓓ

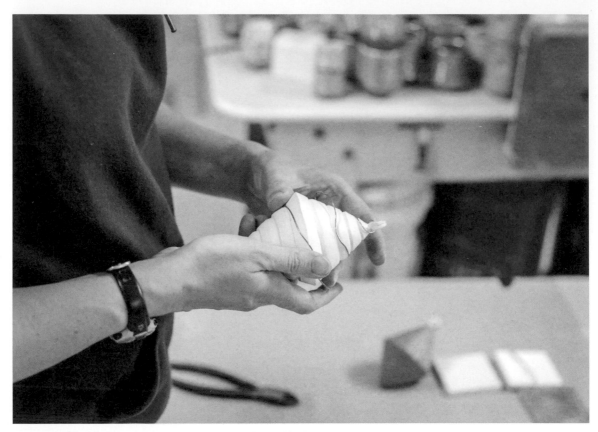

Wrapping a copper wire around a piece can create linear blushing.

SAGGARS

A saggar can be any noncombustible material that helps create a barrier around the piece. Saggars are used to either protect the pot from the outside kiln atmosphere or create a unique atmosphere within the saggar that will be a point of interest on the pot's surface. Saggars can be open or closed. They are not unique to pit firing and can be used in any type of firing. In this chapter, I cover basic pit firing and saggar types; however, you can find further saggar explorations on page 100.

When pit firing, aluminum foil and bisque saggars are commonly used to enhance the effects of the washes and natural combustibles that would otherwise be more subtle. Simply place various combustibles or colorants in foil or directly on the pot and then wrap the foil

around the pot. You can fully wrap the pot (for a closed saggar) or partially wrap it (for an open saggar). In the case of a closed saggar piece, you want to make sure there is enough combustible on the inside of the saggar so the piece doesn't look bare. By fully closing off the pot from the atmosphere of the kiln, none of the smoke from pit firing will affect the surface of the fully saggared piece.

Russel Fouts, whose work can be seen on page 122, has done a lot of research on permeable, semipermeable, and smoke resists. One of the techniques he has developed using foil saggars is to place paper cutouts onto a pot and then fully and tightly wrap it in foil. Where the paper cutouts were sealed against the pot, a smoky shadow is left behind.

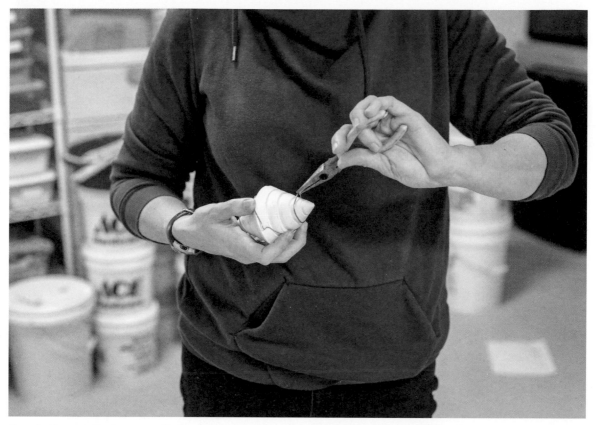

To make the copper wire more effective, wrap it closely to the pot. Here, I'm using needlenose pliers to torque the wire and cinch it closer to the pot.

A bisque saggar can work twofold. It helps protect the piece from the quick temperature increase that is unavoidable in pit firing. The saggar heats up first, creating a more even or controlled temperature for the pot it is insulating. The saggar also allows more space to fill with combustibles. If you are testing new combustibles in a pit and want to isolate them to a certain area within the kiln to determine how they affect the results, you could fill or mostly fill a bisque saggar, open or closed, with the combustible experiment, isolating it to the pot that is inside the saggar.

Sometimes, combustible materials that are used to wrap a pot or hold surface-enhancing materials near the pot are referred to as saggars as well, such as paper, natural fiber cloth, or seaweed. Strictly speaking, they are not saggars because they completely or partially burn off; however, in practice they can be referred to as such.

Note Try wrapping your pieces with copper wire, which will leave dark-gray to light-gray marks on the surface of the pot. It works best when the wire touches the pot. Copper wire can be bought as a spool in different gauges or even in net form, like a scouring pad.

LOADING THE KILN

Wait, we haven't even discussed the kiln and firing yet...why am I talking about loading a kiln? When pit firing, you have many options for combustibles and experimentation when firing. I think it's important to run through some of this before we get to the firing.

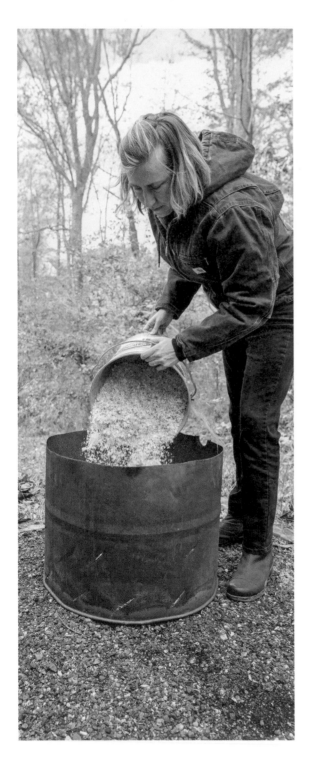

Beyond sawdust and wood, there are many options for what you can burn in your pit. Like the cow patties used in the Martinez firings (page 91), pit fire traditions historically developed hand-in-hand with the combustible materials that were readily available. The results these combustibles yielded varied from village to village, and a particular village would be known for the results linked to the combustibles or fuel they used to fire the kiln. Today, the same is true: the results combustibles yield vary, as does their consistency from firing to firing. The results of many of the more experimental combustibles can feel random, and it takes a level of commitment to successfully use them.

When evaluating combustibles, first things first: if you want it to burn well, it must be dry. (If it is not dry, it will make a big blob on your pot.) Second, keep in mind that salt or sodium chloride helps promote fuming. Along with the copper carbonate and other combustibles, it is important to sprinkle salt in your sawdust to promote fuming. Table salt, rock salt, and sea salt will all work. You can either mix the salt into your copper carbonate and sprinkle them together or sprinkle both separately. In addition to sprinkling salt on the sawdust, it is also common to add seaweed, kelp, and driftwood into the kiln as combustibles or to soak a material in saltwater. (But dry it out before putting it in the kiln.)

When pit firing, the results on the pots from the smoke is dark grey to black. This means that where the pot is sitting in the sawdust or other combustible it will be dark grey to black. If you really like this black, consider a sawdust firing, saggaring with

sawdust, and using darker sigs and clays with the smoke effect (maybe even rakuing). On the other hand, if something that will not burn is touching your pot, like a foil saggar or another pot, it will be a quiet spot that does not get much fuming or smoke. If you like less smoky action on your pieces, try packing them closely together, use more closed saggars, and don't put a lid on at the end for the cooling, which could trap smoke.

Note There will be times that you work really hard to layer different surfaces around a pot to burn. Then, when you unload it, it does not look like anything has happened. Other times, you might hurriedly load a bare pot, and it comes out looking like a galaxy. This is one of the many reasons to love alternative firing.

Here is a starting list (in no particular order) of combustibles/colorants or other elements to try in your pit. Listing the colors or surface textures that might result would ruin too much of the fun of your own list making and experimentation. Instead, I'll list some materials to get the ball rolling. I have not tested everything on this list and, in general, I would advise that you not stand around the pit while it is burning and not burn plastics or materials known to release hazardous fumes.

As a rule, start your testing by using a small amount of a material and adding more once you see the results and know how you feel about them and how strong or subtle it might be. I also recommend isolating a test to one or two pots to begin with. For example, if I wanted to test what cat litter might do to a pot, I would load an open bisque saggar with a little sawdust and then a handful of cat litter, making sure that cat litter comes into contact with just one pot. I would add the sawdust in the saggar because eventually I might plan on not using the saggar and want to better replicate how the combination of cat litter and sawdust would be. I would avoid using any of the other

materials I might commonly sprinkle in my pit, like copper carbonate and salt, because I want to see as clearly as possible what surface results the cat litter creates. Alternatively, or in addition to the open saggar test, you could also place cat litter inside a closed foil saggar, isolating the pot from any other combustible material.

In the case of something like nutshells, I would also recommend being as specific as possible. For example, I might do one firing with peanut shells, the next with almond shells, and another with walnut shells. In the end, I might want to use a combination of the shells, but it is a good idea to get to know the possibilities with the subtle variations first.

It is also worth noting that all carbonates, sulfates, and chlorides are very reactive and should be used sparingly.

Here is a springboard of materials to consider when you are thinking about what to start testing in your pit kiln:
Copper carbonate, copper wire, steel wool, red iron oxide, banana peels, orange peels, apple peels, eggshells, pine cones, pine needles, cow patties, cat patties, unused cat litter, used cat litter, compost, Miracle-Gro, copper sulfate, cobalt sulfate, cobalt carbonate, ferric chloride, iron sulfate, dried flowers, newspaper, magazine, leaves, twigs, seaweed, kelp, shells, bones, rice hulls, peat, coffee, tea, straw, wheat, barley, bark, bamboo, hair, hay, horse manure, nutshells, ferns, bamboo, fruit seeds, fruit pits, cat food, dog food, fish food, and the list goes on!

KILN DESIGN

As previously mentioned, "pit firing" is a term that loosely covers a large variety of open-fire designs including belowground, on the ground, and aboveground. In the section that follows, I will outline these main types of firing. From there, the variations are numerous. I've seen firings in large pits dug 2 feet (61 cm) deep that can fire hundreds of pots; and aboveground firing in a repurposed grill or 55-gallon (208.2 L) drum.

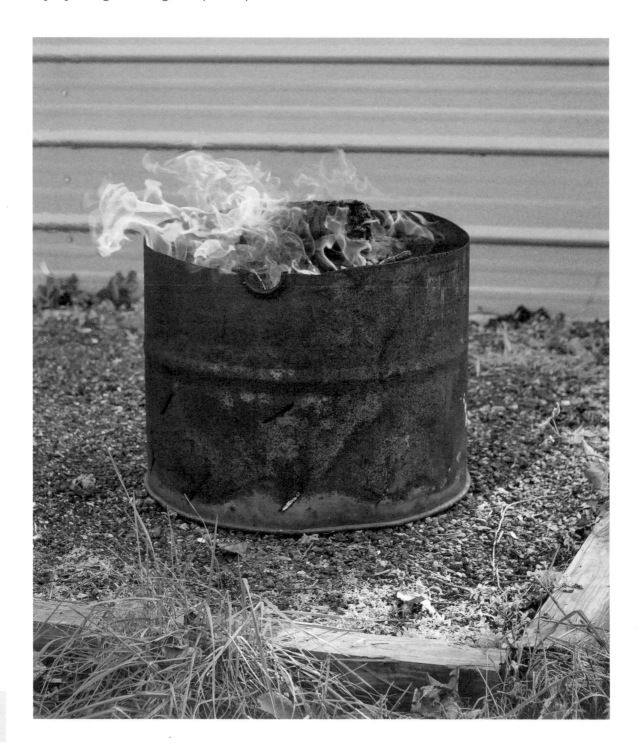

With all pit fires, you need to check with your local county regulations and nearest fire chief to make sure you are following the regulations for an open fire. For example, in the county where I live, there are specific regulations stating that I need to be at least 8 feet (2.4 m) away from any burnable structures, which includes wooden fences. I am not allowed to fire during the summer months and need to get an open-fire permit before I begin firing, no matter the time of year. I also live in a relatively urban setting, with neighbors to the left and right of my house. Any time I fire, I always let my neighbors know to expect to see flames in my backyard. I usually invite them over if they want to learn about what I am doing. (This has built many neighborly friendships for me, and I highly recommend working with your neighbors. It could be easy for all that smoke to become a nuisance for neighbors that live close by.)

I also want to stress the importance of the "better safe than sorry" mentality. Always wear protective gear, have a fire extinguisher nearby, and when possible, have a water hose handy as well. You never want to be in a situation where you lose control of the fire.

BELOWGROUND

Before you dig a belowground pit, you need to check your land plot and make sure you are not going to hit any septic lines, cable lines, electric lines, gas lines, or other underground lines that are integral to your house and safety. The advantage of a belowground kiln is that it has a nice slow burn. The temperature increases more slowly than aboveground kilns because it does not have as much airflow and the ground acts as an insulator, keeping the heat longer. It is also the best choice if you know you want to fire a lot of pots at once because it is the easiest kiln to go wide with. The main disadvantages are that the pit is

not portable and the maintenance of the pit is more involved than aboveground versions.

If you are digging a smaller pit, say 2 feet × 2 feet (61 × 61 cm), I also recommend clearly marking it somehow if you have children or other persons that might regularly play in the yard around the pit. If someone is running after a ball, an underground pit this size (or smaller) could be easy to miss. Alternatively, you could construct a lid for the pit that safely covers the hole when it is not in use.

To build this type of pit, you need the following:

Land to dig

Shovel for digging

Tamper or other tool to compact the hole

Bricks to line the pit (optional)

Noncombustible lid (optional)

A few things to ask yourself when you are planning a belowground pit:

- How deep do I go? You want to have at least 8 to 10 inches (20.3 to 25.4 cm) above your tallest pot. So, if you think you might make something as tall as a foot (30.5 cm), your pit should go as deep as 20 to 25 inches (50.8 to 63.5 cm). I would not go much deeper than 25 inches (63.5 cm).

- How wide should I make my pit? This is tied to how many pieces you plan to fire at a time. Other factors include how many people will use the pit and how often you want to fire it. You will likely be constrained by what your yard space allows for as well. There is no easy answer on width. Often, wider pits are also refered to as trenches.

- Slope or no slope? After you have tried your first couple of pit firings and after adjusting your stacking and combustibles, you may still find it difficult to get efficient

combustion of your initial sawdust bed. If this is the case, you might try sloping your walls. Both types of pits are commonly used (sloped and no slope). By sloping the sides, you make it easier for that initial layer of sawdust to get air and burn. However, by sloping the walls, it is likely the overall fire will be hotter more quickly than before the walls were sloped.

- Brick or no brick? Retaining wall bricks, standard brick, and stones are sometimes used to line a dirt pit. A bricked pit will stay hotter longer than a pit that is not lined with brick. In certain situations, brick also helps maintain the form of the pit over time and has a more resolved or finished look.

ON THE GROUND

This is the closest thing to the original pit fires used 10,000 years ago. The pros are that it is easy to move around, easy to work in non-bisqued pottery, and easy to adapt the size of the fire because there is no preset size. The cons are that it is highly susceptible to wind, harder to control the temperature changes, and it needs more attention and maintenance during the firing. If you go with this type of firing, it is not advisable to use a lot of the colorants because you will be standing around the fire more often. The results from this type of pit tend to be more natural.

To build this type of pit, you need the following:

An area where you can build a fire a safe distance from other combustibles

Metal grill grates (optional)

Sheet metal (optional)

A few things to ask yourself when planning an on the ground pit:

- Do I have any wind protection? Even on a day that is not too windy, it is a good idea to think about where the wind is coming from and build somewhere that is sheltered from the wind. Once the pit fire has died down, you can place pieces of sheet metal around the pit to protect the pots from wind and help them cool more slowly.

- Is the ground and surrounding area free of combustibles? Do not build a fire in your grassy, tree-laden yard. Instead, fire on only dirt, gravel, sand, and other materials that can handle the heat and will not burn. Similarly, do not build your fire on concrete. Concrete will crack and pop when it gets too hot.

- What am I going to use as my structure for this pit? Do you have any scrap metal or grill grates that can be used to help construct a chamber that will cool the pots more slowly? Maybe at the end of the fire you want to place manure on top to enhance the smoke effects. It is possible to not do anything and let the fire simply cool, but it is also not uncommon to frame and protect it somehow.

ABOVEGROUND

Last but not least, is the aboveground firing option. In fact, it's far from "least!" If you are a solo potter making pots as a hobby or part-time job, this is probably the best choice. It's certainly the most common type of pit firing you'll see these days. An aboveground kiln can be any structure that exists that you can repurpose for pit firing, like a 55-gallon (208.2 L) drum. (In the photos in this chapter, I used half of a 55-gallon [208.2 L] drum.) You can also stack a single layer of bricks in a square or rectangle shape to act as your structure.

Pit firing in a drum is also referred to as a barrel firing and depending on how the pots get stacked with the combustibles, a sawdust firing. The pros to this design are it is easy to find or create a structure that is lightweight and portable, and it is easy to maintain the structure when not in use. It is also a shorter firing, lasting only four to five hours unless you add more fuel during the firing. You can load, fire, and unload all in the same day. The cons are it is a set size, the structure will eventually need to be replaced, and it does not retain heat as well as a belowground pit.

To build this type of pit, you need the following:

Half of a 55-gallon (208.2 L) drum, or similar above- ground structure

Noncombustible lid (optional)

The holes in the bottom of the drum increase air intake and help combustion.

A few things to ask yourself and keep in mind when planning an aboveground pit

- Is the ground and surrounding area free of combustibles? Do not build a fire in your grassy, tree-laden yard. Instead, fire on dirt, gravel, sand, bricks, or cinder blocks and other materials that can handle the heat and will not burn. Similarly, do not build your fire on concrete. Concrete will crack and pop when it gets too hot.

- How is the structure getting air? If you have loosely stacked bricks, the spaces between the bricks will be sufficient for airflow. Over time, you will find that you may need to adjust the spacing between the bricks to add more or less air. With 55-gallon (208.2 L) drums, puncture the drum every 8 to 10 inches (20.3 to 25.4 cm) to allow airflow. If you are of the engineering mindset, you can also cleverly engineer ways to introduce air into the structure that better suit your style.

- Is the ground level/are the walls flush? If you are bricking a structure, level ground is more important than if you are using a barrel or other existing structure. Level ground will make it easier to build straight walls, which in turn make for a more stable structure. Do not mortar your structure. It should be a loose stack. Otherwise, you won't be able to adjust your bricks for airflow or easily unstack to make size and scale adjustments.

Joe Molinaro | Visiting Two Pottery Villages

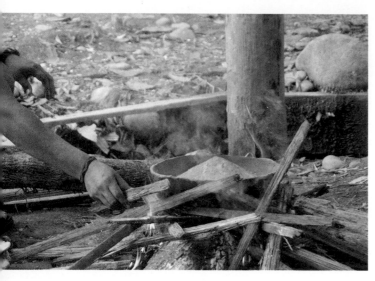

Firing Pottery. *Photo courtesy of Richard Burkett.*

Stacking with brush. *Photo courtesy of Richard Burkett.*

JATUN MOLINO
A Pottery Village in the Upper Amazon Basin Region of Ecuador

The ceramic work of the Kichwa people of the upper Amazon basin region of Ecuador is fired in an open pit with three large logs coming together to form a circle. Forms dry slowly in the damp air of the jungle, so potters often preheat pieces by placing them near burning logs which further prepares them for the firing process. A large bowl-shaped container, which has a hole approximately 6 inches (15.2 cm) across cut out of the bottom, holds the form to be fired as it is placed upside down in the larger firing container. The piece to be fired is then covered with wood ash, which serves as an insulator for the heat. The firing chamber is placed onto the three logs whose ends, as well as other smaller bits of kindling, are burning. This chamber is set on the fire for approximately thirty to forty-five minutes while the potter continues to stoke the fire. Once the flames are ablaze and the desired time has expired, the chamber is removed from

the firing site, followed by the piece and ash from the container. They immediately dust off the form with leaves and set it in the firing chamber, which is now placed upside down on its rim. The hole in the bottom of the firing chamber serves another purpose as it becomes an area where the finished pottery can rest. While the piece is still hot, the potter takes a chunk of hardened tree sap and rubs it on the form. The sap, which comes from the Shillquillo tree, melts onto the piece and creates a protective, gloss-like coating. This surface enhances the painting and helps make the form impervious to water.

JATUMPAMBA
A Pottery Village in the Andean Mountain Range of Southern Ecuador

The women potters of Jatumpamba fire their pottery by arranging a carefully layered raft of pots covering approximately 20 square feet (1.9 m²). The base is formed by placing rows of pots gently balanced on their sides against each other on

Amazon Mucawa. *Photo courtesy of Richard Burkett.*

top of a bed of clay shards. With the high winds of the Andes blowing freely across the plateau of the village, firing is timed carefully to take full advantage of the afternoon lull in wind velocity. Kindling and larger branches of leafy brush are placed on top of the first row, followed by another layer of pots until there are three full layers of pottery with branches between each layer. A perimeter of old (previously fired) pots is constructed around the base of the pottery to be fired, which is used to control airflow and temperature. Brush is packed around the spaces between the ware, adding fuel to the fire. The fire is lit and the blaze quickly burns. The fire tenders control the heat, carefully monitoring the wind direction. Broken pot shards are regularly moved

to channel or deflect the breeze as the fire builds. Fire tenders add or adjust the brush judiciously to help the fire maintain a steady temperature as the blaze progresses. Once the heat has had time to spread evenly throughout the mound, the bonfire is stoked from all sides until the fire rages uniformly. The last combustible material added to the burning pile is chosen for its fineness, which, after the conflagration slowly dies down, leaves a fine insulating ash on the surface of the mound. The bonfire lasts approximately three to four hours, depending on the size of the pile and the strength of the wind. After the fire runs its course and the mound is covered with the fine ash, it is left to cool slowly overnight.

FIRING

In this section, I will outline several common firing strategies and stacking methods. These are general starting-point strategies that you can easily adapt to work with your personal preferences. In general, using a metal grill grate to place your work on is optional. Sometimes, people like to use the grates because they offer better balance for more fragile pots. At other times, you may use a grate because air can get under it better because the pots are not compressing the initial bedding as much. With this latter idea in mind, you can also brick the grates up on quarter bricks to allow even more airflow and provide an area for the coals to burn. With all of these firing strategies, never leave a fire unattended. Even if you do not need to stoke, remain close by to keep an eye on it.

TIME AND TEMPERATURE

Pit firing runs the gamut from a small cubic foot (0.08 m²) hole in the ground to a dugout trench the size of car. As we have already discussed, they can be belowground, on the ground, and aboveground. They can be built with bricks, dirt, and metal. While all of these variations are pit fires, they differ in what you can expect in terms of time, temperature, process, and results. With that in mind, I'll speak in very general terms to define what you can expect to encounter when you first start pit firing. As a clear starting point, I will outline the time it took me to load, fire, and unload the half 55-gallon (208.2 L) drum pit. Once you have a few firings under your belt, you will be able to make the necessary adjustments and experiment with time, temperature, and results from there.

Generally speaking, the larger the pit, the larger the fire, the more combustibles there are to burn, and the longer it will take. On the other hand, the more available air to help fuel the fire, the quicker the pit will burn. All things being equal, if you add more air, the fire will burn hotter and faster than if you have less. All this to say the time it takes and the temperature your pit fire reaches depends on the size of the pit, the amount of available air to help combust the fuel, and the type and amount of combustible. Paper burns at 451°F (233°C), and dry wood burns at just above this temperature. Small campfires are thought to burn between 500 to 1000°F (260 to 538°C). Larger fires that burn longer with air to help combustion can get above 1000°F (538°C).

Typically, a pit fire reaches its peak temperature very quickly and then burns and fully combusts the fuel just under that peak temperature. When all the fuel is burnt, the fire begins to smolder, and then cool. When

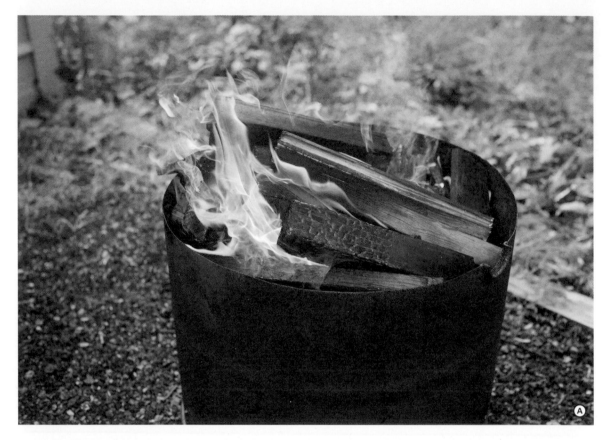

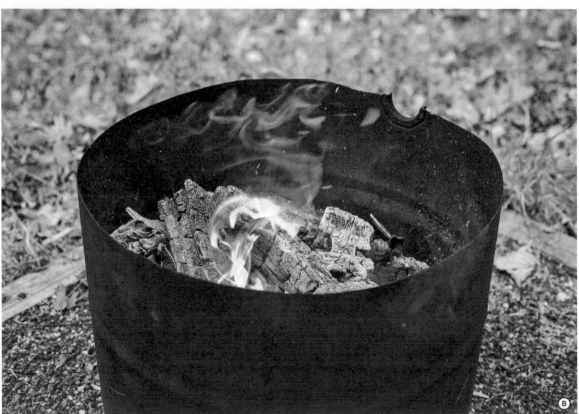

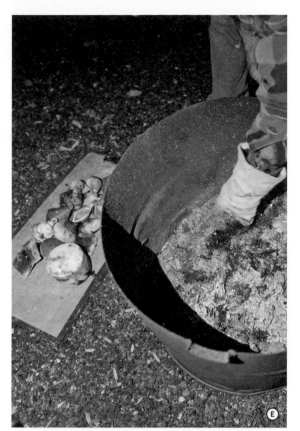

the fire begins to smolder, you can put a lid on it or frame it somehow with metal, bisque shards, or damp earth to protect the pots from cold air, slow the cooling process, and promote surface results from smoke.

Just like a campfire, when you don't continue to add new pieces of wood, the fire is relatively quick to burn down. As you watch your fire burn, take note of the color of the flame. (One way to identify the heat your fire is creating is by the color of the flame. Cooler fires do not get as bright as hotter fires.) If you are not satisfied with the amount of time your fire was burning for or the color of your flame, you can lengthen the firing by adding additional wood as the fire burns. Longer firings will naturally get hotter as well.

For the half 55-gallon (208.2 L) barrel firing, here's the timeline:

- 30 minutes: I loaded the pots with a layering of combustibles (see page 112 for more on layering combustibles).

- 3 to 4 minutes: I started the fire with a few pieces of wood doused in diesel fuel. I used a blowtorch to help quickly ignite the final layer of wood and driftwood. Ⓐ

- 2 to 3 hours: The fire burned to a smolder. Remember, the barrel I used had air holes pierced throughout. Ⓑ

- 3 to 4 hours: I let the barrel and pots cool without a lid. Ⓒ Ⓓ

- 10 minutes: I unloaded the warm pots with welding gloves on. Ⓔ

- 10 minutes: I doused the remains in the barrel with a little water to make sure the fire was completely out.

Note *When you first start out, everything takes longer. Do not rush! Take your time. Try to enjoy being outside and the process. Just plan on adding a little time to the suggested schedule. Also, never reach into a pit that you think is too hot! Just wait. It will get cooler.*

FIRING FOR EFFECTS OTHER THAN SMOKE

For many pit firings, the main goal is not smoke from the combustibles, but the colors. If smoke is your goal, see page 100. To coax out colors and textures, it's all about the layers of additional materials and experimental combustibles. Note that the closer a combustible is to the pot, the greater the chance is you will see the result of that combustible on said pot. The layers themselves will intermingle.

First layer Use about 3 to 4 inches (7.6 to 10.2 cm) of sawdust or a combination of sawdust, leaves, paper, and hay. This is meant to be a good dry, soft bed on which to begin placing pots. Ⓐ

Second layer Give a light dusting of copper carbonate and salt. (Some prefer to dust these materials around and on the pots after they are placed.) Ⓑ

Third layer It's time for the pots! Stack as closely or loosely as you like. Remember that where pots touch each other there will be less smoke and, in general, the results will be subtler. If you are using saggars, you should pre-saggar your pots, making it easier to load the combination of pots with and without saggars. Your pots will be nestled into the second and first layers and should not strictly be on top. Ⓒ

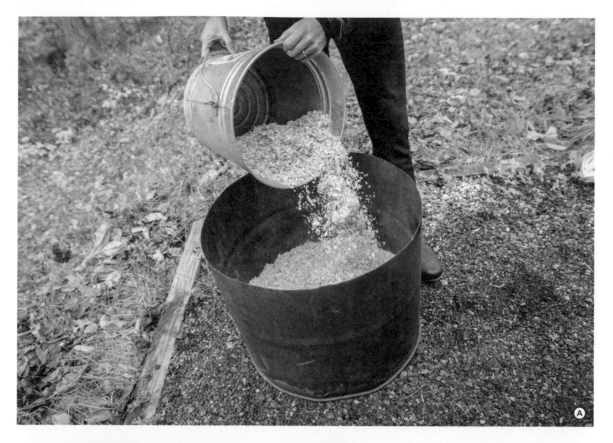

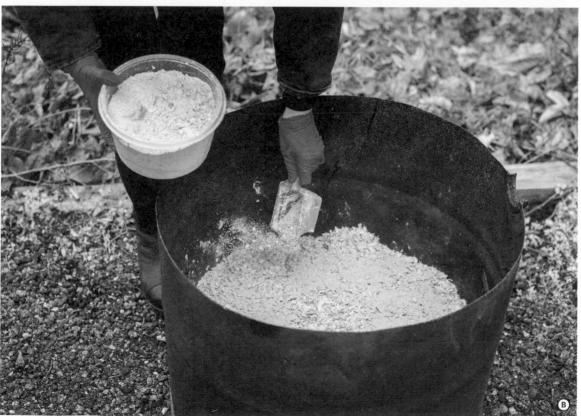

Fourth layer Add the additional combustibles and colorants you want to try on your pots (see ideas on page 101). These can be strategically or randomly placed. Take photos to help translate results. Ⓓ

Fifth layer Place a blanketing of small pieces of wood, sawdust, small twigs, etc. Ⓔ

Sixth layer Add twigs, small pieces of wood, and medium pieces of wood. (The pots should be fully covered now, with just enough room left for your last two layers of wood.) You might also notice that as we layer, the pieces of wood are growing from small to big. Ⓕ

Seventh layer Add some medium pieces of wood and driftwood, to the top of the pit or just above the top of the pit. Ⓖ

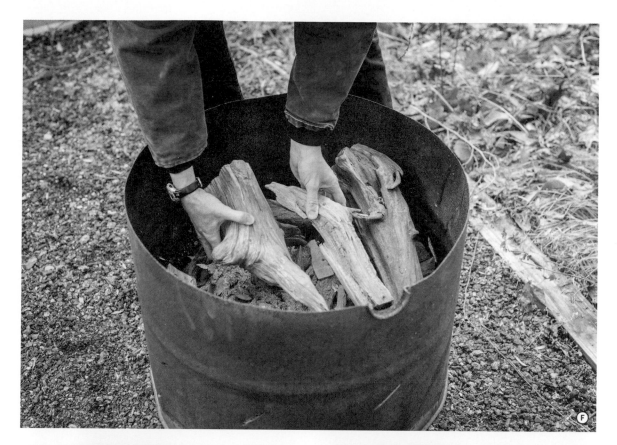

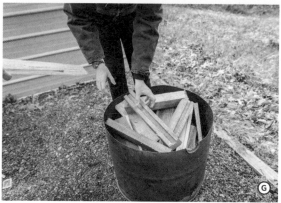

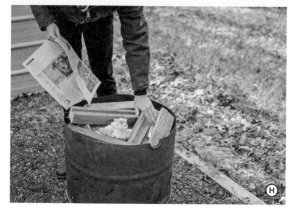

Eighth layer This is where you add the fire starter. This is not a full layer, but more an igniter of some sort to help get everything going. Options include a few pieces of wood doused in flammable fluid, paper, kindling, or other hot flammable. (More details on fire starters are at on page 118.) Ⓗ

After you finish layering your pit, you are ready to start the fire! I recommend using a small handheld torch or a weed burner torch. Both project a hot flame and make it easy to move around the pit, starting several small ignition points on the top two layers of the pit. These small fires will grow and develop into one larger pit fire. *Voilà!* You are pit firing! If you notice a breeze you didn't before, and it is hindering you from starting the fire, I recommend using the torch a little longer than you otherwise would. If you have a piece of scrap

metal or other noncombustible material you can use for a barrier to the breeze, use it.

Depending on the size of your pit, the fire will last roughly four to five hours without adding any additional wood. If you want the fire to go longer, gently stoke it until you are ready for it to start to go out. Unload when the pots are cool.

FIRING FOR SMOKE (SAWDUST FIRING)

The key to a successful sawdust firing is decreasing air circulation. You'll follow a similar layering strategy as in the previous section, but with some variation to reduce airflow. With this goal in mind, underground straight-walled pits work well, especially those with bricked walls. Aboveground bricked structures and barrels are also suitable. Just keep in mind that you want to reduce airflow, so consider lining the structure with paper before starting the load.

First layer Use about 3 to 4 inches (7.6 to 10.2 cm) of sawdust.

Second layer Add some pots. These pots should not touch one another, but be closely nested. If the pots are closed forms and won't easily fill with sawdust while loading, fill them with sawdust before you start loading. You can also nestle small pots inside big pots within the sawdust. In this case, the big pot acts like an open saggar, helping the smaller pot inside get good smoke results. If you are working with any greenware pots, this first layer of pots would be the best place to layer them. It will get hot more slowly than the layers above.

Third layer Add enough sawdust to cover all the pots and have a good 3 inches (7.6 cm) of bedding.

Fourth layer Add more pots, similarly layered to the second layer.

Fifth layer Add another layer of sawdust. It should cover all the pots and create a good 3 inches (7.6 cm) of bedding.

Sixth layer (and possibly beyond): Add more pots, like the pot layers before, and continue this layering pattern until you run out of space in the kiln (leave 6 to 8 inches [15.2 to 20.3 cm] at the top for the two layers that follow).

Seventh layer (or second-to-last if you have more layers than listed here): Add sawdust to the top of the kiln. Toward the top of this layer, you can also work in paper or wood shavings that will act as kindling and help get the firing going.

Eighth layer (or last if you have more layers than listed here): Add paper, wood shavings, and wood kindling as a fire starter.

Lid or lids There are a few ways to work with a lid. You can start your fire, let the big flames die down and the smoldering begin, and then place the lid(s) on top. Alternatively, you can place your lid before you begin the fire. The lid(s) will be adjusted to allow air in, bricked up on the edge of the kiln. Again, as the fire starts to die and the smoldering begins, you close the lid(s) by removing the brick prop.

Similar to Firing for Effects Other than Smoke (page 112), here too, use a handheld torch to start several small fires in the final two layers, in various spots around the pit. These smaller fires will slowly turn into one larger pit fire. Sawdust firings do heat up more slowly and take longer to fully burn because there is not as much air to influence the combustion. It is also more difficult to determine when they are fully burned because of the use of a lid and added smoke. This type of firing can feel a little like sitting and waiting. At the earliest, plan on not unloading this pit until the next day. With your first few sawdust

FIRING WITH GREENWARE POTS

Historically, all pit fired pots were fired greenware. This is still the technique in many pit-fire traditions around the globe. The trouble you will find with firing greenwares pots is that they crack because of how quickly a pit fire gets hot.

When firing greenware pots, it is important to warm them before putting them directly in the fire. With this method in mind, I suggest using an on the ground firing method. Think of it like a campfire; in fact, you could use a fire ring at a campsite to control the burning radius. The pots should be a generous distance from the fire. Think about how close your shoes can get before they begin to melt. Start there and then slowly rotate the pots with tongs, getting them closer and closer to the fire before they are actually in the fire (this should take about one to two hours).

Once the pots are in the fire, continue to stoke the fire, building a teepee stack or log-cabin stack of wood around the pots. My preference is a log-cabin stack because the wood is less likely to fall and break the clay.

A combination of these stacking methods works great too.

As an alternative to slowly working the pots into the fire, you can think about how to saggar your pots or protect them in the fire in a way that helps them heat up more slowly and evenly. This could be by nesting them in one another with sawdust (or another rich fuel source) or by surrounding them with broken pot shards from previous firings. Then, build the teepee stack or log-cabin stack of wood around them. You'll be starting the fire in a similar manner to how you would start a campfire.

You can fire like this for as long as you see fit, and with time, I am sure you will keep track of the firings and experiment with several firing lengths (likely about two to five hours). When the fire is on the downward slope and beginning to smolder, you can cover the pots with sawdust to promote smoke or let the kiln smolder and then cool. Congratulations! You have just joined the ranks in the most traditional firing method.

firings, take notes on the time you started the fire, when you noticed the smoke dying down, and when you were able to unload. I also recommend noting the weather, as the climate could affect the rate of combustion and cooling. From these initial firings, you can make the assumption that if you build a smaller pit, it will be faster, and if you build a larger pit, it will take longer. As a starting point, allow for two days. The first day is for the firing; the second is for the unload.

The next day, when the smoking is done, check the warmth of the lid(s) and then, if cool, lift it to check the warmth of the pots.

Be careful that there are no live embers and begin to unload your smoldery beauties. If you check the lid and/or the pots and they are too hot to comfortably unload, wait until they are cooler to start the unload.

COMMON PIT QUESTIONS

What if my pit is wet when I start?

You do not want to use a wet pit. The sawdust and smaller combustibles will absorb the moisture and not burn as well. You need to dry your pit before firing. One way is to start a campfire, warming and drying the pit. Now, it is ready to load.

Can I reuse the ash and unburned sawdust from the previous fire?

If you are sawdust firing, I recommend sweeping out the pit and starting with clean sawdust. If you are using it as the first 1 to 2 inches (2.5 to 5 cm) of your initial bedding and will have 2 to 3 more inches (5 to 7.6 cm) of fresh sawdust bedding on top to start your layers, it shouldn't be a problem.

What are some fire-starting solutions?

- **Fuel** I do not recommend using gasoline as a fire starter. It flames up too quickly and is overly dangerous. If you do use a liquid propellant, I recommend charcoal lighter fluid, diesel fuel, or kerosene. Do not douse your pit, but rather select three or four pieces of wood, douse them to the side, and then place them on top of the pit.

- **Kindling** You can make a fire starter with dryer lint and petroleum jelly or lip balm. (This works great for campfires too.) Other kindling includes crumpled newspaper, wood shavings, and cardboard. I would steer clear of toilet paper and leaves because they are too light and you will get a lot of flyaway burning ash. Place the kindling under a small teepee of wood to start the fire.

- **Flame** As you can see in the photos, I used a weed burner (on wood doused with diesel fuel) to start the pit. The weed burner has a nice strong flame, gives me a good distance from the fire, and there is no doubt the fire is going to catch. Other flames that work include handheld torches, lighters, and matches. It is a good idea to start the fire in several locations.

CLEANING YOUR POTS

Cleaning pit fired pots is fairly easy, as long as you do not have any strange unburned combustible blobs stuck on your piece. Brush any debris off as you unload the kiln. Once you are ready, use a wet abrasive sponge and gently scrub your pots clean. Scrub and then rinse with clean water at the end. Similar to raku pots, once your pot is dry, you can finish it with a finishing wax. This will bring out the luster of the clay surface and deepen the tones of your results. (I recommend bowling alley wax. This will give your piece a nice luster and protect the surface.)

If you do have any kiln blobs gracing your pieces, you can refire them to burn them off, but know that the pot's surface will look very different. If you like your current finish, the only option is to spend the extra time scrubbing. If you deem the piece valuable enough and the spot is trouble enough, you could also use a Dremel tool with a flap wheel sandpaper attachment to remove them.

As with all ceramics, there is a plethora of additional cold-surfacing finishes you can experiment with: paint, flock, sandblast, colored epoxy, etc. You can also think about adding wooden, metal, glass, or other mixed-media elements to the piece.

GALLERY

All photos courtesy of the artists.

Chris Corson, *And the Light and the Dark Came Back Together*, pit fired.

Clive Sithole, *Figurative Pot*, saggar fired.

(opposite) Chris Corson, *Cosmos*, pit fired.

Virgil Ortiz, *Pueblo Revolt*, pit fired (black paint).

Virgil Ortiz, *Watchman Canteen*, pit fired (black paint).

Clive Sithole, *Mottled Pot*, barrel fired.

Marcia Selsor, *A Remembrance; Every Life is a Book*,
sawdust pit fired.

Ken Turner, *Lidded Vessel 1*, foil saggar fired.

Russel Fouts, *Untitled*, electro-smoke fired.

Mehmet Tuzum Kizilcan, *Intersection*, saggar fired.

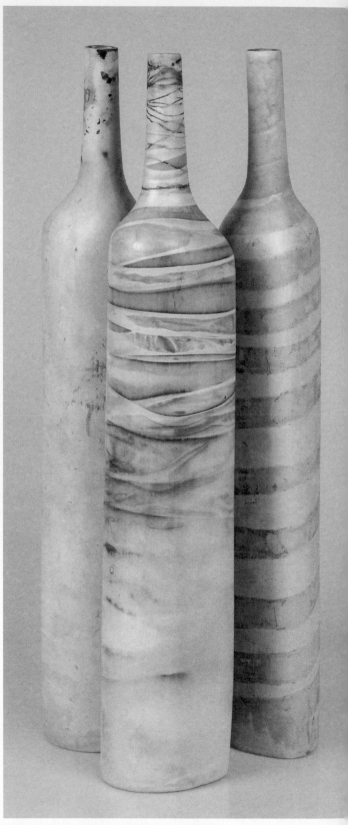

Mehmet Tuzum Kizilcan, *Trilogy*, saggar fired.

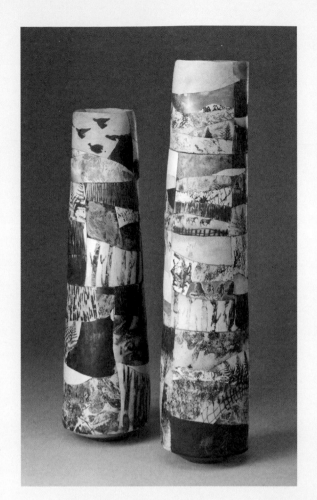

Shamai Sam Gibsh, *Organic Stripes*, saggar fired.

(left) Irina Okula, *Saggar Shard Towers*, saggar fired.

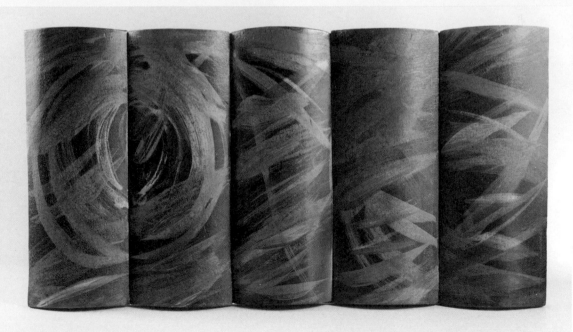

Shamai Sam Gibsh, *Circular Movement*, saggar fired.

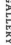

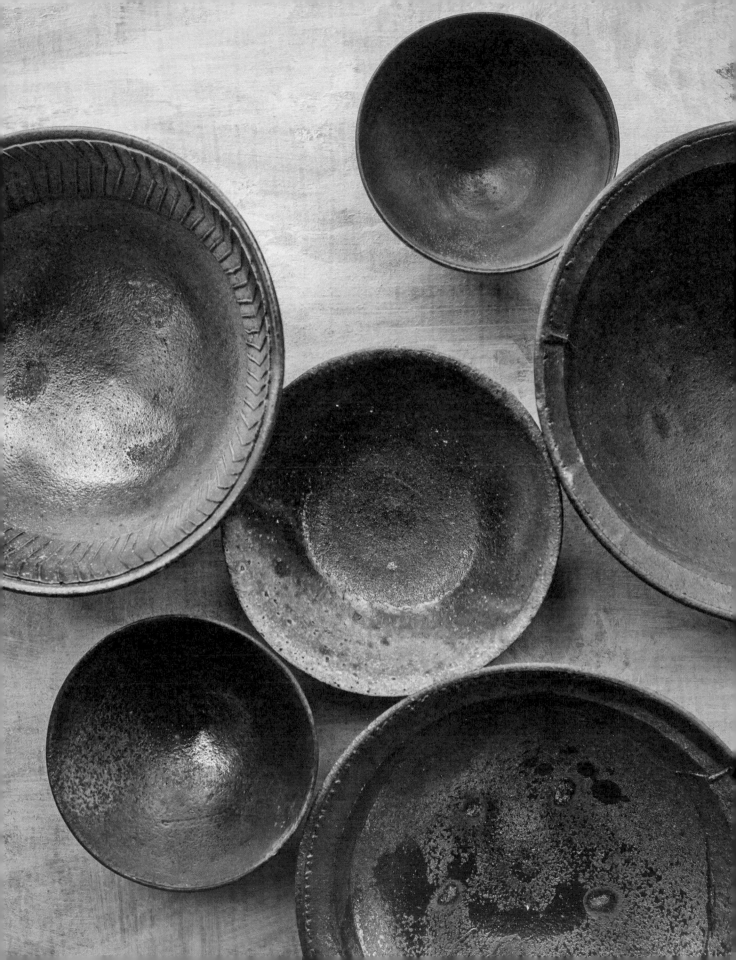

5

WOOD FIRING

WOOD FIRING IS ENDLESSLY REWARDING. EVERY firing is slightly different, and you must employ critical thought, problem-solving, ingenuity, teamwork, time management, and physical labor. I've found that even the worst firings tend to offer a gem of a pot that keeps you motivated enough to make work for the next firing. Plus, for those used to the solo practice of making pottery, there is nothing quite like coming together with friends and fellow potters to fire a kiln and celebrate the moment.

In this chapter, we'll learn about wood firing from the reference point of a train kiln. Beyond the fact that this is the type of kiln I use in my own practice, it is a good reference because it is a cross-draft kiln, like many other wood kiln designs. It also gives the potter a good variety of achievable surfaces, from pots blasted with lots of fly ash to more soft-flame work. In other words, many of the basics can be easily translated to other wood kiln designs.

Everything I outline about the firing should be considered as a soft guideline or starting framework to begin your own journey. Once you fire your kiln for the first time, some of

these tips will become relevant and make more sense, while others can be cast aside. I can't stress enough the importance of taking good notes on what you are doing from start to finish, especially in the beginning. Your understanding of the process and your kiln will develop much faster if you take the time to keep the following: an accurate log of clays, glazes, and slips used; photo documentation of your loading strategy with notes; an hourly kiln log; and photo documentation of the unload with notes. It is also important that you are present for as much, if not all, of the firing as possible.

One final disclosure: In this chapter, I am specifically talking about high-fire temperatures. That is not to say that the same principles don't apply at low-fire and mid-range temperatures; however, at lower temperatures, you generally need to worry less about warping from the firing (unless it is a clay body issue), you typically use more glaze throughout the whole kiln, and there is no accumulation of fluxed fly ash on the pot. The surface variations from the atmosphere are from the flame.

MAKING WORK FOR WOOD FIRING

I still hold myself to this rule: Experiment with something new every firing. This could be a test clay body, glaze, or new form. It could also be a new loading strategy or using a different type of wood. Continually and incrementally testing ensures you are continually learning from each firing. Then, you can apply what you learned to the next session of making and firing.

You'll find that making work for a wood kiln is not that different from making work for any other type of firing. There are only a few additional things to think about along the way, and some of these considerations can be worked out during the loading of the kiln.

Start by considering your pot's form and wall thickness. As the flame moves through the kiln and wraps around your pot, it carries fly ash with it. How the fly ash gets deposited on your pot and develops the wood ash glaze through the firing directly relates to your forms and how those forms are loaded in relation to one another. Simply put, the wood ash will follow and highlight shape changes in your wares.

If the wall of the pot is too thin, it is more likely to "taco." "Tacoing" is when a round pot warps to an oval pot in the firing. This happens because the velocity of the flame and the draft in the kiln pulls against the pot. Wood firings tend to be hotter for longer than many other types of firing, making warping more of an issue. One way to avoid this is to make

your walls thicker or add a little weight to the rim. I have also found that warping tends to be worse if the kiln gains temperature really quickly. If your temperature gain is slow and steady, the flame velocity is softer.

Next, think bare clay. Glazes often soften the marks left behind from making. However, in wood firing, those throwing rings, finger marks, and clay grog are much more visible after the final firing. Try to use this to your advantage. That said, fine details are difficult. If you make wares that are highly decorated and have very fine details you want to maintain, try to put those pots in an area in the kiln that does not get much accumulation of wood ash or protect them with a saggar (see page 98). A good starting point would be loading high and to the back of the kiln.

GLAZE AND SLIP

You don't actually need to use glaze when wood firing: for many potters, this is one of the bonuses! If you do use a glaze, make sure

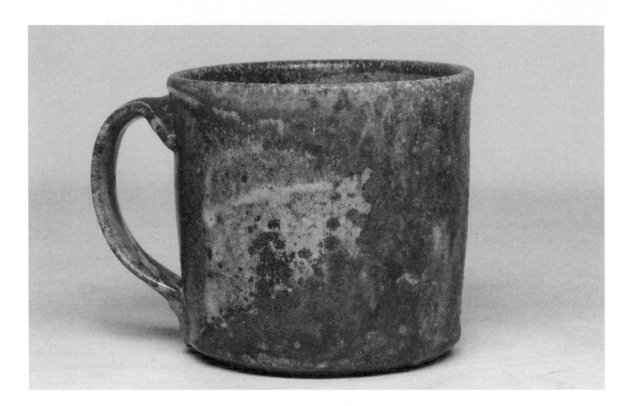

that it aids your work in some way and don't just use it out of habit. I mention this because glazing in particular can become a habit when you're used to firing electric or gas kilns. When wood firing, even the use of a liner glaze should be questioned. Why do you want to use a liner glaze? Is your clay not watertight on its own? Does it aid in its function or design?

Yes, of course there are some really beautiful glazed wood fired pots being made, and if you have a favorite glaze or slip—or think a slip or glaze could help you achieve something new—by all means, test it! To get the most accurate understanding of what the slip or glaze will look like, make small pieces that are reflective of your work's typical form and surface and put the same test in several different spots in the kiln. For example, one of the pots I generally glaze are my mugs. My clay is iron-rich and rather dark. I have found that tea drinkers like a lighter surface to gauge the strength of the tea and steep time. I use a Shino glaze on my mugs that works well with both my clay body and the firing. The Shino

is a lighter finish and works well throughout my kiln. I probably tested between twenty and thirty different Shinos before I landed on the one I use now.

Ask yourself why are you firing with wood: is it primarily as a fuel source that can offer beautiful and subtle surface variations or is it primarily for a new complex surface on your artwork? If it is the latter, try glazing less or only using a glaze as a liner. Think about bare clay more. Test clays while you're testing glazes. Of all the forms I make, I only glaze two of them—everything else is either bare or slipped.

Slips can be used to add a contrasting element to your clay, or you might slip your pot with a clay that has a more active flashing surface. Slips are used often in wood firing because they are easy to work with and range from being subtly different from the bare clay to offering contrasting elements without being too different from the surface texture of the clay. Slips are also nice because you can always stack pots that are slipped and use wadding on top of the slip.

WADDING

Wadding is a highly refractory material that acts as a buffer between your work and the shelf. Without wadding, your piece is at greater risk of getting sealed onto the shelf because of wood ash fluxing on its surface. This makes wadding not only a necessity but also an aesthetic component, as it leaves surface marks. When considering it as an aesthetic surface mark of the process, do your best to incorporate the wadding mark into your overall design.

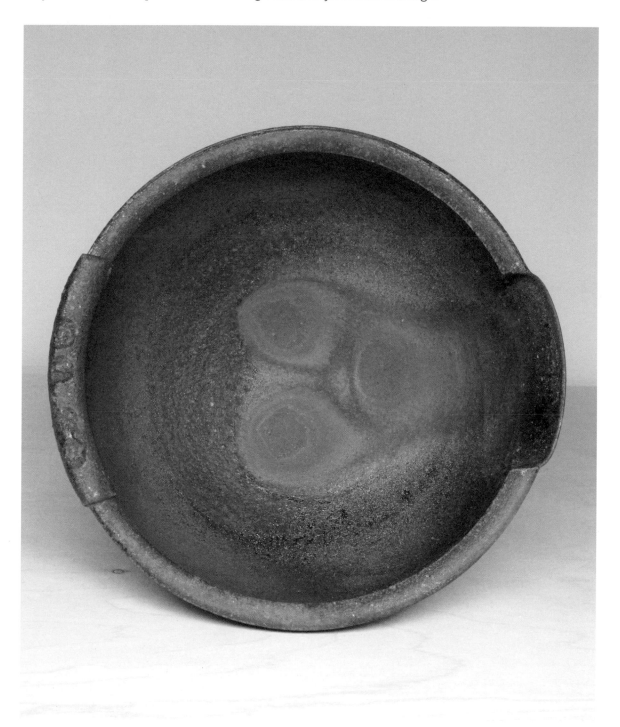

Generally speaking, everything going into the kiln must get wadded, as you need to put something refractory between your work and the shelf to prevent the wood ash from glazing it to the shelf; it also needs to keep your work stable. Wadding is also used in loading, leveling kiln furniture, and between the posts and shelves. Because everything going into the kiln gets wadded, you will develop a preference for a type of wadding.

Note *As you get to know your kiln, there are some exceptions to pots going in without wadding. In zones that are protected from fly ash, you don't necessarily need to wad the pot. However, it is good practice to wad everything.*

WADDING OPTIONS

Fireclay This is the wadding I use. It's easy to work with, can be used for kiln furniture as well, and leaves good marks. Fireclay wadding is generally a mixture of fireclay, sand, and sawdust or other material that burns out. I use rice hulls instead of sawdust because it is easier for me to get, but I also like how small the rice hulls are in comparison to the inconsistent and chunky sizing of sawdust. The sand helps with the shrinkage and strength of the wad, while the organic material aids in the surface mark and makes the wad more porous and easier to remove. Some artists use just fireclay and sand, while others add a mix of several different materials that burn out.

EPK and Alumina Hydrate Start with an equal-parts recipe. It creates a very light-colored wad mark and tends to be used on lighter-colored clays. Alumina hydrate is an expensive material though. If this is the wadding you prefer, I would still use fireclay wadding for the kiln load because of the expense of materials for this wadding. The exception to this suggestion is if you are planning on also incorporating salt or soda into your atmosphere. In that case, the EPK/alumina hydrate wadding works better for the kiln too.

Shells Shells are often free, but they can be difficult to use to stabilize the pots. For this reason, they are often used in conjunction with clay wadding. Shells can be used aesthetically when you want the distinct shell mark. Unlike the other wadding materials mentioned, shells can be used on both glazed and unglazed surfaces. The easiest way to remove this type of wadding is to soak it first and then sand whatever the water does not dissolve.

Rice Hulls Rice hulls work best in more protected areas in the kiln. For example, shake some out on shelves that don't get as much fly ash or mound some inside a bowl to set another bowl on top of, as part of as a stack. Rice hulls can also be used in conjunction with clay wadding, if you are nervous about not using enough rice hulls are not sure about how protected the area in the kiln is.

Silica Wash This type of wadding (more accurately, this is a resist) works best in a more protected area in the kiln and really only works well for small applications, specifically lid seats. If you have a really thin lid or a lid seating that you are worried will warp with traditional wads, a silica wash might do the trick. Simply mix fine-mesh silica with water and brush on both the lid and the lid seat or anything that will make contact. It is a thin wash, so ensure you have a good application. This wash leaves a slightly dusty-looking appearance on the finished ware.

Drywall If you make really large sculptures and can't imagine how you would successfully use individual wads, try this material. It is nice because you can load it in like a shelf to support the work. If you are using drywall a

Making rolls of wadding to use between the posts and shelves.

Rice hulls can be used as wadding on their own or together with clay wadding.

lot in your studio, be mindful to keep a clean space. You do not want the drywall material to contaminate your clay body.

Other Materials This endless list includes quartz rocks, DIY shell-like wadding with a plaster calcium carbonate mixture, and so on. Just like your clay body, loading scheme, length of firing, and type of wood, wadding can be personalized to your preferences.

WADDING IN ACTION

You can wad ahead of time or as you load the kiln. I do a little of both. I tend to wad smaller items ahead of time to save time during the loading process, but I wad larger items and pieces I know I want to stack in sets as I load. The reason to wad as you load is because many of the shelves gain warps after being fired a lot and have uneven surfaces. If you wad as you load, the wad is still malleable, and a bigger piece will more likely sit evenly on the shelf without a wobble. To adhere a wad to your pot, all you need is a small amount of inexpensive glue.

Wad size makes a difference. Scale your wads to be proportionate to your pot size. Similarly, bigger wads should be used in zones of the kiln that are going to get hammered with wood ash, especially the floor by the firebox. If you find that your furniture is becoming fluxed to the floor or the shelves, you could also put a protective wad coil in front of those posts. When you wad stacks of bowls or plates together, make sure the wad is tall enough that the flame can easily travel between the pots in the stack; otherwise, the pots in the middle of the stack will look very dry with underdeveloped surfaces. Just like you line up kiln furniture when you're loading, you line up wads when you are stacking pots. The wads conduct heat and are weight-bearing. If they are stacked and spaced similarly within the stack of pots, you will be less likely to see warping from the wad placement.

Okay, let's shape some wadding. Here are a few options:

- Balls are the typical wad shape and are easy to make quickly and compress evenly.

Placing wadding on the bottom of a mug.

Wadding a large basin as it's loaded into the kiln.

- Logs, skis, turds, and worms are all names used for the various coils placed in lid seatings. They can also be used when you need a little more surface contact for warping or balance reasons. Two coils are also a good choice for using on top of the kiln furniture before placing the shelf and for cone packs.

- Rings and patties are the way to go if you want to close off the inside of a vessel for some reason. You can place a full wad ring before placing the lid. Patties can be used as a wide single wad and offer a very dramatic mark.

When wadding your pots, I recommend using an odd number, unless you have an aesthetic reason not to, like on a square shape. An odd number of wads balances the work better than an even number. One wad is the exception. If you want to use just one wad, make it more like a patty.

Note *Generally, wads are out of necessity, and the marks they leave are a consideration for their placement. However, they can also be used as a mark in their own right—just ensure they are placed on the pot/by the pot in a way that won't fall off during the firing.*

When you are placing the wads on the pots, you can stack any way you want; just make sure it's stable. Keep in mind that the wads are weight-bearing, so you should not wad on the thinnest part of the pot, unless your goal is to intentionally warp the piece. Also, because the wood ash fluxes and becomes a drip on the side of your piece, make sure you inset your wads slightly from the edge of the pot, so the wads do not fuse to the pot. (You can grind it off if this happens, but it's a pain.) When loading the kiln, I also recommend not placing wads in the very front. Offset it from the direct path of the flame.

LOADING A KILN

Wood-fire potters would argue that good loading is as important as good work going into the kiln. A load can sometimes make or break the firing. Indeed, my worst firings and results have been due to clumsy wadding and too tight of a load. In this section, I'll highlight some of the loading considerations to keep in mind. Take photos and notes when you are loading and unloading. Taking the extra time to do so in the beginning will help you better understand your results. You'll be able to experiment more and achieve a higher percentage of successful pots over time.

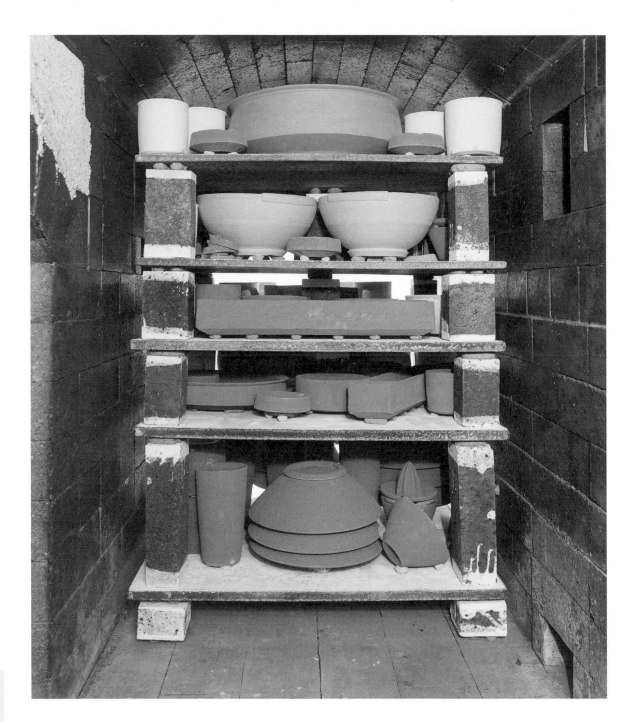

When talking about loading, I am referring to the firebox-side of the kiln as the front and the chimney-side as the back. Standing at the firebox and looking down the kiln becomes its left and right.

First, let's think about the kiln and shelf placement. This is mostly dictated by the wares you are loading, but some kilns can be finicky about the space between shelves. Some kilns prefer a more open channel, from front to back, where the flame can easily travel, while other kilns love back pressure and being packed tightly overall. With shelves and pots, always consider the path of the flame. Your decision of where everything in the kiln goes directs the flame path during the firing.

- As a rule, leave the stacking closest to the firebox looser and be mindful not to pack it too tightly around the throat arch (if applicable).

- If possible, it is good to leave a few extra inches (7.6 to 10.2 cm) around the side stoke ports to help ensure that side stoking does not knock pots over or off the shelves.

- Try to leave the same amount of space between the shelves and the kiln wall (in other words, centered between the applicable walls). If you pack too close on one side of the kiln, the other side of the kiln could heat up faster because the flame has more room, making the kiln fire uneven side to side.

- It is a good idea to stagger your shelves front to back. This bounces the flame up and down and creates more deflecting and points of interest on the pots' surface.

WOOD FIRING

Different areas of the kiln yield different results, as you can see from these juicers.

These posts have wadding in place and are ready to have shelves placed on top.

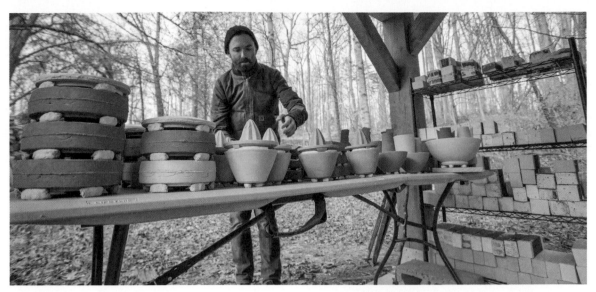
Bill Jones helping me load the kiln.

- The same odd-number rule for wadding (page 133) applies to kiln posts per shelf as well. If you are loading larger shelves, you should use three posts. With larger shelves, the only time I suggest using a four-post configuration is if you have a really large, heavy piece going on one side of the shelf that would tip it. In that case, use four (for the whole stack). If you are loading two smaller shelves to complete one shelf, they share one or two posts depending on your post configuration of four or five (for both shelves).

Note *I tend to use the five-post configuration because it lets me place two posts left and right facing the fire-box and side stoke. In both cases, with the posts on the sides of the kiln, I feel less likely to knock it out with a stoke.*

- Do not stack the shelves too close to the wares. Leave about an inch (2.5 cm) of space between the top of the piece and the underside of the next shelf. Some of the wares may be taller and shorter than this, but generally, there should be an inch (2.5 cm) of space.

STAGGER AND STADIUM

The most universal tip for loading a kiln is stagger and stadium. When you go to see a movie or live performance, what is the best seating? In my opinion, it's when there is a slight incline to the seats and the chairs in front are offset to ensure a clear sightline. This same principle can be applied when loading shelves. Ensure each piece can see a bit of the stage: in this case, the firebox is the main stage and the side stokes are side stages. Nothing should fully block anything from getting a piece of action. When you place something so that it covers half of another piece, that piece becomes part of the other's surface. The piece that half-blocks the other from the flame will show up as a surface change on the finished pot. If you come into trouble because you inadvertently made a lot of wares that are the same dimensions, you can post off hard or soft bricks to create the stadium seating.

CONSIDERING KILN ZONES

When I first started wood firing, I used to have favorite zones in the kiln. Now, I find I really love the variety between the zones and between the firings. One firing might be darker and more matte, while another might be shinier and more metallic. These beautiful, subtle (and not so subtle) variations that can only be partially predicted are one of the main reasons I wood fire. While I still have my favorite pots, I appreciate the variety throughout the kiln.

When thinking about the different zones in the kiln and loading the pots on the shelves, keep in mind the front of the kiln is going to get the most love. This area will be loaded with rich surfaces created by the fluxed and unfluxed wood ash. (Drips, rivulets, and crust, oh my!) The floor of the kiln will be full of embers and ash. Depending on how close you start your first stack or if you place pots on the floor in the throat arch or near the firebox, the bottoms of your pots could get covered. I like making really tall, narrow pots for the spot right in front of the first stack. The pot ends up representing a great visual of the different surfaces, top to bottom.

Throughout the kiln, you should not load the pots too close together. I learned this lesson the hard way, as I imagine most do, to some degree. Leave breathing room for the flame to travel around the pots; otherwise, you will be fighting to get the kiln to an even temperature front to back, and you'll end up with dry pots. While you can wad pots off each other, off the wall, and in stacks, the trick is to do this in clusters and still leave enough space. Stack the pots with wads tall enough that the nestled surfaces don't end up completely dry.

Note *Tumble stacking, in which you stack pot on top of pot on top of pot, also uses beefy wads and is more often used at the top of a stack to help fill the arch of a kiln.*

When you load on the edge of the shelf near the side stoke, leave about 2 inches (5 cm) of the shelf open and make the pots placed closest to the side stoke wider-bottomed or more stable, so if they do get hit with side stoke they are less likely to tumble. It is also a good idea to protect open forms, like bowls, and stacks of pots from the edge of the shelf near the side stoke on the lowest shelves. Pots next to the side stoke on the floor or the first shelf can get buried with wood ash. A bowl will fill with wood ash. If you make a lot of bowls or love the surface result from this zone, simply flip the bowl and wad it upside down on a post. This protects the inside of the bowl. The same rule applies for stacks. If the forms being stacked won't collect and hold the ash, they can also be more successfully loaded on the edge of the shelf.

When you think about where to place glazed ware, it truly depends on the glaze. This is something you will only work out after a few firings. The glaze I use most often is a Shino glaze, and I can appreciate the results anywhere in the kiln. In the front, it handles the wood ash really well; at the top, it gets a really nice shimmery finish; and in the back, it gets dark and subtle. I use this glaze for its versatility and how it interacts with my iron-rich stoneware. It's simply a matter of getting to know that glaze in a particular atmosphere.

Ted Neal | Train Kilns

The train design is a worldwide phenomenon in contemporary wood fired ceramics and there are now hundreds of these kilns across the globe. I believe at the heart of their popularity is ease of building, easy and efficient firing, and the potential for dramatic wood fired effects that is often associated with larger wood kilns.

The design for the train kiln comes from John Neely, Professor of Ceramics at Utah State University. I studied under John while completing my BFA degree and subsequently returned after my MFA to work as his studio coordinator and technology instructor. Over the years, I have been a part of building several generations of the kiln at USU and have now built dozens of them throughout the United States and Canada. Although I have several wood kiln designs in my building repertoire, the train is the most requested design.

There are several factors that make the train kiln unique. The form of a train kiln is, in simplest terms, an elongated horizontal box with an elevated firebox at one end and a chimney at the other. This is vaguely like other types of wood kilns with a few key differences. The first difference is a level floor from the front to back of the kiln in the ware chamber, whereas other kilns often feature a sloped or stepped floor.

Additionally, the firebox employs a stepped floor grate that ramps down toward the ware chamber with an air supply built into each step. This element is critical to the design as it gives a great amount of control in efficiently dealing with the coal bed, allowing for selective opening to manage buildup without raking. The checkering of the air holes into the firebox and coal bed respectively allow for the precise management of a responsive kiln.

Another part of the design is the elevated firebox. The unique position of the firebox in relation to the setting allows primary air to enter the firebox on top of the wood, which is then

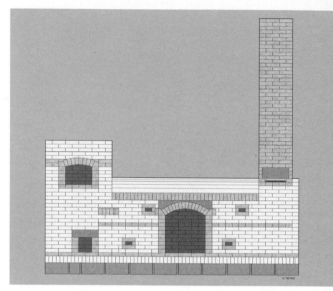

Ted Neal, small train side. *Photo courtesy of the artist.*

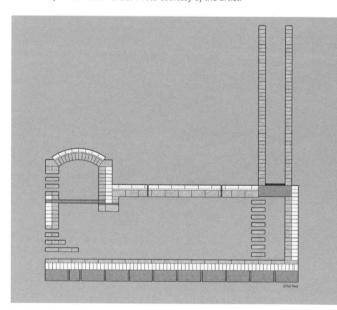

Ted Neal, small train center cutaway.
Photo courtesy of the artist.

drawn downward through the fuel and into the ware chamber. Wood is held in position by hobs on the front and back wall of the firebox and a pair of steel grate bars. This orientation is critical as it works with gravity and promotes greater ash deposition.

Ted Neal, *Silo*, metal attachments, fired in a small train kiln, reduction cooled. *Photo courtesy of the artist.*

FIRING

I have built and enjoyed firing many kilns but choose to fire the bulk of my work in a train kiln. I know the kiln instinctively: I enjoy how easy it is to adjust and how responsive it is to those adjustments. I have had many other wood fire potters join me over the years. The ones who have never fired a train kiln before are generally surprised at how easy the kiln is to fire and how nonchalant I am during the process.

There are many beautiful kilns out there that are also amazing and easy to fire. I suppose the biggest difference I feel in the train is its efficiency. Similarly-sized smaller wood kilns that can be fired quickly are frequently bereft of wood-fired effects. The train seems to maximize these effects while still consuming less than average amount of fuel in doing so.

In the end, the biggest reason I fire the train is that it continues to give me surfaces that suit my work and keeps me excited about the process. I imagine that can be said of any kiln that does the same.

ADVICE

There are literally hundreds of little things that I have learned over the span of 20+ years of kiln building that have become part of my building process. It would be nearly impossible to outline them succinctly as it falls into the minutia that happens while physicality dealing with the materials during the build and would require a whole book to adequately describe. The best way to learn is to volunteer to work with someone who is an experienced builder and take notes. My only real recommendation is to do your homework.

FIRING

If this is the first firing that you are leading, I recommend having your kiln log (see page 186) ready to go, and your target temperature goals clearly marked through quartz conversion and red heat, roughly 1200 to 1300°F (649 to 704°C). If you feel more comfortable and have several firings under your belt, you can also set these goals during the first firing shift. The first shift on a wood kiln has become a favorite of mine. Along with starting the fire, it is a great shift to better seal your door, clarify goals on your kiln log, and organize for the fire to come. If you have young kids who are interested in what you are doing, this is also the safest time for them to be around the kiln, and it's a nice time to include them in what you will be spending days doing.

FIRING START TO FINISH

Your kiln is loaded, your thermocouples and pyrometers are set, your wood and side stoke wood are prepped and ready to go, you have your kiln log on hand with a watch or clock nearby, and you have volunteers ready to help you, if need be. In the case of working with volunteers, I recommend organizing kiln shifts anywhere between four to eight hours. During a shift change, I recommend that the leaving shift stays on an extra twenty minutes and the starting shift arrives twenty minutes early. This lets both people explain and show what they are doing to keep the temperature gradual and controlled. I recommend shifts that last four to eight hours because it takes at least an hour to really understand what you are doing on a shift. Plus, if you change shifts too frequently the kiln can quickly stall out, because everyone is too new to the firing. I recommend not going longer than eight hours because volunteers get tired, which can result in not being able to keep up with the fire. Generally, I tend to use help in six- to seven-hour shifts.

Checklist:

- Kiln is loaded

- Door is bricked up

- Damper is opened appropriately

- Primary and secondary air ports are bricked

- Cone pack peeps and side stoke ports are bricked

- Thermocouple and pyrometer are set

- Wood and side stoke wood is prepped and ready

- Small scrap wood, small to medium twigs, small side stoke pieces, paper, and a hand torch are organized to start the fire

- Kiln log is on hand with a pen or pencil and watch or clock

- Water and snacks ready, and maybe some coffee

- A comfy seat for you and anyone else who might join you

- Volunteers know their shifts and you have their phone numbers

- You are wearing only natural fiber and closed-toed shoes

- You have notified your neighbors and fire station, if need be

- Lights are ready to go for when it gets dark (or a plan in place for this)

- Leather gloves, welding gloves, and welding glasses on hand

- You are well-rested and ready to go!

Similar to how you would start a campfire, you should start this fire with small pieces of wood, newspaper or cardboard, and a torch. You can get away with using matches or a lighter instead of a torch, but the torch ensures you won't need to start it over and over. With some kilns, you may need to take a few extra bricks and build a small stoop outside the kiln next to the primary air ports. For other kilns, you'll build a small fire just inside the primary air ports or bottom firebox door. Either way, go slow and steady. Your goal is to slowly push the fire inside the kiln. You should also try to keep your flame short in the beginning, introducing enough air to keep the fire going and start the kiln drawing.

Depending on your kiln load, whether you have greenware or bisqueware, and the size and thickness of your wares, your temperature goals per hour will vary. Usually, you can safely follow a schedule like the one on the next page.

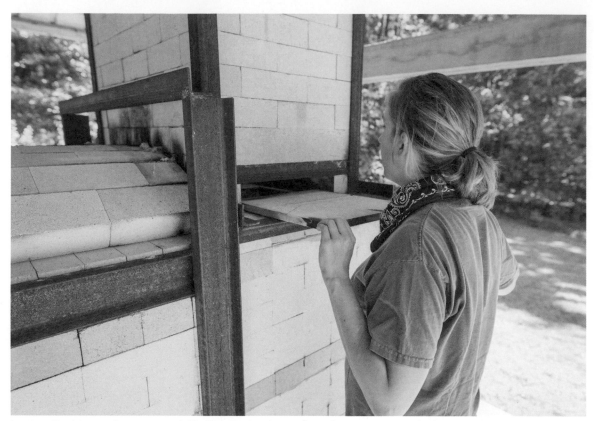

I reopen the damper after a successful body reduction. I start the reduction once cone 08 has gone down in the front of the kiln and then stall the kiln for 45 minutes to an hour.

50°F (28°C) an hour until 500°F (260°C)

75 to 100°F (42 to 56°C) an hour until 1000°F (538°C)

100 to 150°F (52 to 83°C) an hour through quartz conversion and red heat (1200–1300°F [649 to 704°C])

150 to 200°F (83 to 111°C) an hour to your holding temperature

As you can see, even after 1200 to 1300°F (649 to 704°C), I still keep it rising around 150°F (83°C) an hour, as I've found that warping is an issue if you go too fast. You'll figure out that at somewhere between 800 to 1000°F (427 to 538°C)—usually closer to the higher end—your main firebox will be hot enough to start burning wood on top of the grate bars. To make the transition on top of the grate bars, place a medium (dry) piece of wood on the bars and

see what happens. Does it start smoking and burning rather quickly? If so, you are ready to start transitioning. At first, you will want to place several pieces on the grate bars and several under the grate bars. With a train kiln, you can either toss them through the grate bars from the top or continue to feed through the lower firebox. I generally toss them through the top.

When you transition to on top of the grate bars, you also want to shift where your kiln is drawing air from. Your primary air ports are now up high with the main firebox, and the air ports below are considered secondary. You want to draw air across the wood on the grate bars to help burn the wood. Your kiln will naturally drop upwards of 200°F (111°C) during the transition from bottom to top and maybe stall for half an hour as it gets used to firing on the grate bars. This is normal and should be expected.

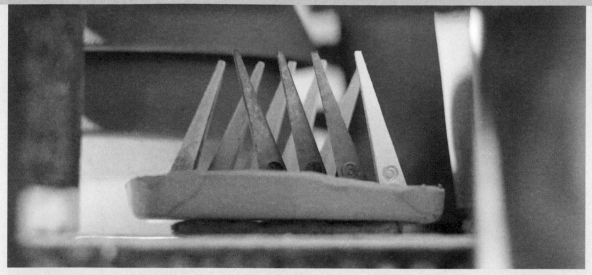

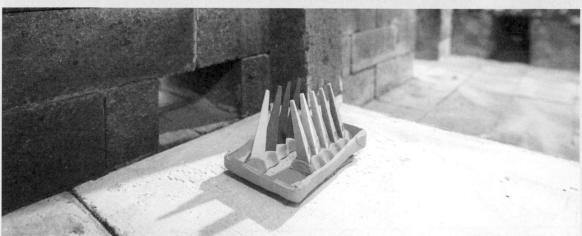

For your cone pack, start with more cones and as you get better at reading the kiln's other cues, shrink the number of cones in your cone pack. To start, I suggest having a body reduction cone (08), a side stoke cone (1), an early cone to see where it is getting hot first, in terms of even firings (3, 5), a surface development cone (7), cones to keep track of temperature control (8, 9, 10), and a safety cone (11). If you plan on going hotter than cone 10, I recommend including a safety cone that is one cone hotter than what you plan to go to. When placing your cone packs in the kiln, it is important to place them a few inches (7.6 to 10.2 cm) away from the port for a better read. If they are too close to the port, the regular introduction of cold air when you read your cone packs will affect their ability to indicate the correct temperature. The number of cone packs in your kiln is also up to you. I suggest having at least one in each zone: front, back, middle, top, and bottom. Of these, it is also a good idea to ensure that there are a few on the left side of the kiln and a few on the right side of the kiln. This will help you know if your kiln is firing even top to bottom, front to back, and side to side. Additional information on how to make cone packs can be found (on page 21).

WOOD FIRING

Towards the end of firing, I check the kiln log to make sure I have a good 8 hours at or above cone 7 throughout the kiln, then decide when to start the cooling process. Having this amount of time at high temperature helps build the wood fire surface on the pots.

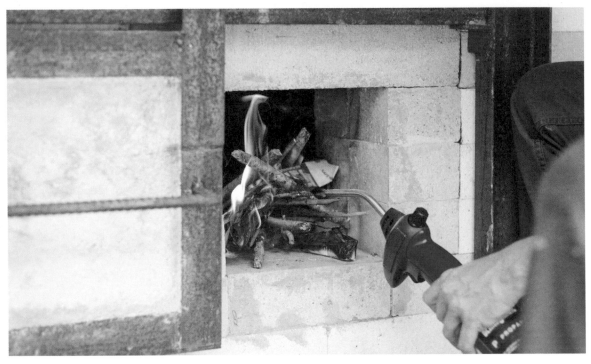

I start my kiln with a small fire just inside the door of the bottom firebox.

During the first shift on the kiln, I take the time to better seal the door by filling the gaps with small bits of insulating fiber.

BODY REDUCTION

I generally go into body reduction after cone 08 has dropped in the front of the kiln. I do this for the clay, but also for the kiln. Most of the firing is spent gaining temperature, and I find that I have a more even firing if I take an hour between cone 08 and cone 1 to stall the kiln.

To put the kiln in reduction, shut all the primary and secondary air ports, stoke the firebox, and push the damper in until you see a little back pressure. Once you see back pressure, pull the damper out a bit until the back pressure goes away. You should now be in body reduction. You will smell the typical reduction smell. If you are not familiar with the smell of reduction, you only need to smell it once to know it from then on. It essentially smells like a sulfery gas, and you can even taste it a little. This should not be a strong smell. If it is overwhelming, open the damper a little more to reduce the smell. The flame will also be softer and dance more, and the temperature in the kiln should drop some and begin to stall or at least climb more slowly. If the temperature keeps dropping, pull the damper out a bit more. You don't want to lose too much temperature during this phase, and a small climb is okay too. During this phase in the firing, you will stoke the firebox less often than you were previously. Your stoking will increase again once you come out of body reduction.

Note *Back pressure refers to pressure created in the kiln because the flame is not able to efficiently exit. In this case, it is because we are closing the damper some and closing the primary and secondary air ports. What you are looking for is flame coming out of the primary air ports or firebox door.*

To come out of body reduction, put the kiln back to how it was operating before body reduction. Reopen any primary air ports that were open, and reopen the dampers. I generally open the damper slightly less than it was in the beginning of the firing. In the beginning, your damper could be all the way open. At this point, it is several inches (17.8 cm) closed on each side.

Coming out of body reduction, you are only a short way away from a good target holding temperature of 2000 to 2200°F (1093 to 1204°C).

SIDE STOKE

If your kiln has side stoke options and you plan to do so, I like to start side stoking as soon as the kiln starts burning well in the side stoke aisle. You can start checking this when cone 1 starts to move in the cone packs closest to your firebox. To check, open the bottom side stoke port closest to the firebox and slide in a piece of side stoke wood. Does it immediately catch fire? If so, the kiln is ready to side stoke. If you have multiple side stoke ports, do this check with each bottom port. Generally, you will start side stoking the front of the kiln first and work your way down the kiln until all side stoke ports are active. At this point, you will start cycling firebox stokes with side stoke stokes until your temperature rises to the point you want to hold and fire for surface developement.

From here on out, you should keep side stoke in the cycle of firing the kiln. This does not mean you will always side stoke, but rather that you keep it in mind. There are two main ways to side stoke. The method referred to as "side stoking" is when you quickly—but gently and keeping the wood straight—toss in pieces of wood that fall to the bottom and burn low. The second method is called "wicking." When you wick, you fill the top side stoke port with wood, push it in as far as it will go without dropping, and let it burn high in the

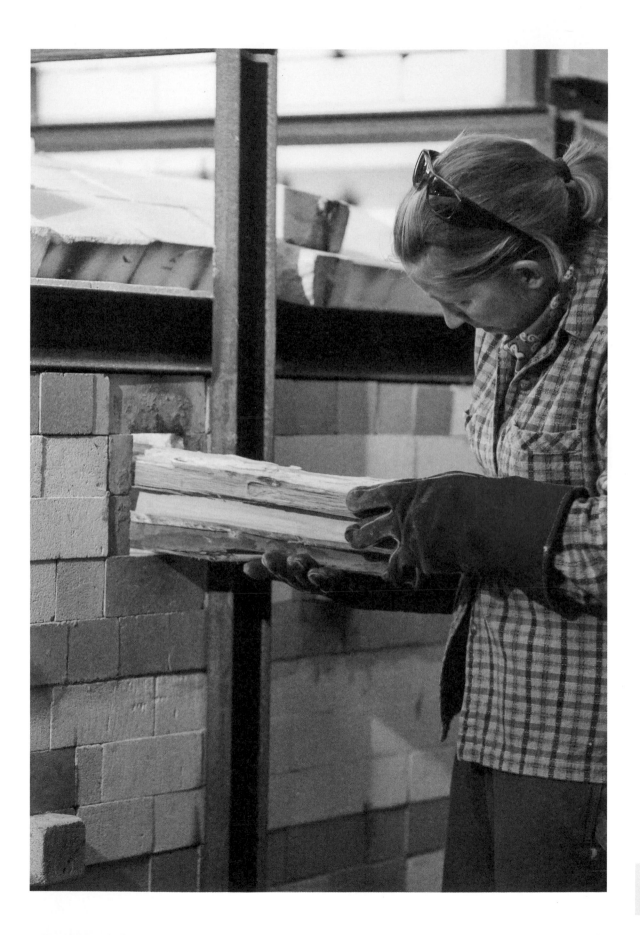

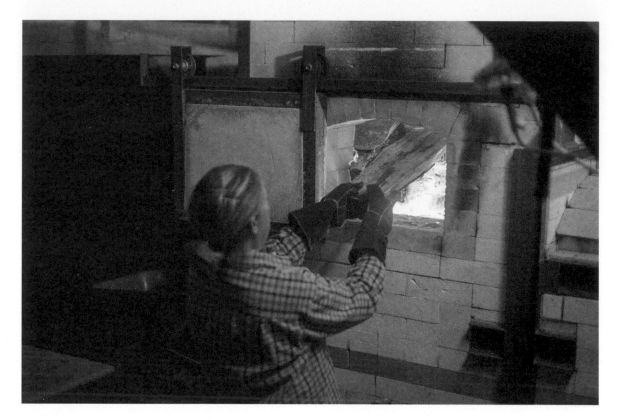

port itself. Essentially, it allows you to combust high and low at the same time. Wicking is great when you have a cone pack in the middle or top of the kiln that seems cold. It is also great for surface development in those same zones.

Even if your kiln has a side stoke option, you don't necessarily have to side stoke. Maybe you want more subtle surface results, more flame work, or need the side-stoke aisle for stacking pots. I recommend using the side stokes if a kiln is designed with them, but after a few firings and more knowledge on how the kiln fires in general, feel free to experiment by not using the side-stoke aisle for stoking.

HOLDING TEMPERATURE

I generally hold my kiln for eight hours around 2100°F (1149°C). I like to hold at a slightly cooler temperature than some wood-fire potters because I use an iron-rich stoneware and don't want any cone over 10 going down throughout the kiln. Other wood-fire potters might hold at lower temperature if they want to fire at a lower peak temperature than cone 10, while others will fire hotter, holding at 2200°F (1204°C) and firing to a peak temperature of cone 12. I find eight hours generates a good development of ash on the surface of my pots.

The length of time and temperature at which you hold your kiln at are great areas to experiment. If you glaze a lot of your wares, maybe you don't need to rely on the wood for surface development as much—and you don't hold at all. Or maybe you want to see what happens when you hold for a full day. The key to holding your kiln for surface development is that the wood ash is hot enough to flux on your pot. I recommend not holding any lower than cone 7 for this reason. I also recommend not holding any hotter than cone 9 if you want to hold for a longer period. Clay responds to time and temperature. If you hold at cone 9 long enough, the clay feels like it reached a temperature of cone 10 or 11.

To make the mudding to seal your kiln you need goopy reclaim clay and playground sand. You can use silica sand, but playground sand is cheaper and available at the hardware store. Fill half of a 5-gallon (19 L) bucket with your goopy reclaim clay and add about half that amount of sand. I typically just mix it with my hand and work it until the sand is fully incorporated. The sand helps with the shrinkage, so when you neatly trowel it on your hot kiln when it is time to seal, it will not crack off when it quickly dries. By hand-mixing it, you will also gain impressively baby-soft exfoliated hands and forearms. It's a real crowd pleaser!

If you don't have any goopy reclaim clay when you're ready to mix, you can make it by filling a 5-gallon (19 L) bucket almost full with dried clay reclaim you have on hand. Then, fill it with water,

making sure you cover all the dried clay. It must sit at least twenty-four hours in order for the clay to get soft enough to make the desired consistency.

After everything is sealed, I start to push in the damper. Depending on your final stoke, it might take up to twenty minutes to work your damper in all the way. If you have a really strong flame because of large final stokes, push your damper in incrementally. There is no reason to close your damper too soon and create tons of back pressure in your kiln, shooting out flames. If you see this, open your damper until it goes away and slowly work your damper shut again. Once your damper is shut, your firing is over. Congratulations! At this point you can either go home or, like me, down fire your kiln in reduction. Either way, you are in for a much calmer time.

Once the primary and secondary air ports are shut and the firebox door has been bricked and mudded, I start to slowly push in the damper. While moving the damper into position, I watch the firebox for smoke. Once I see smoke, I stop pushing the damper in. I repeat the process as many times as I need to, waiting 5 to 10 minutes between each push.

Bricking up the firebox after the final stoke.

FINISHING THE FIRING

You are at the end of your scheduled firing if, when you look into your kiln, the clay around the cone packs looks glossier, from either the glaze getting to temperature or a good development of ash from the wood. At this point, it is time to call the final stoke, close the damper, seal up the kiln, and go home.

Ending your firing on a hot note, with high coal beds, low coal beds, or a big final stoke in the firebox and/or side stoke aisles is a personal preference. I like to end on a big stoke because I plan on firing down in reduction (as described in chapter 6) and want to start the reduction with a big stoke. Other potters I know really like a hot finish, ensuring that the wood ash is nicely fluxed out on the pots. You will find your own preference with experience. Once you have decided to end the firing, it is time to seal (and/or brick) the firebox, seal all the cone ports and side stoke ports, and seal any clear gaps in your door. Again, with time and experience, what you seal might also change. You seal with a mudding mix made of reclaim clay and sand. It should be the consistency of warm icing. I like to use a trowel to thinly apply the mudding in the cracks, but anything that works to get it on, works to get it on.

COMMON QUESTIONS & CONCERNS

My kiln won't draw.

In some windy areas, I have known potters who need to create a second fire in the chimney to help draw the heat through the kiln. This is not possible with all kiln designs and is not really necessary. It might just take a little longer for your kiln to start fully drawing if you are in a windy area. You should also think about ways to shelter the kiln to eliminate the problem.

The other reason your kiln might not be drawing properly is the load. If your kiln seems to have issues gaining temperature in the back or is stuck in a permanent stall, the load may be too tight and there is no clear path for the flame to travel. If you have fired your kiln over and over and still are not happy with the temperature gain in the back of the kiln or the draw of the kiln, it could be the kiln design. Try adding a little height to your chimney to make the pull stronger.

Why is the kiln stalling?

You know your kiln load is good, you know your kiln design is good, and you are doing everything you know to do to gain temperature. Yet, the kiln is stalling. With the other variables covered, it comes down to fuel and air. You need more or less fuel or more or less air.

- An easy check is to slightly open your firebox door and watch the pyrometer: is the temp going up or down? If the temp is going up, then open up an air port. You have too much fuel and not enough air. If the temp is going down, your stokes are not big enough. On the next stoke, add two or three more pieces.

- As you are trying to gain temperature, it is also helpful to vary the size of the wood for each stoke. If you mix larger pieces with medium and small pieces, the temperature gain is more even. If you use pieces all the same size, your temperature gain will spike up all at once and then drop faster. This is more critical as you try to gain temperature.

- Every time you put wood in, the kiln will naturally drop in temperature. As the wood starts to combust, the temperature will slowly rise. These fluctuations are part of firing with wood. Deciding when to stoke next depends on whether you are trying to gain temperature or hold the kiln in a temperature range to develop the surface of your pots.

This cone won't go down!

Generally speaking, your kiln is doing great. But there is one cone pack that seems cold.

- Is it surrounded by embers? Stop side stoking and burn the embers down; the cleared area will get hotter.

- Are you able to better direct the flame in that area by wicking with your side stokes? Wicking means you burn the wood in the side stoke port without pushing it in fully. It burns the wood high, helping bring heat to the top and middle areas.

- Is it too close to the wall of the kiln? Cool air from outside the kiln is being drawn in and the cone pack is in a cold spot—next time, set it a little further back on the shelf.

- Is it set behind a piece of furniture or large pot? It could be missing the flame because it is being blocked by something in front of it. Next time, double-check that is it not being blocked.

- Is your damper open enough? Try opening your damper, which will strengthen the overall draw in the kiln.

Oh no, all the cones are dropping!

Try reversing some of the previous tips:

- Stop wicking.

- Build up an ember pile.

- Push the damper in a bit. This works best for the back of the kiln.

- Drop your holding temperature. Clay reacts to time and temperature. If you hold a temperature for long enough, over time the clay acts like it has reached a hotter temper. By dropping your holding temperature by 50°F (10°C), you can hold longer before cones begin to drop.

My kiln has a mind of its own. It keeps getting hotter and hotter!

There are two ways to fix this: add more fuel or add less fuel. This depends on your kiln design, or what you are looking for in your results. By adding more fuel, you add more fuel than your kiln can efficiently combust, thus stalling and dropping the temperature. If you do this and your firebox is full and you are being generous with your side stoking and the temperature is still on a rise, close some of the air ports. Is it still rising? Close your damper a bit.

The other method is to let your temperature drop by adding less fuel. I don't like to let the grate bars get empty, so it might also mean closing some of the air ports to ensure you can keep wood on the grate bars.

UNLOADING & EVALUATING A FIRING

You have finished firing and had time to rest (and/or worry about your pots in the kiln). Now, your kiln is cool enough to unload. Get ready to reap the rewards of all that hard work!

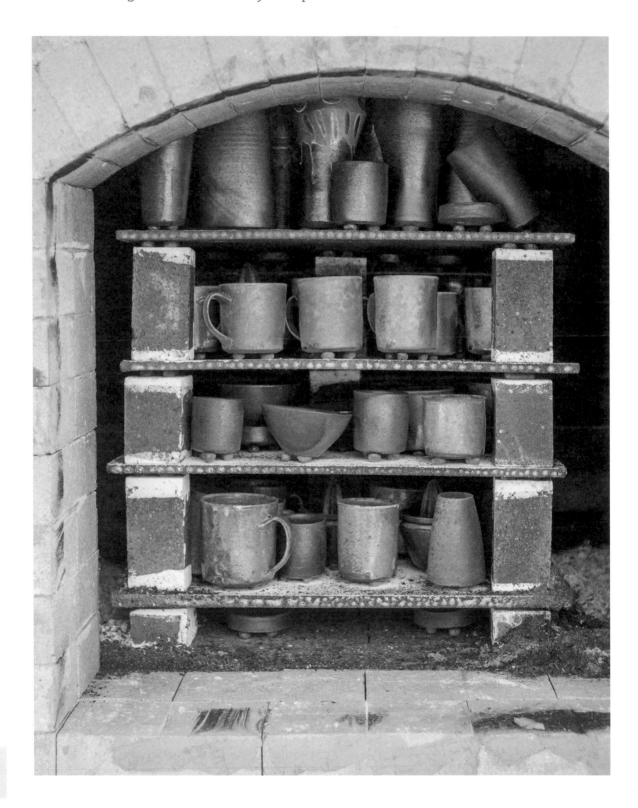

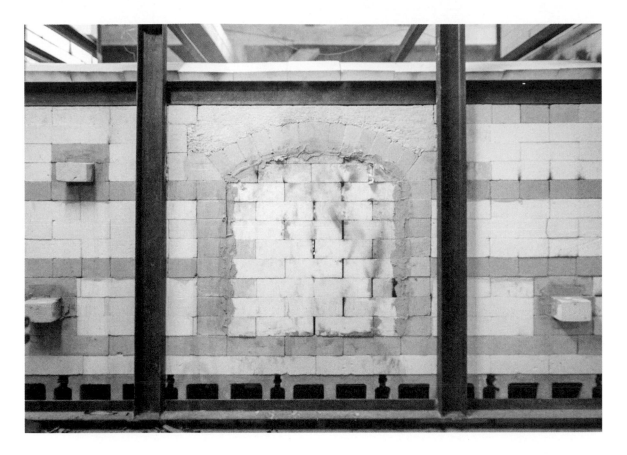

When you start unbricking your door, be prepared for the first few bricks to be a little stuck. As your kiln heated up and cooled, it expanded and then contracted. And you did seal your kiln while it was hot. Because of this, it takes a little patience to get those first few soft bricks loose. I like to use a fettling knife or the edge of a trowel to help scrape off the mudding and clear the first couple of bricks. As you unbrick your door, it is good practice to have the door in a spot that you can keep it well organized, saving you the headache of finding your door bricks the next time you are done loading. There are often at least three rows in an arched door that are specialty cut with a brick saw when you are building the kiln. Taking time to be organized with your door saves time and headaches in the long run.

Now the brick door is down and you are ready to start taking out your pots! Remember to photograph each stack before removing a pot. This documentation will pay off tenfold

when you start to think about the next firing. As long as your pots are cool enough, there is no reason to wear gloves. By unloading pots with bare hands, you are less likely to drop them. However, when it is time to remove the shelves and posts, I recommend putting work gloves on. Sometimes, the edges of the shelves and posts can be sharp. When I unload a kiln, I like to get as many of the pots out as I can before removing a shelf. Sometimes, even with kiln wash and wadding, the posts stick to the shelf and need to be wobbled a bit. If a post should drop or a shelf moves in an unexpected way, it's best if most of your pots are already safely removed.

Depending on the amount of ash, it might be a good idea to gently sweep the ash in the side stoke aisle before unloading beyond the aisle. I recommend always using a metal dustpan to be on the safe side, in case there are any hot embers. For each stack, take the time to photograph your results. This does

two things. First, it accurately documents the results for that area of the kiln and is a good comparison for the before photos. Second, it allows you to hold judgement for that pot and that area of the kiln.

Hold your judgment until you clean your pots and get to see them individually. I don't know anyone who loves the results as they are unloading the kiln. There is too much to think about, too many pots all together, and it's not easy to see the beauty and nuance each pot has to offer.

Generally, pots around the firebox and the floor of the side stoke will be crustier, with more wood ash accumulation, while pots higher up in the kiln will be hotter, shinier, and have more flame action. Beyond the zone that you are unloading, if you notice any flaws on your pot, hopefully it will not be too hard to identify the causes. Here are some common troubleshooting tips:

- There is warping everywhere, and there is bloating too: It's your clay body. For one reason or another, your clay body does not like your firing. It could be the length of the firing or your peak temperature. You need to either change your clay body or change your firing.

- Many pots have tacoed, and there are cracks on the front side of bigger pieces: You might have gained temperature too quickly. Next firing, gain temperature at a slower rate.

- The wads have warped the pots: Double-check that you are wadding at the thicker areas of the pots. If you stacked pots, did the wads align with each other and/or the thicker areas of the piece? It could also be that you did not use enough wad for a given space. If you used three wads and it warped, try increasing the surface contact of those three wads or upping the number to five.

- All the wads fused to the pots: You did not inset the wad enough, or you wadded on a glaze.

- The wads are really hard to clean off: Try using cleaner sand (e.g. course silica sand, instead of playground sand) and double-check that you used fireclay or the correct materials in your wad. Sometimes, a simple change can make a huge difference.

When it comes to troubleshooting and firing in general, I strongly suggest talking with someone who fires a kiln similar to yours. Wood fire and ceramics is a strong community for a reason. Potters and artists with more experience are almost always willing to share what they know and help.

GALLERY

All photos courtesy of the artists.

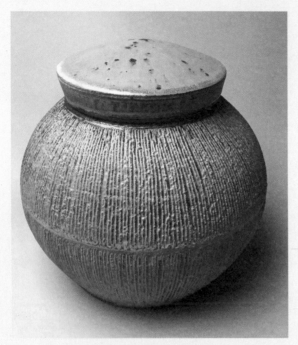

Liz Lurie, *Jar*, wood fired, reduction cooled.

Courtney Martin, *Grey Platter*, wood fired.

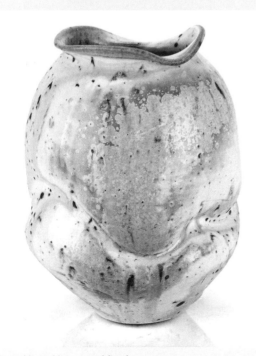

Perry Hass, *Vase*, wood fired.

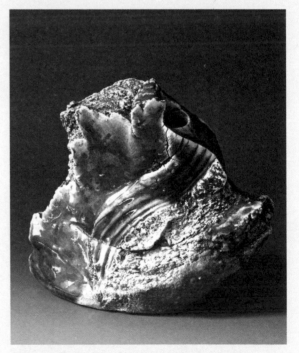

Akira Satake, *Sculptural Vase*, wood fired, reduction cooled.

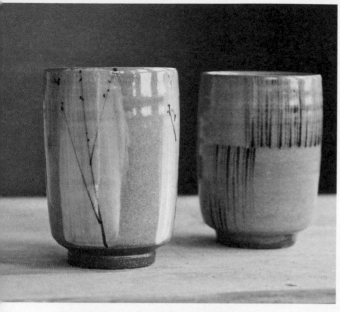

Betsy Williams, *Two Cups*, wood fired.

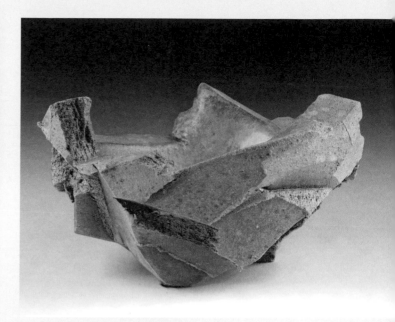

Lars Voltz, *Crust Bowl*, wood fired.

Trevor Dunn, *Splined Gear*, wood fired, reduction cooled.

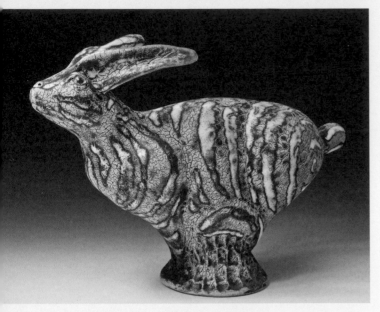

Ken Sedberry, *Rabbit*, wood fired.

Jonathan Cross, *Core V*, twice fired, soda kiln, then wood kiln.

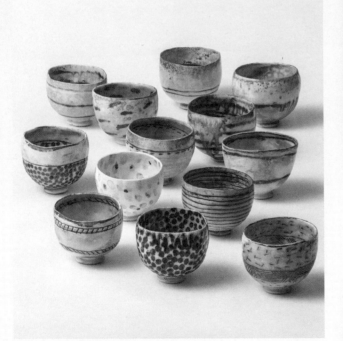

Priscilla Mouritzen, *8 Bowls*, wood fired.

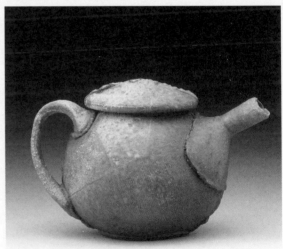

Daniel J Murphy, *Tea Pot*, wood fired, reduction cooled.

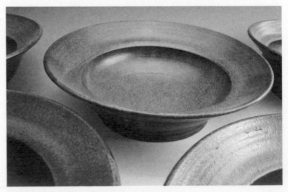

Jane Herold, *Pasta Bowls*, wood fired.

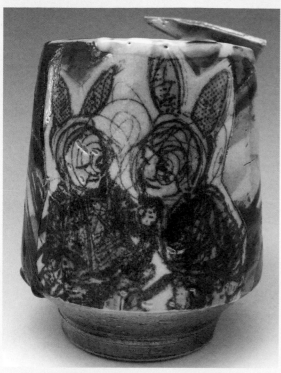

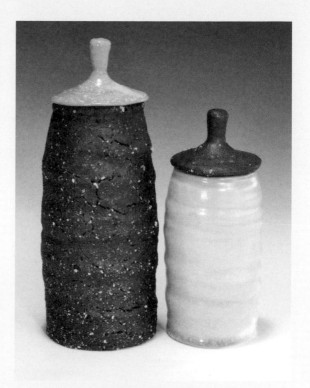

Israel Davis, *Bunny Ears Dreaming*, wood fired.

Sandy Lockwood, *Black and White Series*, Jars, salt glazed, wood fired.

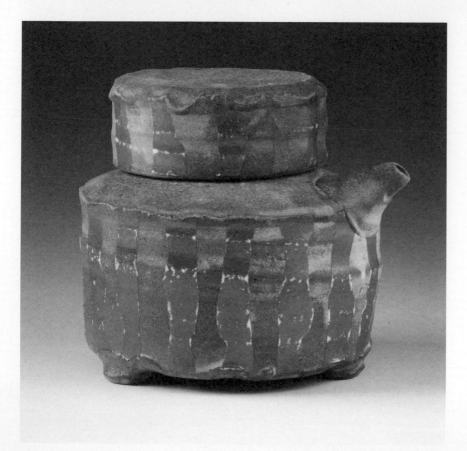

Linda Christianson, *Red Striped Ewer*, wood fired.

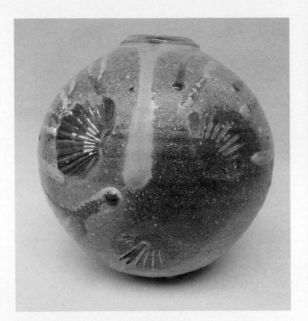

Daniel Lafferty, *Moon Jar*, wood fired.

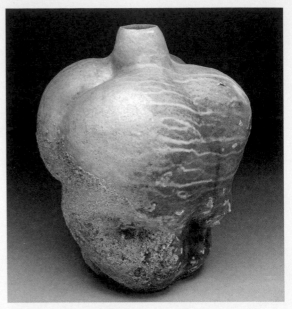

Ted Adler, *Vessel*, wood fired.

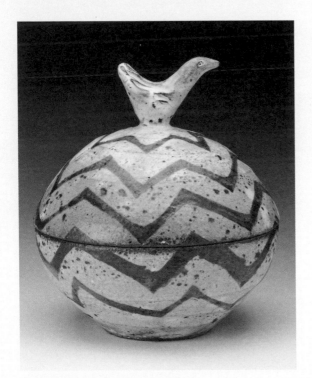

Hunt/Dalglish, *Animal Jar*, wood fired.

Liz Lurie, *Carved Bowl*, wood fired, reduction cooled.

Zoe Powell, *Small Divided Bowl*, wood fired, reduction cooled.

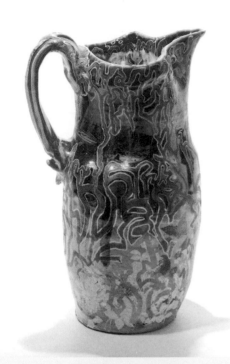

Henry Crissman, *Porcelain Vessel*, wood fired mobile anagama

Ted Neal, *Spice Jar,* wood fired, reduction cooled.

Donovan Palmquist,
Cassoulet Pot, wood fired

6

FURTHER EXPLORATIONS

I AM CONTINUALLY INSPIRED BY THE resourcefulness and inventiveness in our field. As a community of makers working within a traditional craft, we are always looking for ways to express and discover something new while working with what is in front of us. We utilize local resources, dig our own clay, reuse found materials, upcycle old materials, repurpose tools, and continually welcome new information, adjusting our process and firing. All the while, we invite others to participate and freely share failures and successes along the way. As permanent as clay becomes when we fire it, this does not seem to hinder how adventurous we are in approaching the process of getting to that final object.

Problem-solving is probably my favorite part of the whole job of being a creative: Taking a new idea through sketch, maquette, and final form; and working on new clays, firing with new people and new kilns, and experimenting with something new in the kiln. I am motivated by the potential of making something better than has been made before, and I enjoy the details of the process that come from working with my hands. In this chapter, I'll cover simple modifications you can try with your own firings that will alter your results in both big and small ways, supporting your studio problem-solving.

I will also look at fire from the perspective of performance, rather than a means to an end, by highlighting artists who are challenging what we think of as a kiln. Looking at their creative and thought-provoking approach might inspire a new idea or process in your own studio or backyard. Who knows: you might be the next artist to go from pit fire to fire sculptor!

FUEL SOURCE

Sometimes changing a fuel source is by choice, and sometimes it is by circumstance. Either way, it aids you in discovering what other results are possible from your firing. This can be an easy adjustment to diversify your results. Start keeping track of the type of wood (or sawdust) you are using and group similar types of wood together or change the kind of wood you use entirely. This might change the overall amount of wood you use to get to a specific temperature, the size of your coal beds during the firing, and the characteristics of the fluxed wood ash on your pots. You could also try using green wood in the hotter part of the firing or soaking some of the wood in a water solution mixed with salt or potassium. For example, I have found that green wood creates more iridescent results in the back top of the train kiln and also reduces the smokiness of the firing itself.

In pit firing and barrel firing, driftwood is used because the salts dried in the wood subtly help promote vaporizing in the results. By soaking wood in a saltwater solution and then drying the wood out, it could act like driftwood. Try testing different ways of introducing salt to a pit firing and record how it changes the results. Experiment with spraying a salt solution on the sawdust and drying it out before using, or sprinkle table salt, rock salt, or salt pellets in before and/or during the firing.

Using waste materials around you will reduce your cost of fuel and could also offer something interesting on the surface. There are several potters who use pallet wood and designed the size of their firebox around the size of the pallet wood for minimum wood preparation. You could experiment with finishing your kiln with waste oil from local restaurants using a simple burner system;

recently, there have been quite a few advancements to these burners.

Other interesting fuels that have been used and tested to varying degrees of success include: wood pellets, grass pellets, bamboo (lots of silica), and methane gas (in relation to landfills). If you look to other industries and the recycled and renewable fuels and energies they commonly use, an idea might "spark"— solar, wind, hydrogen, hydroelectric, and food waste. This might sound impossible now, but years ago, no one would have imagined there would be a microwave kiln either.

Coal can also be used. Historically, coal was commonly used to fire kiln loads; today, however, because it is a dirtier fuel with more toxic emissions, it is used in smaller quantities. If you want to experiment with using coal, you can add it to your pit fire, use it inside saggars, or add it for effects in the wood kiln stoke aisle.

FRAMEWORK

The shape of your kiln, your wares, and your loading patterns control the path of the flame. By adding or eliminating nonsupporting structures in your kiln, you can change the flame's ability to deposit ash and/or wrap around your wares. A "bag wall" is commonly built between the firebox and the ware chamber to soften the buildup of ash on the pots closest to the firebox. Generally, it is a checkered pattern like the ones shown here.

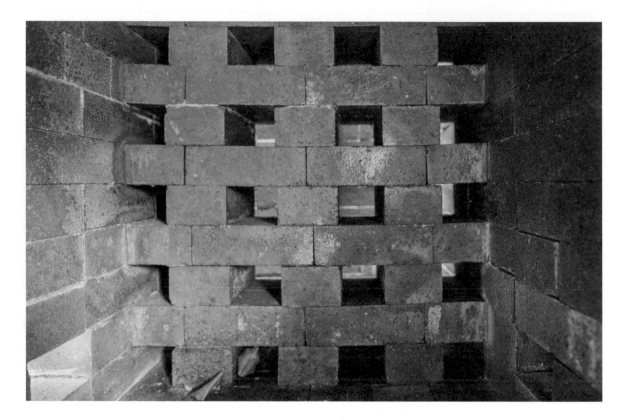

This pattern, while protecting the wares, is also open and lets enough heat through so that the temperature should not be greatly affected. While this wall is usually parallel to the firebox, it could be interesting to build it at an angle, directing the flame toward some pots, while protecting others. This same idea can be used throughout the kiln to direct the flame or protect wares. Note that if you leave a bag wall up and fire a kiln enough times, the wood ash will seal the bag wall in place. If you like the idea of adjusting and readjusting, check that you can easily remove your bag wall or use a refractory between the layers of bricks. In a pit fire, you could build open bag wall saggars to nestle pots into to try to create subtle surface patterns. It could also be interesting to see how the results vary if you change the thickness of the brick you use for the bag wall. Using bricks that are narrower than typical width (as long as it is still stable) could change the pattern mark.

Another framework addition to the firing are saggars, which can both protect the pots inside them and create unique micro environments. I have covered the basics of saggars in chapter 4 (page 98), as they are commonly used in that firing method. However, they can be used in any firing type. For example, featured artist Patricia Shone shares her technique of using closed saggars with charcoal in her wood kiln.

With that in mind, let's run through a few other ideas about how to use open and closed saggars in larger kilns. A common example of using an open saggar is placing a pot inside another pot. The outside pot acts as an open saggar. This is common practice when loading a wood kiln, and it's also a great way to experiment with different materials for wadding, a new clay test, or anything else on a smaller, more protected scale. Just like the bag wall, open saggars can also have various cutouts in the wall, depending on what your intention is. Gallery artist Israel Davis (page 165) uses the shields and baffles he creates to protect his more decorated work in a wood kiln. Sometimes, these baffles are part of the final piece. I always enjoy being able to "read" a pot and try to figure how it was placed in a kiln, as well as how the surrounding objects influenced the marks on the surface of the piece.

Both open and closed saggars can be made in any size you need. Closed saggars are shut off with a lid or by placing another saggar of the same circumference on top. In either case, stacked saggars with a lid require either wadding or a refractory wash between the top and bottom to make it easier to unstack and unload after the firing. If you are using wadding, make sure you use a full ring of wadding, keeping the saggar closed.

I want to mention wadding or refractory wash for another reason. Even if you are not fueling your kiln with wood, the combustibles inside the saggar could also affect how easy it is to remove the lid. Wadding or brushing on a refractory wash on the lid seating of a closed saggar is generally a good habit. This is more important at high-fire temperatures (above cone 7). I should also mention, if you make your own closed saggars with a refractory clay, be generous with the wall thickness. You want to be able to use the saggar over and over, and it should be stable enough to last a long time without warping.

Portable kilns are either made simply enough to be quickly constructed after they are transported to the site intended for the firing or small enough that they can simply be carried. These kilns are a great tool to introduce a younger audience to ceramics and kiln building. They also offer an opportunity for communities that cannot afford their own kilns, either because of cost or space constraints. This is such a fun way to be able to share kiln building and firing with a new community. Portable kilns build knowledge and camaraderie—and they are fun to build small-scale as a project or sculpture in their own right. You can make these kilns out of extra materials you might have on hand, including clay, a clay and sand mixture, or any handy refractory material that you think might do the job. While the results might be really great coming out of these kilns, I consider this type of kiln more about sharing the process, building ideas, and growing the community. They are great learning tools and fun ways to involve younger students in the building.

FIRING VARIATIONS

Changing the length of the firing, peak temperature, or adding a cooling cycle are all ways to create variation without making any actual design or loading changes. By changing your firing, you effectively make one big change for the entire kiln load. Depending on the extent of the firing change, you will see differences in how fluid a glaze is, how much surface is developed from wood ash, how vitrified your clay becomes, and the overall color palette of the materials.

COOLING CYCLE

For an example of a firing variation, let's look at how I finish my wood firings with a reduction cool, or controlled cool, cycle. This cycle adds roughly six hours onto my schedule. Without the cooling cycle, my clay is a dark, shiny brown. With the cooling cycle, my clay is dark gray to black. The cooling cycle also changes the characteristics of the wood ash, making it slightly more matte. Even this small part of the overall process is an area that I am constantly investigating and tweaking. What I like about reduction-cooled surfaces is how diverse they are, while remaining very dark and subtle. Conceptually, I use this process and the surfaces it yields to support my interests in how place and time slowly affect or wear on our surroundings—the way river stones, worn leather, and antique industrial objects are all uniquely changed by the environment in which they exist. Using the wood kiln, I am able to convey a similar narrative of time and place in my work. The placement of the piece and process of firing is recorded on the surface of the object and begins to reveal the qualities of the material and tell a visual story.

My cooling cycle starts when the firing of the kiln is over. I finish with a large stoke in the firebox and plentiful stokes in both side stokes. I then brick up the firebox, brick and mud around all the peeps, side ports, door, and primary and secondary air ports, and I start to slowly shut the damper. The flame in the chimney starts out as a roaring flame and over time, lessens to a quieter flame as the damper is slowly and completely shut. One of the signs

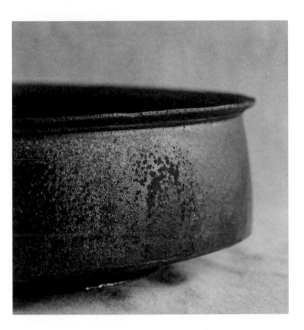

that it is time to stoke during the cooling is that the soft flame that licks around the closed damper disappears. Once that flame disappears and the pyrometer reads any increase or there is a long stall in the temperature, it is time to stoke. Generally, I stoke one piece of wood in one of the secondary air ports in the firebox and one piece of wood in one of the side stoke ports. For the cooling process, I like to use green wood or dense woods because you get a better drop in temperature. The back of the kiln generally stays hotter longer than the front, so in the end of the cooling process, I focus my stoking on the back stoke furthest from the firebox. I want to keep the kiln in a reduced atmosphere the entire time I am in the cooling process. I fire down to no hotter than 1625°F (885°C).

SALT AND SODA FIRING

Another way you can alter your firing is by adding salt or soda ash to the environment. Keep in mind that once a kiln has had a reasonable amount of salt and soda added during a firing, it is always considered a salt or soda kiln. This is because the excess vaporized sodium begins to coat the bricks. So, every time you fire the kiln, the sodium from the bricks will vaporize and create a subtle salt or soda surface. For this reason, I suggest picking an area toward the back of a cross-draft kiln or making sure you are fully aware of the choice you are making for the rest of your firings moving forward. Salt and soda firings are generally the most corrosive environments in terms of wear and tear on the kiln, so if you choose to go down this path, you will most likely need to replace bricks sooner than with other types of firings. Note that if you are using salt or soda, you will also need to wad your pieces to prevent them from getting stuck to a shelf. And consider keeping the furniture and shelves you used for the salt or soda kiln organized separately from your other furniture. Like the kiln, the furniture and shelves will also always have a residual buildup. It should also be noted that because salt and soda quickly vaporize, the kiln should not be indoors.

Adding salt or soda ash can be done in several ways, even if you do not have a port or ports that are designated for integrating salt and soda into the firing. One way to introduce salt is to load little cups of salt in the area of the kiln where you want it to be dispersed. Another way is to treat the side stoke aisle like a salting chamber. Using a piece of longer angle iron, fill it with rock salt and when the kiln is at or above cone 7, add salt to the side stoke aisle in between wood stokes. You can also wrap a newspaper burrito of salt and place it on a piece of wood, sliding it in like a stoke.

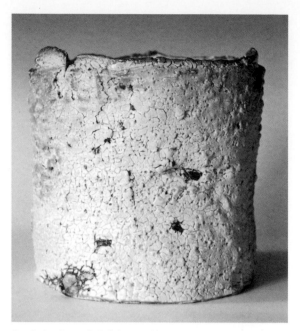

Sandy Lockwood, *Subduction Series Vessel*, wood fired, salt glazed.

For soda, mix it into a solution with warm water and use a 1-gallon (3.8 L) weed sprayer to spray the soda solution into the kiln through the side stoke ports and peeps. Knowing you are going to be adding soda during the firing, I suggest changing the number of cone packs you use, so you have more ports to spray into. To mix the soda solution, slowly pour 1 to 3 pounds (0.5 to 1.4 kg) of soda ash into the gallon (3.8 L) canister of a weed sprayer, using a wooden stick to stir the water constantly and ensure the soda ash dissolves. In general, soda ash sprayed in the kiln is going to be a softer, but more directional, effect than salt. Of course, there is always the option of adding soda to your glaze or as a wash on your clay body; however, be mindful it is caustic and should be handled with care.

It is also worth mentioning that when you add salt and soda in the kiln the vapor can be corrosive, and it is not good to breathe it in. With this in mind, if it is a rainy, overcast day and the vapor from the sodium in the atmosphere outside the kiln is not clearing, do not

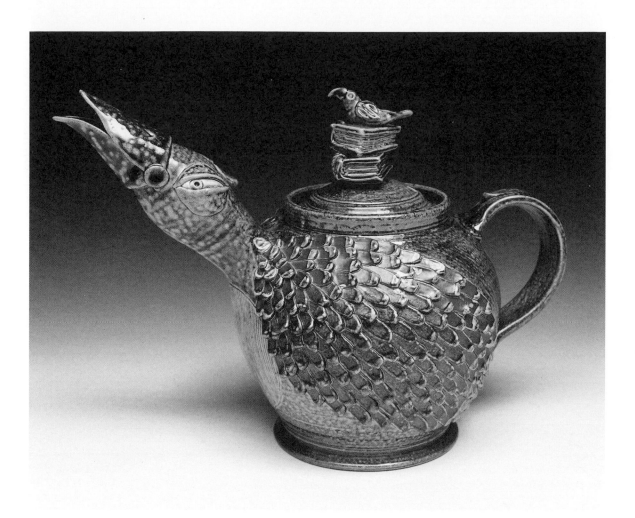

Dan Finnegan, *Bird Teapot*, wood fired, salt glazed.

stand by the kiln and breathe it in. (I recommend you avoid firing all together in that type of weather.)

The amount of salt or soda you use in your firing depends on three things: the size of the kiln, how seasoned your kiln walls are, and what you are looking for in the results from salting. It is not uncommon for a first time salting of a kiln to use 10 pounds (4.5 kg) or more of salt to help season the kiln. However, after a kiln is seasoned, 3 pounds (1.4 kg) of salt could be effective. If you really want the classic German orange peel effect, you may use upwards of 10 pounds (4.5 kg) or more of salt. Before wood firing, for years I salt fired in

a gas kiln and found that I typically used 3 to 5 pounds (1.4 to 2.3 kg) of rock salt per firing. It was actually the reducing and oxidizing during the salting that first got me interested in the cooling process.

Note *When you add salt at the higher temperatures, it is common practice to reduce the kiln, closing the damper, and then minutes later clear the kiln by opening the damper. In other words, when you salt, do not try to also gain temperature.*

DRAW RINGS

If you decide to experiment with adding salt or soda into your kiln, you will want to make three to six draw rings that you can pull out in between when you add salt or soda. A draw ring is a ring of clay somewhere between the size of a quarter and a half-dollar. The coil itself is about a quarter of an inch (6 mm) thick, and where the coil begins and ends, the ring is pressed flat so that it stands upright on the shelf, making it easier to draw out of the kiln during the firing.

When you place the draw rings behind the port you plan to draw from, make sure you diagonally stagger them, ensuring they are easy to see, and remove them one at a time from a hot kiln. After a couple times of salt or soda firing or if you keep track of the amount of salt and soda you have introduced, plan on drawing a ring and quenching it in water. The purpose of drawing the ring is to have a gauge of how much salt or soda surface is building on the pots inside the kiln. It could be that after you draw a ring, you decide to add more or less than you originally planned because you are happy with the surface on the draw ring. You never really know until you unload the kiln, but a draw ring is a good indicator. It is also a good idea to make the rings out of the same clay body you are using, and if you have a large amount of pots with a certain slip on them, it's not a bad idea to slip a few draw rings too. That way, they are as accurate as they can be for the kiln load. In terms of placement in the kiln, I suggest a good center point.

When you draw the rings out, you should wear welding glasses and leather or welding gloves. Use a narrow piece of rebar that is long enough to hold comfortably and go inside the kiln and simply place the end of the rebar inside one of the draw rings; carefully lift the ring and carry it out on the rebar. As soon as you can, quench the draw ring and rebar in a bucket of water near the kiln. Within seconds, you should be able to reach in the water and inspect the draw ring. The more times you fire with salt and soda, the fewer draw rings you will need, but it is always a good idea to have one or two, just to make sure everything is going to plan. And if you ever rebuild the inside of your kiln, it is a good idea to make a few extra draw rings, as you will most likely add more salt or soda than normal.

FIRE AS PERFORMANCE

SCULPTURAL KILNS

For mankind, learning to create and manipulate fire is one of the greatest advancements in our history. Fire allows us to make tools, cook food, live in a wider range of climates, change the physical properties of diverse natural materials, and generally prosper. Despite our long history with it, fire is still extremely dangerous and elusive, burning down large sections of land and homes and wreaking havoc when it is out of control. Making fire is a primitive skill that we are still working to master.

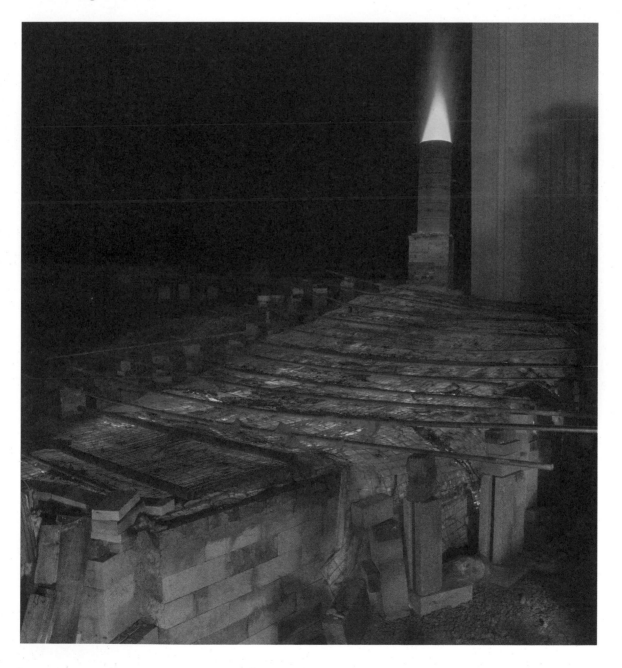

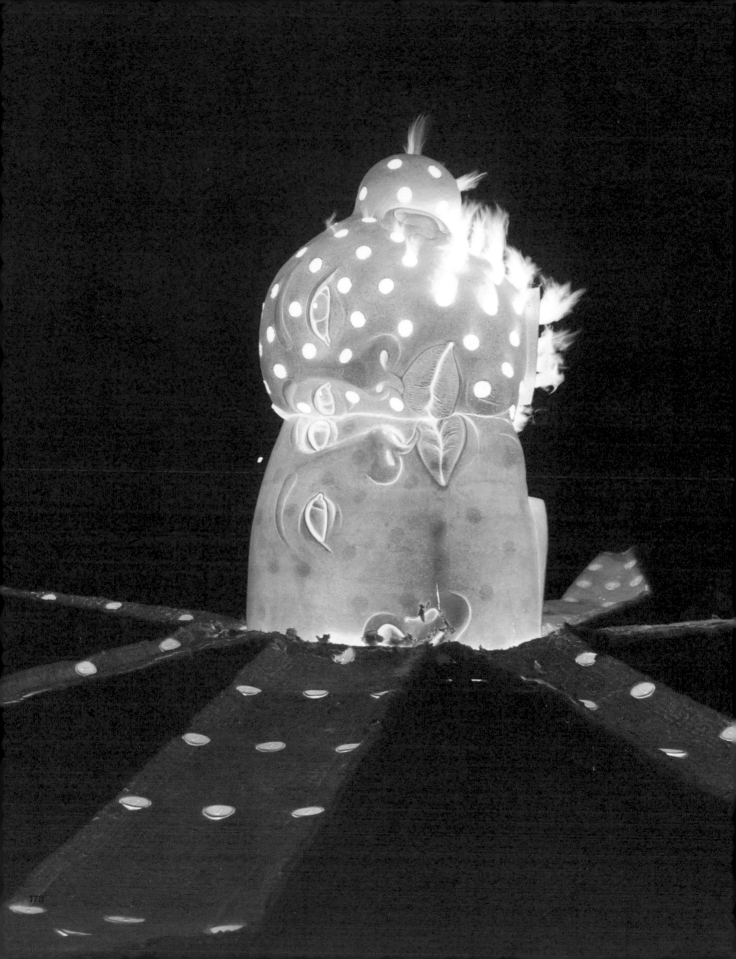

Every time I light a fire in the kiln, I am thankful for both its power and beauty and I am centered in that moment. As it hisses, pops, and bubbles the wood, I am calmed by how direct of a process it is. Working with wood kilns and fire in ceramics is hot, physical, and requires continuous attention. A sculptural kiln dedicated to the performance of firing takes the relationship we have with fire to the next step—it showcases fire's unpredictable yet reliably active nature.

This section of the book is, in a lot of ways, a departure from what the rest of the book offers, in terms of practical guidelines and helpful tips on starting down the path of alternative firing. At the same time, I like the idea of ending the book on such an open-ended concept of firing, as we all bring a unique perspective to the process and performance of the kiln and the possibilities with how we approach the fire are great.

Potters always joke: If only this kiln was transparent. We want to see exactly what is happening and watch the wildness of the flame as it dances through the wares. As a spectator of a sculptural kiln and firing by Alexandra Engelfriet, it was the closest I felt to realizing that desire of watching the flame inside a kiln. Her kiln was wide and low, made primarily of ceramic fiber insulation and a framework of wire, climbing up a shallow incline. As night fell and the insulation got glowing hot, you could see the flame's movement under the thin glowing insulation. It felt almost as if the flame was being projected onto a movie screen on the ground, only much

better. Alexandra's kiln was designed specifically to fit around a large-scale installation piece made of kaolin and red slip. As Alexandra describes it, "In *Mixed Blood* (STARworks, NC, US, 2017), the kiln followed the shape of the piece like a second skin. The work determined the shape and size of the kiln instead of the other way around."

If you try your own sculptural kiln, take great precaution and follow your county's regulations. As you can see from some of our gallery and featured artists (see pages 172, 180, and 181), a kiln can be made out of a wide range of materials.

Beyond the practical questions that come with working with new materials and innovative structures, it is key to also keep in mind how your kiln engages fire conceptually and contextually. When you are building your kiln, think about how you can bring interest or intention to the draft, flame path, smoke, and remnants left behind. Logistically, you want to consider all the same needs of a basic kiln: what is the path of the flame, where is the firebox, what is the size of the ware chamber or kiln body, and how is the flame going to escape (is there a need for a chimney)? Additionally, for sculptural kilns, you should also consider how you are going to engage and intrigue the spectators and showcase the energy of the fire. Because this is the least traditional of all the kilns mentioned in this book, there are no real rules to follow—it's more a matter of following your own idea. To reiterate, it is important to always take precautions and do your research before you start the fire.

GALLERY

All photos courtesy of the artists.

Liming Zhang, mini kiln.

Liming Zhang, extremely small-scale kiln made from clay.

Sergei Isupov assisted by Anne Partna, work in progress.

Andy Bissonnette, converted electric kiln.

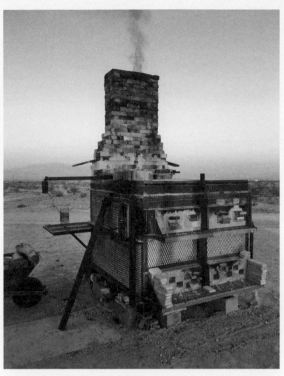

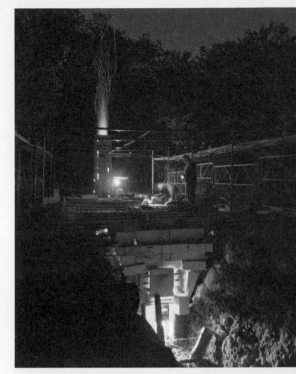

Jonathan Cross, Komakigama-style wood kiln designed and built by Steve Davis.

Alexandra Engelfriet, *Tranchée*, les Vent de Forêts, France. Trench kiln echoing the remains of World War I trenches in the area.

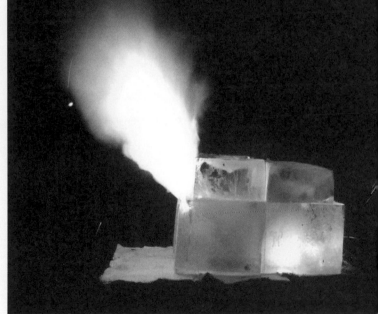

Duncan Shearer, kiln made from a block of ice.

(left) Duncan Shearer, kiln made from potatoes.

Patricia Shone | Cross-Draft Kiln & Saggar Firing

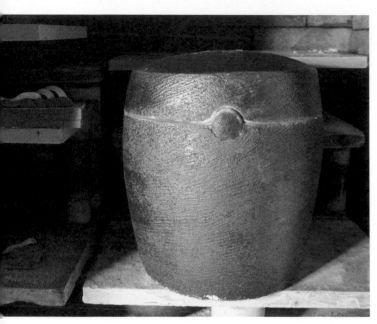

Patricia Shone, saggar loaded in the kiln with its lid on. *Photo courtesy of the artist.*

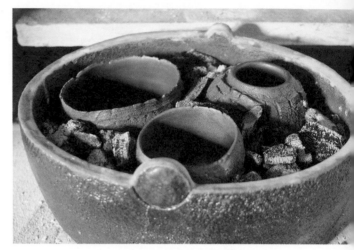

Patricia Shone, three small jars sharing one saggar post firing. *Photo courtesy of the artist.*

My first kiln was a homemade bottle gas raku kiln built from a 45-gallon (170.3 L) oil drum. It lasted twenty years, during which time I developed my practice. Along the way, I acquired a couple of low-power electric kilns, which got me to earthenware temperatures without dimming the lights too much. All the while, I was yearning for stoneware and to try out wood firing. I thought it would never work where I live on the Isle of Skye—too windy and exposed. One day, I was lamenting this situation to one of my ceramic suppliers, only to see his eyes light up as he said, "Fast firing then!"

After a few group firings of a small anagama, 250 miles (402 km) away, I had the confidence to build a small cross-draft phoenix design kiln. I adapted the design with a larger firebox, which runs the full length of and directly underneath the chamber. The kiln absorbs a lot of moisture over the three months between firings, even when it's not actually raining. For this reason, I

pre-fire it the day before for about three to four hours, up to no more than 750°F (400°C). This has made a huge difference in the ease of getting cone 11 down within the sixteen solo hours that are required.

I fire mostly with locally sourced split pine, 31 inch (80 cm) lengths, and whatever hardwood is available. In the pre-fire, I usually add a large bundle of dried Jerusalem artichoke stems, which grow well here. They are high in silica and improve the quality of ash deposits in such a short firing. The kiln fires in its own rhythm, reducing at around 1650°F (900°C) for a couple of hours to 1920°F (1050°C). Above that, it's a fairly neutral atmosphere. I follow this pattern, as I appreciate these constraints in a medium of almost infinite possibilities.

I heard about *tanka* (charcoal saggar) firing in Japan and thought it might be a way of achieving the monochrome subtleties of raku fired work, but at stoneware temperatures. I knew my kiln would struggle with reduction cooling, as would I without help. Yet, I wanted to try it.

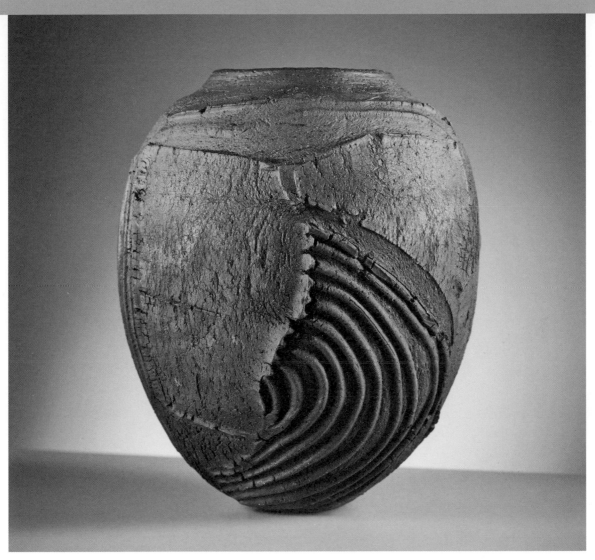

Patricia Shone, *Erosion Jar 35 'hill riggs'*, fired in a charcoal saggar, cone 10. *Photo by Shannon Tofts.*

I now make saggars from a course crank clay. They crack after a few firings, which is a shame, as by then they are beautifully seasoned by the flames. Large pots are fired in their own saggar, the gaps filled with lumpwood charcoal. I include additions in small amounts to flavor the results: locally sourced wood ash, dried peat, seaweed, and/or horsetail (*equisetum*, which is also high in silica). Smaller pieces are fired together, separated by pieces of charcoal. The saggar lids are sealed with a zircon kiln wash to prevent sticking and inhibit the ingress of oxygen. This system produces an atmosphere of extreme reduction within the saggars, and I prefer to use a particular course wood fire body for the pots, which copes well. My favorite glaze is a tenmoku type, which is lovely and shiny when fired in the open body of the kiln. In the reduction saggars, it turns into a matte blue-grey, which develops spots of rust with dampness, showing that some of the iron oxide (Fe_2O_3) within the glaze has been reduced to metallic iron by the firing.

I have little idea what internal temperature the saggars reach. I tried a set of cones in one and they all boiled spectacularly.

RECITES

Aside from a few recipes in this section that are based on rough quantities (such as wadding and kiln mud), recipes are listed in percentages. Translate the percentages to grams and multiply by 10, 100, or your desired multiplier to create your batch size. I recommend trying a small (100 to 300 gram) batch test to make sure it is what you want. Then, you can use a 5-gallon (19 L) bucket for your slips and glazes, which holds a 5,000-gram batch.

I also want to note that while I am suggesting consistencies for each recipe, you may want a consistency thinner or thicker to suit your aesthetics, materials, and firing. It is good practice to screen all glazes twice and be mindful with the shino glazes that soda ash is caustic, so wear gloves or rinse quickly. Always wear an appropriate dust mask when mixing.

LINDSAY OESTERRITTER

LATERITE SLIP (PAGE 127)
100% Laterite

I generally mix this in a 5-gallon (19 L) bucket, filling about a quarter of the bucket with Laterite and adding enough water for a skim milk consistency. When I dip a piece in the slip, I want the edges to just break through, where you can barely see the bisque color. When using this slip, you need to stir frequently as it will settle quickly.

REDART SLIP (PAGE 127)
100% Redart

Follow the same steps and visual cues that are described in the Laterite Slip. The main difference between this slip and Laterite is the surface finish. Laterite tends to be more matte, while Redart is shinier.

KILN MUD (PAGE 151)
Fill a 5-gallon (19 L) bucket about half to three quarters full of reclaimed clay that is already goopy and wet. You'll want to slowly add scoops/cups full of sand, hand mixing the whole time. I use playground sand because it is readily available at the hardware stores and cheap, but any courser sand will work. Add enough sand so that it is visibly grainy (you can imagine using it to exfoliate). The sand

will help with the quick drying and shrinking when using it to seal the kiln. Mix to an icing-like consistency.

WADDING (PAGE 129)
Mix roughly equal parts rice hulls and playground sand. Add enough Fire Clay and water to make it easy to work with. I mix mine in small batches on my table like it's pasta: creating a volcano shape and pouring the water in the middle, slowly working and wedging it all together. I find working on the tabletop helps me get a good mix without getting too wet. The amount you need really depends on the size of your kiln, but I would recommend making enough to fill a 5-gallon (19 L) bucket between three quarters and all the way full. Wadding will keep to the next firing if stored in a well-sealed container.

RANDY JOHNSTON'S DRY SHINO
39% Nepheline Syenite
29% Spodumene
29% EPK
3% Soda Ash

Mix dry and then add water and mix until it reaches a cream consistency so it can be thinly applied.

LINDA CHRISTIANSON

TILE 6 SLIP
70% #6 Tile Clay
15% Grolleg
10% Nepheline Syenite
5% Flint
1% Bentonite

Mix dry and then add water and mix until it reaches a skim milk consistency.

SHINO GLAZE (CONE 4 TO 14)
42.3% F-4 Feldspar
35% Spodumene
5.9% EPK
9.4% Soda Ash
3.5% Nepheline Syenite
3.5% Ball Clay
2% Bentonite

Mix dry and then add water and mix until it reaches a heavy cream consistency.

COURTNEY MARTIN
(page 160)

CASEBEER BLACK (MARTIN REVISION)
7000 Alberta Slip
3000 Nepheline Syenite
100 Black Iron Oxide
350 Mason Stain 6600

Mix dry and then add water and mix until it reaches a light cream consistency.

WHITE SALT
71.6 Nepheline Syenite
4.8 OM4 Ball Clay
23.6 Dolomite
18.8 Zircopax
4 Bentonite
3 Mason Stain 6600

Mix dry and then add water and mix until it reaches a light cream consistency.

GREY SALT (Martin adaptation of White Salt)
71.6 Nepheline Syenite
4.8 OM4 Ball Clay
23.6 Dolomite
18.8 Zircopax
4 Bentonite
1.1 Rutile

Mix dry and then add water and mix until it reaches a light cream consistency.

MARCIA SELSOR
(page 59)

JANE JERMYN'S OBVARA RECIPE
Obvara is a smokeless process where you quench the hot pot in a yeast and water mixture. To create this mixture, combine 2.2 pounds (1 kg) of flour with 1 or 2 packs of dried yeast, 1 tablespoon (13 g) sugar, and 8 to 10 liters (2.1 to 2.6 gallons) of warm water. Leave covered in a warm place for 3 days, stirring frequently. To use, remove an unglazed pot from a raku kiln at about 1650°F (900°C), immediately place in the yeast mixture, and then quench in water.

TIM SCULL
(page XXX)

Sawdust Firing Slurry

Tim uses this clay slurry to act as a resist for pit firing. He loads the kiln while the resist is still wet.

FIRE CLAY SLURRY RECIPE (measure by volume)
5 parts Hawthorne Fireclay
3 parts EPK
0.5 parts Aluminum Hydrate

Mix dry and then add water until it reaches a thick sour cream consistency.

KILN LOG

DATE _____ CREW ___PATRICK, MARIA, AND BOB_____

CONE PACK

| 08, 1, 3, 5 |
| 7, 8, 9, 10, 11 |

hour	time	temp	cone	goals/notes
1	8 AM	85°F (25°C)	N/A	*(There is always a big jump in temperature during the first hour. As long as you keep the fire small and away from the pots, there's nothing to worry about.)*
2	9 AM	243°F (117°C)	N/A	
3	10 AM	303°F (150°C)	N/A	

KILN LOG

DATE _____ CREW _____

CONE PACK

hour	time	temp	cone	goals/notes

ACKNOWLEDGMENTS

At the beginning of this project, I was more confident in my experiential knowledge in wood firing than in raku and pit firing. I have truly enjoyed researching all the alternative firing techniques touched on in this book. I could not have learned or included as much without the generosity and expertise of the contributing gallery and featured artists. It has been rewarding on many levels working with you all and my clay community now feels much broader. Thank you.

A special thank you for Ray Bogle going above and beyond in allowing me to fire your kilns and work in your studio space and for taking the time to rebuild your raku trash can kiln. Thank you for being so generous with your knowledge, time, and studio. Thank you to Abram Landes for being available to photograph and capture the beauty and details of all of these processes so well, even in the wee hours of wood firing. It has been a pleasure working with you on this project. Thank you to Sunshine Cobb for recommending me for this project and being there to support me when I was not sure of myself. Thank you to my editor, Thom O'Hearn, for helping me through all my writing and editing obstacles and for being such a strong advocate for craft books. To the rest of the team at Quarto, I am grateful that you continue to champion such high-quality ceramics books and that you allowed me to contribute to that endeavor with this book.

Thank you, John Neely, for writing the foreword and for your continued support, guidance, and friendship throughout the years. Thank you to all of my mentors, teachers, and to the larger clay community. All of you continually inspire me to try new things, push my own limits, and work to be a better maker. Thank you to my mom, Abbie, for always supporting my decision to pursue a career in ceramics. I truly appreciate the countless road trips you have taken to be there for exhibition openings, not to mention your own growing ceramics collection.

And a huge THANK YOU to my husband, Jason Vulcan. Even as I am writing this acknowledgment from my home studio, I can hear our two children, River and Micah, playing upstairs with their dad. Thank you for affording me so much studio time and always being there to say "yes" when I mention traveling for work, firing a kiln, or any of the multitude of activities that fill our calendar. It goes without saying that none of this would be possible without Jason's love, respect, and support. River and Micah, thank you for being understanding of mommy going to work and always being glad to see me when I return, even if I am covered in clay.

ABOUT THE AUTHOR

LINDSAY OESTERRITTER is a studio potter based in Manassas, Virginia. She is a cofounder of National Clay Week and Objective Clay. Lindsay held the position of Assistant Professor of Ceramics at Western Kentucky University (2009–2015) and earned Associate Professor in 2015. She was awarded the highly regarded University Award for Research and Creativity in 2013. Since stepping away from teaching full-time at the university, she enjoys traveling to teach workshops and fire kilns. She lectures and exhibits nationally and internationally, most frequently on wood-firing techniques, and is continually inspired by the craft community.

Lindsay earned an MFA from Utah State University in Logan, Utah, an MA from University of Louisville in Louisville, Kentucky, and a BA from Transylvania University in Lexington, Kentucky. Lindsay has been a resident artist at Arrowmont School of Arts and Crafts in Gatlinburg and in Australia at Strathnairn Arts Association. Her work and articles have been featured in *The Log Book*, *Ceramics Monthly*, *Pottery Making Illustrated*, *The Studio Potter*, *American Craft Council*, *Clay Times*, *Ceramics Technical*, *Mastering Hand Building*, and *Handbuilt: A Potter's Guide*. View her work and workshop schedule at: loceramics.com

INDEX